Art and Death

Art and...

Contemporary art can be difficult. Reading about it doesn't need to be.
Books in the *Art and...* series do two things.

Firstly, they connect art back to the real stuff of life – from those
perennial issues like sex and death that trouble generation after
generation to those that concern today's world: the proliferation
of obscene imagery in the digital age; our daily bombardment by
advertising; dubious and disturbing scientific advances.

Secondly, *Art and...* provides accessible theme-based surveys which
energetically explore the best of contemporary art. *Art and...* avoids
rarefied discourse. In its place, it offers intelligent overviews of art –
and the subjects of art – that really matter.

Art and Death

Chris Townsend

Published in 2008 by I.B.Tauris & Co. Ltd
6 Salem Road, London W2 4BU
175 Fifth Avenue, New York NY 10010
www.ibtauris.com

In the United States and Canada distributed by Palgrave Macmillan, a division
of St. Martin's Press
175 Fifth Avenue, New York NY 10010

ISBN: Pb 978 1 84511 663 7
 Hb 978 1 84511 662 0

A full CIP record for this book is available from the British Library
A full CIP record for this book is available from the Library of Congress

Library of Congress catalog card: available

Typeset in Rotis by Dexter Haven Associates Ltd, London
Printed and bound in the UK by T.J. International, Padstow, Cornwall.

Contents

List of Illustrations

Acknowledgements

Thanks are due in particular to Shimon Attie and Nan Goldin, as well as to Ed Coulthard and Adam Barker of Blast! Films for long ago making available the transcript of the film *I'll Be Your Mirror* and protracted discussions about it. I'd like to thank Damien Hirst for his generosity in making available images of his work for publication here, and similarly the new owners of Cézanne's *Preparations for the Funeral*, and Keith Collins for allowing me to reproduce two of Derek Jarman's paintings. It's not often an author gets to thank his mother-in-law, but I must acknowledge the help and advice of Elizabeth Beasley concerning the thought of Thomas Merton. Credit is also due to Kate Briggs for insightful comments on my lumbering translations of Barthes, to Nemonie Craven-Roderick for helpful and critical readings of several chapters in their later drafts, and especially my suffering-longer-than-most editor Susan Lawson. This book could not have been completed without a sabbatical from my post at Royal Holloway, University of London, and my thanks go to the college authorities and my colleagues.

Introduction

When I am laid in earth may my wrongs create
No trouble in thy breast
Remember me! Remember me! But ah! Forget my fate.

Nahum Tate, libretto for Purcell's *Dido and Aeneas*

Appropriately, this book had its inception at a funeral, for death is about beginning as much as it is an ending. Death has in common with birth that it is an event that cannot belong to us, but rather only to those around us. Neither are events at which we can be consciously present. I cannot apprehend the moment of my death, nor can I represent or communicate it. As Simon Critchley puts it: 'Death is radically resistant to the order of representation. Representations of death are misrepresentations, or rather representations of an absence.'[1] Such a constraint might suggest that any study of the relationship of art and death, beyond an aesthetic history of its misrepresentations, is going to be either brief or a work of sophistry.[2] Yet death, however intractable, however marginalised by contemporary culture, remains central to that culture, certainly through traditions of painting, sculpture and the memorial, but also in the very necessity of making art. And it is central too to a possible politics, anticipated in culture. This is a potential, perhaps necessarily always and forever latent, rethinking of our relations with others, through their deaths, that may radically transform the lives that we inhabit.

So, if not in the moment of my death, when? If not *my* death, then whose? To borrow a passage from the philosopher Jean-Luc Nancy, at this point of exit, as at our moment of entry to life, 'We are others – each one for the other each for him/herself – through birth and death, which expose our finitude.'[3] Whereas Martin Heidegger felt that a vital characteristic of his idea of the authentic being in the world (what he called *Dasein*) was the capacity to comprehend, or grasp, one's own death, I would argue, along with Critchley, that '[d]eath is that in the face

of which the subject is not *able to be able*'.⁴ Indeed, we cannot lay hold of *our* death. Critchley claims that finitude 'is not something that can be heroically assumed in a free fatefulness [which is how Heidegger imagines it as a condition of existential being] but is, rather, something radically ungraspable, a weaker and ever-weakening conception of finitude'.⁵ But if *our* death is something so utterly disabling that we cannot lay hold of it, as human subjects who die, perhaps it may be laid claim to by others, or bestowed upon them, even if they misunderstand or misrepresent it. It may even be that death is the foundational moment of a necessary incoherence here; death as a separation of sign from object, text from author, is a beginning of 'meaning' that necessarily undermines itself. Jacques Derrida remarks: 'Less than for any other noun, save "God"...is it possible to attribute to the noun "death", and above all to the expression "my death" a concept or a reality that would constitute the object of an indisputably determining experience'.⁶ Yet that which cannot be a sign nonetheless produces a plethora of signs, produces culture. Death establishes the necessity of meaning and knowledge as concepts, yet, *imagined as limit*, it is not a law that defines limit and ending; as a concept of absolute termination it endlessly initiates beginnings. As Critchley observes, in a discussion of the French writer Maurice Blanchot, '[T]he Book [*as an exemplary form of western thought and originating point of knowledge*] is a strategy for evading the radical absence at the heart of language and culture'.⁷ Culture here comes out of death, and if culture is a form of evasion, its trace is nonetheless an address to death - if not literally, and therefore 'falsely', then through its indirection, its very impossibility. Our making of signs, representation, rests upon an originating absence.⁸

Death offers us the possibility of something more than the phobic iteration of its signs, displacements that might ward off or somehow placate the event. This 'something more' is found both in the work of artists dealing with the imminence of their own death and in our responses to the deaths of others. To continue with Nancy's idea of death, community and history:

> We begin and we end without beginning and ending: without having a beginning and an end that is *ours*, but having (or being) them only as others', and through others. My beginning and my end are precisely what I cannot have as mine, and what no one can have as his/her own.⁹

In this experience it may not be so much we who lay hold of death but, rather, because of our inability 'to be able', it is the deaths of others that lay claim to us, as witnesses. There is a degree to which, as Jonathan Strauss argues, death is 'a fiction derived from other experiences of loss, most significantly that of other people'. He remarks that

> my death is an awareness of myself that I can only have through the idea of others who will survive it, and it is in this sense a blind spot in my self-knowledge. Death always takes me from behind, is reflected only in the eyes of others. And so, my

individuality is not grounded in mortality, but rather in the experience of those others and in their ineffable difference from me. It comes from the pre-ontological condition that Emmanuel Levinas has called ethics.[10]

Death, soliciting responsibility in those who come after the one who dies, announces itself to us, as our death, in advance.

We work out this responsibility and this anticipation, and indeed the dread that it engenders, within culture. These matters are deeply embedded within our art. Describing a cave painting at Lascaux that shows a prone figure between a bison and a rhinoceros, Blanchot writes:

Is he dead? Is he asleep? Is he feigning a magical immobility? Will he come to, come back to life? [...] ...it seems to me that the meaning of this obscure drawing is nonetheless clear: it is the first signature of the first painting, the mark left modestly in a corner, the furtive, fearful, indelible trace of man who is for the first time born of his work, but who also feels seriously threatened by this work and perhaps already struck with death.[11]

If the 'signature' is a warrant of our own mortality, what of our relation and the relation of our art to the mortality of others? Alberti in *Della Pittura* writes: 'Painting contains an absolutely divine force that not only makes absent men present, as friendship is said to do, but shows the dead to the living so that even after many centuries they may be recognised by them with great pleasure and with great admiration for the painter.'[12] This weaving together of fidelity, mortality and representation shapes not only Western art but contemporary theories of ethics and politics that are grounded in the recognition of one's relationship to others, no matter how estranged, even up to and including the estrangement of death. We need to understand death as a fundamental condition of being, *and of culture*, by which we may have some relationship to others, no matter how alien. What happens when we apprehend death as something other than limit? What happens if we admit the death of others as an animating condition of our lives? What happens if we put death *in general* within rather than at the end of *our* life? The way we live in the present is – or, more properly, *can be* – affected by the way that others have died before us, and by the way that we ourselves shall die.

It was in hesitant answer to such a summons to responsibility, the death of a friend, that I began this book. I had known him since he was a piano scholar at the Royal College of Music and then observed the development of an extraordinary voice that would make him into a promising recitalist and opera singer even as a premature arthritis overtook his fingers. When a shredded immune system could not defend him from a rare form of leukaemia, I became one amongst many friends who assumed the duties for those, dying from AIDS, that society's institutions seemed to have abrogated. We ministered to him in his home; unusually for a modern patient he died there, rather than in a hospice or hospital. We knew, in a way, that this

would happen. We did not calculate that he would die before us, but part of the bargain of our friendship was staked in the relation of our deaths to his. It may be a truism to say that 'one must always go before the other' but it is, perhaps, one writ so large that we overlook its importance. In their commentary on Derrida's writing on and for his dead friends, Pascale-Anne Brault and Michael Naas observe:

> There is no friendship without the possibility that one will die before the other, perhaps right before the other's eyes. For even when friends die together, or rather, at the same time, their friendship will have been structured by the possibility that one of the two would see the other die, and so, surviving, would be left to bury, to commemorate and to mourn.[13]

This situation invokes certain responses to the death of the friend, to the death of the 'other'. Amongst those responses is a fidelity which can only reside in us and our incapacity to 'continue' the lives of others on their behalf; a responsibility that is both an assumption of obligations in the present and of memory. Memory here is not a call into the past, reflecting upon events that have been, but, rather, an injunction to 'memory in the future'. For the fragmenting of fraternity that is the death of a friend throws a legacy ahead of us, *an inheritance we may not want but that nonetheless are obliged to accept*, interwoven with the anticipation of our own death. This is no simple foreboding: death does not simply diminish me, at the same time it transforms me; *it makes me.*[14] Death as we know it cannot be *our* death, but is always instead the deaths of others. As Paola Marrati observes, 'The "I", what we call the "I", only emerges, is only delimited, not just through the experience of the other, but through the experience of the other *as mortal*. The other is the one who can die, leaving nothing more than its memory in me.'[15]

Far from being made uniquely free by our embrace of death, as Heidegger would have it, it is death that binds us into social relationships. Our friendship survives my friend's death: it may even be that death marks its true beginning, through my survival rather than his.[16] Our friendship endures in memory and in acts; written here it hopefully survives even my demise and yours as its reader, for to write is necessarily to make a communication that anticipates a future even as it immures a moment, a thought, subjectivity. Our responses to, and anticipations of, death are not limited to a private sphere but, rather, belong in the public domain, and particularly in the realm of culture, because our sign for the other's death so often takes the form of authorship. We 'speak' death, and yet in making ourselves heard, in making our thoughts and feelings visible, we cannot 'speak' in the form of a specific address.

To propose such a culture of fidelity is also to propose a political culture (or, rather, a conception of politics that may unsettle politics as we conceive it). Whilst Derrida's argument for a 'democracy that is to come' is grounded in a wider analysis of fraternity, it proceeds in part from a reading of Blanchot's *Friendship*, especially that writer's tribute to the philosopher Georges Bataille. Derrida, commenting on Friedrich Nietzsche's demand for a 'community

without community', echoed in the 'excessive' notion of friendship in Blanchot's work, cites his epigraph and comments:

> The moment when the hyperbole seems to engage with the greatest risk, with respect to the inherited concept of friendship and all the politics that have ever spun out of it (Graeco-democratic or Christano-revolutionary), is when the 'without sharing' or the 'without reciprocity' come to sign friendship, the response or the responsibility of friendship. Without sharing and without reciprocity, could one still speak of equality and fraternity?[17]

This important distinction between friendship and the comradeship of traditional politics - one made also by Blanchot - allows Derrida to propose a politics of inheritance that needs be neither mutual nor reciprocal, which might supplant conventional relations of fraternity. Such a politics emerges from a stretching of friendship beyond its conventions, from what Critchley calls 'a non-ecstatic experience of the future...irreducible to the autarchy that still determines the ecstasies of *Dasein*.'[18] There can be no sharing with the dead, after all, nothing returned for our gift or sacrifice. But the dead can, perhaps, share something with each other – at least to our eyes. Linking the time of friendship with the experience of ageing, Critchley writes of 'old friends leaning together like bookends', where '[t]he temporality of the future in friendship is an experience of slow protraction, the future tense as distension, as stretching out.'[19] Perhaps this relation and support stretches beyond death: Critchley's simile is mirrored in Hannah Collins's extraordinary photograph of the old Jewish cemetery in Krakow – a picture that occupies an art-historical tradition stretching back to Jacob van Ruisdael and Jusepe de Ribera.

But death cannot be an experience of self-relation; we remain wholly alienated from it. Derrida, in his term *aimance*, seems to describe a love that transcends the traditional structures of friendship as lived experience. We might understand that 'friendship' also to exceed the constraint which mortality might put in place. In such circumstances the epitaph or memorial can be understood not as a 'letting go' (that incorporation of loss into the self which Freud describes in 'Mourning and Melancholia')[20] but as the sealing of a pact for the future between the other (*the dead*) and us. To return this to the specific context of art, we might see the work of Nan Goldin - notable for its engagement with the deaths of an assumed 'family' of friends - not merely as a manifestation of mourning, but as a model of ethical, and in Derridean terms 'political', relation.

Derrida's politics of friendship also emerges, however, from his own writings addressed to the dead. Amongst these is a tribute to Louis Marin - with whom he had participated in discussions of Montaigne's treatment of friendship. Marin's own writing on portraiture is a vital text within this epitaph. One of Derrida's claims is particularly important here, that 'the founding power of the image...did not exist before death.'[21] Derrida is not suggesting that the image does not exist before death – though a European tradition of portraiture does depict the

dead subject as if alive.[22] Rather, he is claiming that the impact of the portrait on its viewers is generated by the *death* of its subject. This death may be actual – we view the portrait of the king *post mortem* - or metaphoric – in that all representation is a form of death, whether by distancing from the actual moment of depiction or the real subject that is represented. (As Blanchot observes, '[E]ach living man, really, does not yet have any resemblance;'[23] it is only with death that 'the lamented dead person begins to *resemble himself*.')[24] Perhaps of most importance, this death may be prospective, but because anticipated it is as if it has already happened. The power of the image comes from its telling us what is to come, both for its subject (who possesses the power to authorise representation) and for us, its witnesses. Derrida asks what the consequences might be of death effectively bringing something (*power*) into existence through its anticipation:

> It means perhaps that the power of the image as the power of death does not wait for death, but is marked out in everything – and for everything – that awaits death: the death of the king gets its efficacy from the portrait made before the death of the king, and every image enacts its efficacy only by signifying the death from which it draws all its power.[25]

Whilst Marin's characterisation of monarchical imagery establishes a paradigm for representations of autocratic power that then inscribe ideology to produce subjects and historical effects, it also provides a model for a public sphere where representations, and therefore ideologies, may be contested. Portraits of monarchs, statues of generals, may materialise particular constructions of power and imaginations of hegemony, but they are nonetheless statues that may, *in extremis*, be toppled, paintings that may be slashed from their frames. The displacement of power into the largely unaccountable institutions of post-democratic, managerial government has been paralleled by a displacement of its representations into intangible motifs that cannot be so readily challenged, far less overthrown.[26] The representation of the absolute ruler, the representation that anticipates death and is effected, as representation, by it, is also, as Derrida recognises, the beginning of a 'democratic', because contested, politics.[27] So, out of the representation of the death that is to come, its anticipation and its continued working upon us comes *politics* in general and, in the absolute alienation of subject from other that is death, comes a politics of friendship. Implicit in this, perhaps, is a *political* culture, an art that is, even if indirect in its address, and certainly not circumscribed by them, always cognisant of the historical circumstances that surround it.

Derrida interrogates the historical possibilities of what he calls 'the gift of death', relating this to the ideas of history and responsibility in the work of the Czech philosopher and dissident Jan Potocka (1907-1977), commenting:

> History can be neither a decidable object nor a totality capable of being mastered, precisely because it is tied to *responsibility*, to *faith*, and to the *gift*. To *responsibility*

in the experience of absolute decisions made outside of knowledge or given norms, made therefore through the very ordeal of the undecidable; to religious *faith* through a form of involvement with the other that is a venture into absolute risk, beyond knowledge and certainty; to the *gift* and to the gift of death that puts me into relation with the transcendence of the other, with God as selfless goodness, and that gives me what it gives me through a new experience of death. Responsibility and faith go together, however paradoxical that might seem to some, and both should, in the same movement, exceed mastery and knowledge. The gift of death would be this marriage of responsibility and faith. History depends on such an excessive beginning.[28]

We have here the theoretical terms by which we might situate death in contemporary culture. In the critique they allow of the image and its function within culture, they come to have an empirical force. We carry death with us, a gift from others that is embedded in culture, history and politics. Above all, these terms allow us to write or illustrate, and live through an ethics and aesthetics of death.

Such faithful, responsible forms of authorship (and citizenship) may, however, pose a problem when we come to scrutinise contemporary art. Fidelity, responsibility and the bearing of memory are not characteristics readily identified in too many œuvres of living artists. How do we connect art and death in an era whose subjects are so embedded in their own construction as and by commoditised signs that they no longer recognise or acknowledge death as a constitutive element of human life, nor understand art as anything other than momentarily entertaining commodity form? We are probably right to have low expectations of art's ethical capacities when it is, largely, harnessed to the economies of a 'spectacular society'. Yet, despite adequate grounds for a general scepticism, I suggest that there are specific practices of art in which a responsibility to history and subjectivity are manifested. (And I allow here a qualification for whatever 'subjectivity' might mean in the age of its degradation and commoditisation.) Often that 'responsibility' is a response to death; it is a sign of the politics of friendship demonstrated in an impossible openness of self to other, in an ethics – and aesthetics – of extensibility.

But we do not, apparently, like to dwell on death *as death* within modern Western culture. This is, perhaps, a consequence of dying as process: it is not simply that we dread annihilation, but the pain that might be associated with death, however ameliorated by modern science. Elaine Scarry suggests that silence, or at least unintelligibility, is a consequence of such suffering. The extremes of bodily experience associated with pain and death form an absolute limit to communication, a defining penumbra to representation that cannot be breached. Scarry argues: 'What ever pain achieves, it achieves in part through its unsharability, and it ensures this unsharability through its resistance to language.'[29] This intense privacy of privation derives from a void within the sign. We cannot speak of the other's anguish, nor can we represent our own. Corporeal suffering, up to and including one's demise, has no external, referential object. Pain is a wholly interiorised experience. Scarry goes on to make clear a

'kinship between pain and death', both of which are 'radical and absolute, found only at the boundaries that they themselves create'.[30] Despite those generations of book-ended gravestones, despite the memorial of mortality that is often erected in advance of the actual death, there is, apparently, no sign for death.

This perceived impossibility of the mark to some extent parallels the observations of Philippe Ariès in his exhaustive history of death's representation and management in Western society. Ariès remarks of the latter half of the twentieth century: 'Relegated to the secret, private space of the home or the anonymity of the hospital, death no longer makes any sign'.[31] Ariès tracks a progressive spatial and cultural marginalisation of death after the Middle Ages, as graveyards at the centres of villages and towns are replaced by suburban cemeteries and crematoria, as fear of death as an absolute ending supplants the belief that it is the gateway to eternal life. In this narrative death's reception is an index of society's secularism. As belief in religion *and* the afterlife waned – a consequence first of the European Enlightenment and then of industrial modernity – so we found ourselves unable to acknowledge or represent the deaths of others, far less accept our own. Ariès's reasoning for death's absence suggests a very different cause from that postulated by Scarry, however. Her representational limit implies a universal incapacity and invisibility, whereas Ariès proposes a historical trajectory of change from the medieval Christian world, where life was nothing but a preparation for death, and its signs, together with its realities, were pervasive. The effect, however, for contemporary culture is much the same: we cannot represent death.

Yet Scarry argues that those limits she proposes may, paradoxically, find representation. Such representations are 'isolated', 'exceptional' and 'extraordinary' in their preparedness to deal 'centrally and uninterruptedly' with 'the nature of bodily pain'.[32] She cites as examples Sophocles's play *Philoctetes*, and Ingmar Bergman's film *Cries and Whispers* (1972). Scarry makes a significant historical and cultural compression here – one that suggests that the experience of pain and/or death, and the impossibility of its representation, are equivalent conditions in classical Greece and modern Europe. In doing so she occludes the centrality of death in specific historical moments mapped by Ariès and other historians. This runs from the identification with pain and suffering, represented by the emphasis on Christ's wounds, in the thirteenth-century phenomenon of the *ostentatio vulnerum*, through the late medieval era (with those manuals that instruct the subject in how to suffer and die, the *ars moriendi*) to Jeremy Taylor's *Rule and Exercises of Holy Dying* (1651) and kindred works of the seventeenth century. We might observe here that many of the *pre-mortem* portraits and tomb sculptures of early modern Europe that Ariès identifies, which become the topic of close historical analysis in the work of Nigel Llewellyn and others,[33] are ways in which subjects other than the king lay claim to the power invested in representation. In paintings such as *The Judd Marriage* (1560) it may be that, as we see a social contract enacted, we also witness love, in some fashion, within portraiture. Since what we know of the classical era so often depends upon its signs for death we recognise that the Judd's clasped hands, already, repeat the union of fidelity *unto* and

into death that we see in the family groupings of fourth-century BC Greek funerary monuments (which were, simultaneously, in their excess, signs of wealth and political status), and in the conventional, contracted, yet fond relation of Aiedius and his wife Fausta, two manumitted slaves on a funeral stele placed on the Appian Way, outside Rome, in the early first century AD. He is an old man for those times, perhaps sixty, his once-lean face now heavy with loose skin, his brow lined; there is a wart over his left eye. In death, the stonemason did not flatter Aiedius as he might in life. She, by contrast, is young – as Roman wives tended to be – her hair fashionably coiffured, her skin unmarked save by the accidents of history against marble. Their right hands are clasped, only the thumb of hers visible, nestling in the void of his thumb and forefinger; their eyes blind but not unfriendly, they look out at the world, but not directly. Their gazes meet at a vanishing point that is roughly where you, the living, stand to contemplate them.[34]

Scarry also obscures the profusion of high cultural works that address death between the classical and the modern era. Emphasising the relation of death and sexuality, the literary scholar Jonathan Dollimore provides an excellent survey of these texts, from their roots in classical and early Christian thought, through the Renaissance into the modern era.[35] Death does not fail to make 'a sign': in the wake of the European Enlightenment it makes different signs, and creates signs of difference. We should not forget that the Western tradition of art since the Dark Ages rests upon continual reinterpretations of the death of a man executed by slow asphyxiation, with nails driven into his hands and feet, and a spear thrust into his side to test if he was dead. Few works of art made since have been such convincing analogues of suffering as Matthias Grünewald's Isenheim altarpiece, or so possessed the stench of the morgue as Hans Holbein's *Dead Christ* (1521), in its stress on Christ's humanity and mortality.[36] Indeed, dismantling Scarry's compressions we discover that engagements with death – literary *and* visual, musical as much as philosophical - permeate Western culture.[37] And contrary to Ariès's claim I would suggest that they proliferate even in what we mistake as a profoundly secular era, when death should supposedly mean least and scare us most.[38] After all, through the spectacle of death in Hollywood's mass culture, mortality is more present to us than ever before, albeit in forms so crass they inure us to it. What is exceptional is not the sign, then, but the sign of relation to the other's death as more than sentimental identification, where we weep over the suffering of those like us, or nihilistic alienation where the stereotyped, otherwise characterless, 'other' is routinely (one might say ritually) dismembered as entertainment.

Ariès suggests that 'the rapprochement between the living and the dead' that characterised the urban spaces of the pre-modern Western culture ended with industrial modernity, 'when this promiscuity was no longer tolerated'.[39] We may indeed no longer be spatially intimate with the dead, but they haunt our language. My own autobiographical meditation emphasises that mortality is at once penumbra and, simultaneously, core: death informs *our* writing, motivates life. Art becomes one means by which the excluded term of 'death' re-enters our culture; it may also be a form of inclusion that, paradoxically, facilitates a further marginalisation. We may

use the deaths of others to talk about ourselves; we may use the deaths of others to protect ourselves from death. My use of 'our' here is neither an expansion of a singular authority nor limited to a moment in time. Rather, death binds a community of readers who rewrite texts and rewrite history, and this community is not bounded by space or time. How else does Scarry lay claim to Sophocles, without reading *Philoctetes* beyond its contextual limits?

If the portrait is always, in some sense, a portrait of the king, what is the self-portrait? It is firstly a laying claim to stature, but also a posthumous gamble for transcendence.[40] Self-portraiture reclaims the artist, as subject, for *a possible future*, through the immediacy of the painterly gesture. In his self-portraits the British painter Francis Bacon undertakes a project vital to any theorisation of death's place in modern art. In producing painting from photographs Bacon seems to illustrate in those paintings, and exemplify in his practice, a problematic relation of being and representation that characterises modernity. This problem is itself twofold; firstly, it is concerned with 'meaning' as it is manifested in the difference between representational forms and depiction - which for Bacon would be the difference between the fluidity of painting and the apodicticity - the absolute fact - of photography. Secondly, it is concerned with an equivalent limit to the meaning of signs, the absolute fact of death as a termination of the subject.

Bacon exploits a medium of modernity to which he remains violently resistant. The photograph is repeatedly theorised as a form of death in itself, a caesura in the flow of subjective time and experience. Such a characterisation, where experience is an intrinsic property *of* the self, rather than an extrinsic effect (for example *inscription* (Michel Foucault) or *Erlebnis* (Walter Benjamin)), might be understood as pre-modern, even romantic. Equally, as an infinitely replicable facsimile of the self beyond its time, the photograph seemingly reduces its human subjects to the same status as the paper on which it is printed; to what Siegfried Kracauer contemptuously termed 'the trash heap of images'.[41] The self's multiplication and dispersion through the apparently democratic facility of technology achieves only its devaluation. Photographic 'death' here becomes analogous to the anonymity of real death in modernity, the lack of dignity mourned by Rilke in his *Book of Poverty and Death*, and Heidegger through his claim for a unique grasp of one's death in *Being and Time*. Against such disposability, Bacon tries to seize a being *there* within the image – a form of the Heideggerian *Dasein*. Pursuing a chimera of authenticity, Bacon protests the literalness of the photograph (*its death*) through an allegory of existence. The photograph is antithetical to the Heideggerian work of being in the world because it substitutes 'this has been' for 'being-the-there', the 'impossible' formulation of his concept given by the philosopher in 1945.[42] Photography arrests the condition of possibility that is 'being'. Bacon wants to redeem 'being' as essence and process from the annihilating objectivity of the photograph.

Syntactically, photographic depiction welds subject and predicate; it can, seemingly, be only wholly literal. Bacon unhinges, rather than destroys, this relation, since the two terms exist together but always uncoupled. This strategy, in literature, is that of allegory – the

loosening of relation that mobilises a latent capacity within the sign itself and its relation to other signs. Paul de Man remarks in his essay on Georg Hegel's *Aesthetics*:

> What the allegory narrates is, therefore, in Hegel's own words, 'the separation or disarticulation of subject from predicate (*die Trennung von Subjekt und Prädikat*)'. For discourse to be meaningful, this separation has to take place, yet it is incompatible with the necessary generality of all meaning. Allegory functions, categorically and logically, like the *defective cornerston*e of the entire system.[43]

Allegory, as we shall see, has been one of the most persistent forms of broaching death as a subject, from the heart-rending meditation on the death of a child that is 'Pearl' in the late fourteenth century to Dmitry Shostakovich's Seventh Symphony, where symbolic narratives of intolerable suffering and mass death, in the Nazi siege of Leningrad and the executions and 'disappearances' of Stalin's purges, become acceptable to the brutes who commissioned both symphony and executions because the malleability of the formal, abstracted sign permits a work about both to be read as only about the siege.

Given her examples of how we might talk about death and pain, perhaps Scarry's problem is not absence, then, but the absence of ethics. The displacement that death requires too often takes shape as a prophylactic, abrogating responsibility through the momentarily spectacular effects of horror as entertainment. Damien Hirst's œuvre exemplifies a contemporary use of death as apotropos, a commoditising of reality that deflects its true demands and effects. Perhaps we hope, by rendering it in black comedy, to disable death's force upon us. Dilettantes, we assume the professional cynicism of the pathologist because we have once walked past the front door of the morgue. Such art is never about pain or death; rather - in the work of Jake and Dinos Chapman, for example - it is a repeated communication of the impossibility of that communication. Such art cannot be witness to the other's suffering, nor meditate on death's effects upon us, survivors. Modern culture *here* is the negation of any space in which relation with the other might be established or imagined possible.

Hirst's address to death is explicit: in the recycling of a teenaged photograph, made in a mortuary; in 'death-machines' such as *One Thousand Years*, and in carefully selected critical commentaries and strategic juxtaposition in exhibitions. Furthermore, he has been sedulous in the nomination and demonstration of his relationship to Francis Bacon. In laying claim to that legacy, however. Hirst fundamentally misunderstands Bacon's treatment of death. As Ernst van Alphen observes: 'Bacon's work is often seen as destructive and scary. But once we engage with the work this appearance seems warranted only by the superficial appearance of the images. Bacon's view of the self is, ultimately, uplifting.'[44] Hirst interprets the spatial structures that Bacon uses as if they were no more than containers of the subject, cages or crypts equivalent to, and legitimating of, his own use of vitrines. Bacon's 'dumb boxes' are anything but dumb; rather, like the mobilisation of the subject in the self-portraits, they are used to unsettle formal relations, 'defective cornerstones' that initiate discourse. Where

Hirst sees only an architecture that endorses his own ironic literalness, Bacon persistently deploys ambiguity.

Irony here opposes allegory: saturated by context, the former has nothing of its own to say; the latter leads us towards a critical re-evaluation of the subject within modernity. (Indeed it is in his treatment of modernity's devaluation of the human, exemplified by the photograph's ubiquitous indifference, that Bacon perhaps has his real relation to history, rather than in the symbolism of his early paintings.) Hirst exemplifies the commodity form that is contemporary art, its treatment of death one more commercially acceptable fashioning of 'difference'. De Man suggests that allegory and irony are 'linked in their common discovery of a truly temporal predicament' and in a 'common demystification of an organic world postulated in a symbolic mode of analogical correspondences [*let's say photography*] or in a mimetic mode of representation in which fiction and reality could coincide' [*the aspiration of painting*].[45] In Hirst and Bacon, however, the ethical possibilities of the modes are radically different. Hirst exposes us to indexical references of death for the frisson of experiencing, at one remove, the phobic limit of experience; Bacon attempts a reformulation of the subject's relation to that limit, and even – perhaps despite his own best efforts at self-sufficiency – of the subject's relation to others. I still find this hard to write, given all that has been said about Bacon's 'coldness' over the years, but love is a vital element within his painting – as love so often is in the allegorical mode – even when it is expressed as violence.

If 'Bacon in love' is hard to imagine, shall I compound the intractability of the idea by adding that he has much in common with the contemporary British artist Tracey Emin? Aside from a certain expressiveness of figuration – I'm thinking of Emin's destroyed paintings and her monoprints – and an obsession with sex and the self, such a coupling seems improbable. Emin's affinities seemingly lie with her own generation of the early 1990s, with those radical feminist artists of the 1970s who were her early tutors,[46] or those expressionist masters, Edvard Munch and Egon Schiele. Both Bacon and Emin, however, are artists whose allegories are persistently mistaken for literalness, and given the awareness of death that permeates both œuvres this is perhaps not so surprising. As Gillian Rose observes: 'Death as nothing is pure violence beyond representation; yet in allegory that death without soul is taken up into spirit. It can thus be witnessed, even if only in the repetition of its nothingness. If death is nothing, then this death and this nothing have a history.'[47] That possible history is vital to this study.

Any autobiographical practice, to remain faithful to experience, must encounter the death of the other and the possibility, perhaps the imminence, of one's own demise. Emin's encounters with death are, therefore, intensely personal, even as they mediate unique experience into more general sign and parallel commentary on the practice of autobiography, even as they run the risk of sliding into sentimentality or pathos. The overt address of *Uncle Colin* (1993) is to a close relative, killed in a car accident. In its 'alchemical' references, however, its hints that a process of signification is a process of metamorphosis, the work discloses both the process of

its making and solicits readings that extend beyond its ostensible subject. I interpret *Uncle Colin*, therefore, as an allegory that uses the epitaph as a meta-commentary on the transformation of life into art, the transformation of autobiography into a form of fiction, as well as the transformation of life into death. But this is not an allegory of the uncle's death. I suggest that in *Uncle Colin* Emin employs the epitaph as a meditation upon the origins of her authorship, the 'death' of the author in making and sending a mark, 'writing', to others. As Derrida observes in his commentary on de Man: 'Funerary speech and writing do not follow upon death; they work upon life in what we call autobiography. And this takes place between fiction and truth, *Dichtung und Wahrheit*.'[48] In *Uncle Colin* Emin uses a written epitaph to speak autobiographically of her transformation into an artist through the figure of relation to the already dead, transformed other. Emin's emphasis upon personal relation, however, upon the 'special nature' of the dead, in its shift from epitaph to panegyric, shears off the relation of subject to other from community. She moves us from a fundamentally democratic form of address that includes both the dead and *all* their survivors to one that, like Bacon, pursues autonomy in the grasp of death.

So far I have emphasised the individual's problematic relationship to death as an over-riding theme of life within modernity. (In ideal circumstances I would delve back to address Charles Baudelaire and, more fully, Hippolyte Bayard, to show that modernity – as an effect of industrial capitalism – is not some unhistorical 'modern world'.) A defining characteristic of modernity, from the emergence of forms of capital in the early modern era, has been an emphasis on the status of the individual, coupled to a progressive detachment of the individual from community. For the second part of this study I attend to the way in which witnessing death, in the late twentieth century, impelled the re-imagining of community. This is not the specious universality invoked by the middle-managers of post-democratic society but, rather, the emergence of communities where death - whether through the socially, temporally and spatially bounded but catastrophic effects of AIDS or disaster, or the demise of one individual within a particular milieu - precipitates both culture and self-identified group. The historical shift from modernity to postmodernity, marked by the state's abrogation of rights previously assumed for all individuals, is perhaps the condition that permits, even necessitates, the formation of such communities. In their emergence, however, they exemplify the opening of a politics beyond the political, grounded in ethical relationships that are extensions, into life, of the deaths of others.

My first model for this new relationship is the work of the American artist Nan Goldin as it reflected the emergence of AIDS as a specific health issue amongst gay men and intravenous drug users in the 1980s. One community profoundly affected by this was Goldin's 'family'. This was not a family in the sense of genetic inheritance but, rather, one predicated upon affiliation within a romanticised re-enactment of modernist bohemia. It provided a context of intimacy within a community where there was already an adopted, largely nihilistic, tradition of posturing towards death. During the 1980s the focus of Goldin's work shifts from

'Love on the Lower East Side' to love for those who cannot return it, to love as responsibility for others as they die, and remembering, witnessing to them after they die. This is at once a profoundly 'conservative' gesture, harking back to a pre-modern time where one death still affected the life of a community, and a radical one, since it opens the possibility of a politics mediated through, even initiated by, the death of the other.

Bacon's 'opening' of the face in his pursuit of individual essence allows us, paradoxically, to talk about the intersubjective relations premised upon face-to-face meetings by the French thinker Emmanuel Levinas. Goldin's shift of emphasis allows us to mark an equally significant shift in Levinas's thought from the individual moment of ethics to ethics as social practice. As they commemorate the dead her pictures mark, therefore, the foundation of a new sort of community. As Alphonso Lingis puts it: 'Community forms when one exposes oneself to the naked one, the destitute one, the outcast, the dying one. One enters into community not by affirming oneself and one's forces but by exposing oneself to expenditure at a loss, to sacrifice.'[49]

Such commonality characterises the work of death, the work for the dignity of that which has been stripped of dignity. It yokes the living and the dead. Consider Paul Cézanne's early *Preparation for the Funeral* (c. 1868–69). Cézanne uses the same gesture with the brush to define the eye socket and nose of the corpse as he does to create a reflection in the bald pate of the man washing its legs. The corpse has already assumed that waxy, monochromatic register that the dead inhabit, but Cézanne extends this to the man at work, striving uselessly in that to work on behalf of the dead can bring us no reward. His pallid toil is a kind of embrace, whereas the woman at the right of the picture, her red jacket perhaps a motif of being wedded to the world, recoils. Goldin's pictures, as they restore the labour of death to visibility, extend the practice of the moment into memory. They return us to traditions of the memorial in its older forms, where the gravestone or the post-mortem painting represented the dead among us. Dido's lamenting 'Remember me' is in some way a plea to equip the subject with a new body, or at least with tropes, substituting for its absence, by which we may continue love. Critchley writes, 'Although it is indeed "difficult to say", it is because of friendship that the *dead live* (*mortui vivunt*), and the condition of possibility for friendship is memory. The dead live because friends recall them; they survive after death because they are not forgotten. In this sense, *philia* is *necro-philia*.'[50]

At stake here is not any desirability of one's own death, the nihilist sublimation and alienation that Dollimore identifies, nor the erotic charge of the other's death typified by paintings such as Pierre-Auguste Vafflard's *Young and His Daughter* (1804), where it's hard to know if it's necrophilia or incest that is higher up the agenda of illicit desire. Nor is it the similar charge bound up in the body of the dead woman as 'other' that Elisabeth Bronfen sees as characteristic of patriarchal culture, still erotic, but now stabilised by a violent representation.[51] Rather, what matters here is the inheritance of life together that the other is left to carry forward. In 'The Family Album of Lucybelle Crater', the last series made by the

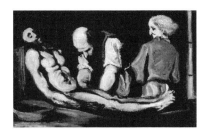

1. Paul Cézanne, *Preparation for the Funeral* (1868–69).

American photographer Ralph Eugene Meatyard, the artist – anticipating his death – places himself within a community and constructs a form of remembering, even as he seemingly erases himself from that community behind a succession of individuals wearing 'his' mask. Where Goldin shows us the face of the other's dying, Meatyard filters his imminent death through the trope of prosopopeia, the masking of the self beneath the other. Here, however, it is not the deflection of one's demise onto another that is effected, because the trope is *extended* into a social world. 'Lucybelle Crater' does not reflect a desire for death, but it is a work in which, I argue, the artist accommodates and even 'names' his own death. In profound opposition to the autonomous location of *Dasein*, however, Meatyard places that death at the centre of his community. Death is a universal; here this is acknowledged, for it has the same name – 'Lucybelle Crater' – as his neighbour and as the artist; it wears the same mask of self-disclosure and self-effacement. But, if death is ghastly, and death is my neighbour, what questions is Meatyard raising for those he is called upon to love, and those who he indeed loves?

One question might be phrased: 'What if my neighbour is a monster?' This is a vital matter for any politics emerging from an ethical relationship to others, founded on the other's death. Indeed, as Slavoj Žižek and Kenneth Reinhard suggest, it is a potentially disabling question, constraining ethics within politics, rather than allowing the ethical field to project a utopian politics of infinite possibility.[52] Pertinently for Meatyard, it is a problem at the heart of the Christian call to love one's neighbour as oneself – a demand made to the artist through his friendship with the Catholic scholar Thomas Merton. 'Lucybelle Crater' is, in part, an exploration of the extreme summons of Christian hospitality, about welcoming everyone, including death, as my neighbour.

If Goldin focuses upon 'her' community, the gaze of the British artist Derek Jarman, knowing he would die soon from illnesses associated with AIDS, is directed out towards the world. Jarman's late paintings and his last film, *Blue*, are profoundly political works. Like Goldin's photographs they are a condemnation of the neoliberal, post-democratic state's surrendering of responsibility for its citizens. But Jarman's furious personal response to institutional neglect is balanced by allegories of community and death, figured through a shattering of aesthetic conventions. The violent writing that dominates the paintings is transformed, in *Blue*, into the calm yet purposeful narration of a community that is to come, a politics of the future, undertaken by an allegorised, displaced author. Violence, here, is reserved for Jarman's approach to medium rather than for subject matter. With its monochromatic screen, *Blue* unites film and painting by annihilating time except as 'writing' – the diary entries and commentary read by Jarman and his collaborators. *Blue* is simultaneously an allegory of the artist's death and an

anticipation of a possible future for others. The annihilation of conventions unites the critique, and prolepsis, of content with the modernist anticipation of a hoped-for utopia that is articulated through form as much as content. In this relation of an inexpressible predicament (death) and the historical possibilities latent in that catastrophe, Jarman is radical in a way that few other modern or contemporary artists have been. In shattering the form of film and displacing himself into a collective and always still-to-be-achieved community, Jarman offers a novel model for the relation of the individual to others, through death.

My closing examination of death, culture and community focuses on a small Welsh village. In 1966 the school at Aberfan was obliterated by a landslip from illegally sited mining waste; 144 people died, including almost a half of the children in the village. For the fortieth anniversary of this catastrophe, the American artist Shimon Attie was commissioned to make a memorial. Attie, whose work to that point had largely concerned the experience of Europe's Jews in the Holocaust, did not use archival material connected to the disaster. Instead he concentrated on the village as it is today, and on its citizens. Filmed against a black backdrop and shown on a five-screen installation, they were at once isolated from each other *and* composed a community. Whereas the extensive mass-media coverage of Aberfan has concentrated on images of the time and the experience of loss, Attie's *Attraction of Onlookers* was an extraordinary portrait of a community that had fashioned itself out of disaster. Largely abandoned to its own resources by the state, Aberfan is a striking model of a community brought together through the practical historical outcomes that may emerge from loss and love. Philippe Lacoue-Labarthe's reading of Paul Celan's poetry offers a model for us here of 'bared singularity' emerging from catastrophe that might offer some hope to the subject in an age when the subject has, apparently, been erased. (Celan is writing as a survivor of the Holocaust; finding ways to bear witness to that which cannot be borne.)[53] Jean-Luc Nancy offers a similar model of possibility for the community in, and as, history, grounded in others' apprehending of my death, of my *happening* in space and time. Aberfan is an example of such a community, of local agency that is both the product of death and of what comes after death – which is not mourning and forgetfulness, but mourning and memory in the future. Aberfan is forever grounded in one catastrophe, and is forever beyond it; not diminished, but *made* by an assumption of fraternal yet alienated responsibility and intimacy between the living and for the dead.

Scarry was perhaps right to draw attention to Bergman's *Cries and Whispers*. The film is exemplary: not for its representation of death but as a model of such problematic responsibility. When Agnes dies, abandoned by her sisters, the one who shows tenderness, who engages with the awfulness of the moment, is Anna, the young servant, who undresses and holds her mistress against her warm, plump body. Ariès, who also recognises the intractability of this film to his theory, embraces this moment too:

I suspect that the son of Pastor Bergman was thinking of the passage in the Book of Kings (IV.4) in which the prophet Elisha brings an adolescent back to life. He lies down

on the dead body, mouth to mouth, eyes to eyes, hands to hands, glueing [sic] himself to the youth and calling upon the Lord: *incurvavit se super eum*. And soon the young man's body begins to regain its warmth. In the film, the scene is inverted, changing its meaning and purpose. In the first place it is the adolescent, not the old prophet, who is the bearer of life and decides to transmit it. Second, in the scene in the film, there is no longer any God: God is replaced by something which is not successful in overcoming death, as Elisha's God did, but which at the same time is not an abstract nothingness: it is a love composed of both pity and tenderness, of vital force and physical urge, of a beauty that concentrates within itself the mysterious powers of nature and reproduction.[54]

What is 'beautiful' about this moment, and what is 'inverted', is the 'gift' exchanged between servant and mistress. It is at one level - certainly that of Agnes's bourgeois sisters - an intolerable, 'impossible' gesture by a stupid, emotionally and physically clumsy plebeian, because it contains no commerce. Agnes cannot reciprocate the gift of her servant's comfort; she has, seemingly, nothing to *give*, only material effects to leave. Nor will this 'gift' restore life. Equally, the servant cannot be a substitute; she cannot die in the other's place. Even if she could sacrifice her life, now, in exchange, the other must eventually die (just as the youth, revived by Elisha, would one day die again). Instead, giving herself, giving a gift that cannot be returned by its addressee, Anna *gives herself* this gift, takes rather than inherits, her mistress's death. If Agnes 'gives' anything, she gives Anna the gift of death.

The repugnance that the sisters feel for Anna comes from her defiance of the law – the rule of propriety that itself symbolises their law of bourgeois commerce, the forbidding of useless expenditure. To rethink our relation to death is - as Levinas understood, I think, in his remarks on charity and the state - to rethink politics and ethics behind the back of the state, beneath its obsessive scrutiny. For 'state' here I am thinking as much of the institutions of neoliberal capital, which would elide the inevitability of death – since in its emphasis on the perfected, infinitely extensible body, the dogma of those institutions never speaks of obsolescence – as I am of the northern democracies that administer and minister to capital. Exemplified in Hirst's work as much as in the spectacle of Hollywood, for capital death is the phobic limit to be experienced at one remove, as entertaining, erotic frisson, if it is to be experienced at all. As Alain Badiou has observed, in the name of capital any excess may be licensed: everything, up to and including death, as an assault upon capital may be commoditised.[55] Even serial killing, whether in

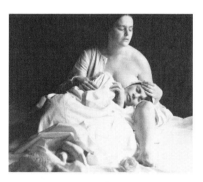

2. Ingmar Bergman, *Cries and Whispers* (1972).

narrative film, art photography or fashion plate, may be ordained part of the spectacle. To respect death, discover it as the basis of a politics rather than finding the possibility of ethics only through the filter of politics, is to defy the law – not the law of death's elision but death's illusion. This is the turn from entertainment by another's fictional death to admitting our responsibility for real deaths. It is as much a defiance of the law of capital as it is a defiance of that illusory law of the signifier to which Žižek and Reinhard appeal in their critiques of Levinas.

Anna's cradling of Agnes is an individual embrace of death, but it is not a heroic grasp that will define her autonomy. She holds in her arms the untouchable death of the other. The effect of this grasp is to change, perhaps, the future of the servant; it opens an infinite legacy that demands recognition of the other and responsibility towards their memory. This is not the responsibility of the hireling, but it is, perhaps, the responsibility of those willing to serve without capital's promise of reward as an exchange for such labour. Responsibility here looks like irresponsibility – clearly, it does to Agnes's sisters. Perhaps this is not so much an act 'beneath' the scrutiny of the state as it is simply unrecognisable because apparently inconceivable.

It is helpful here that Anna is a nineteenth-century domestic servant in a film made in the 1970s, when class antagonism still had some political currency in industrial societies. Her situation places us squarely in that register. To act as Anna does is not simply to breach propriety, it is to breach the hegemony of class relations. The personal experience of the other's death disrupts historical and social ordering; it offers Agnes a subjective liberation, in her comfort of the alienated, governing figure of her mistress. However ameliorative Bergman allows her characterisation to be, Agnes is nonetheless the class enemy, the incomprehensible, authoritarian other who holds Anna in servitude. Her death, as with the deaths of all 'masters of men' in the proletarian revolution that would overthrow their power, should provide the servant with a kind of liberation. We see enough in the convulsion of Anna's body and identity to know that there is a transformation, but it is not that of political revolution. The shudder is one of reconciliation with what cannot be understood, rather than one of triumphant overthrow. Indeed, it may be that Bergman, in the immediate wake of late modernity's failed revolutions of 1968, was half-consciously presenting Anna's experience as a radically different way forward.

This emphasis upon the human is not, however, a return to bourgeois humanism – indeed, that is one of the value systems that Anna's intervention unsettles along with the status of exchange. Whilst it seems to demand historically transcendent values, and certainly does nothing to transform history through the conventional channels of politics, Bergman's proposal is as problematic as Levinas's appeal to 'resources of charity', outside the structure of political institutions, as a practical articulation of ethical relation. Rather, I think that Bergman here is presaging the return to the human by post-structuralist thinkers such as Nancy and, in a less overt way, Derrida as a means of rethinking subjectivity as erased, impossible, incomprehensible

or at best marginal condition in the changed historical regimen of global capital and the administered society. This is a shift – as Martin Crowley identifies – revealed in Nancy's commentary on Heidegger's *Letter on Humanism* and his subsequent 'Being Singular Plural', 'which seeks to develop the Heideggerian position by enlarging the sense of being for which the human…becomes in some sense responsible.'[56] That responsibility is one of community or 'co-presence' where meaning circulates. As Crowley remarks, 'The ontological privilege of the human is relativized [*sic*]: the human has a privileged place, but only on behalf of everything else.'[57] Anna's grasp of Agnes illustrates how this 'on behalf of' has political consequences, because the emergence of what we must best call 'friendship' in death undermines the conventions of affiliation. Friendship in these circumstances is not a matter of mutual interest – the foundation of conventional politics – but, rather, of what Blanchot calls 'common strangeness'. The relation of Anna to Agnes is premised on the alienated condition of the one's death; they do not have even this in common. As Derrida declares, 'It is thanks to death that friendship may be declared.'[58] But this is friendship – what Derrida terms *aimance*, a compound of *amour* and *amitié* - that, as Critchley observes 'disrupts fraternity, patriarchy, androcentrism and "the familial schema"'.[59]

So why is this a book on art and death, rather than one directly concerned with 'politics and death'? Because, I would suggest, it is within culture that a politics of death and a politics of friendship is signified and enacted. It is only here that there is a subversion of circumstance by the embrace of, and initiation of action *through*, what is most repugnant to a political domain predicated upon the uncontested management of safe consumption, rather than the debated promotion of public good. Just as there are social spaces, in the interstices and the margins of such societies, where a politics of disinterested friendship may be effected by those excluded from power, so there are spaces within art where that politics is symbolised, reflected and anticipated. It matters little here that most contemporary art is nothing more than entertaining placebo that distinguishes those with 'culture' from those without, is nothing more than an element in the neoliberal hallucination of 'creative economies'. Indeed, there may be a certain advantage in the culture industry's incorporation as branded product of what once, as semi-autonomous object, critiqued it. Art, too old, too difficult, too esoteric, and in sharp distinction to the product that flows through the advertising pages of *Artforum* and the booths of globalised art fairs, now occupies a space beyond the scope of the administrators of the 'society of the secretariat' and the sumptuary ambitions of corporate executives. Art may adopt structures that, in their eschewing of the permitted forms of the culture industry (and I'm thinking immediately of Jarman's *Blue* in contrast to the meretricious drivel offered by the narrative film industry), render it unrecognisable because they no longer share common conceptual and linguistic paradigms. This is not a heroic resistance to power that exploits death as unique limit; after all, Hirst's diamond skull, *For the Love of God* (2007), shows that it is perfectly possible to ironically commoditise death to a level that leaves even the super-rich a little breathless. Death here is neither a constitutive limit of difference (a radical 'exterior'

that has been theatrically embraced by romantic writers and thinkers and the sub-cultural industrial niche of Goth) nor a constitutive interiority characterised by the radicalism of a spiritual meditation on death in an age where the material extension of life is all (typified by the video works of an artist such as Bill Viola). Art's use of death is, rather, a living in, and through, death. A practice, then; a use of the individual as at the same time it is communal, a turning of the edge into what may be, simultaneously, at the centre; a ghostly trace in each signature and every image.

Chapter 1

Francis Bacon

Francis Bacon's painted self-portraits are unusual as examples of their genre. For much of art's history the convention for self-representation involves the use of a mirror, from which the artist paints his/her reflection, with the mirror itself often taking a figured role as a metaphor for meditation and self-scrutiny. The most obvious examples of this *mise en abyme* – a concept which they come to define for André Gide - are perhaps Parmigiano's *Self-Portrait in a Convex Mirror* (c.1524) and van Eyck's inclusion of himself, painting, in *The Arnolfini Betrothal* (1434).[1] This convention of the artist representing himself *in vivo* continued lustily into the twentieth century, checked only by oddities such as Bayard's *Le noyé* (1839), where the artist poses as if found drowned and arrayed for inspection in the Paris morgue. It is no accident, I think, that this example of the self-portrait of the artist apparently *ex vivo* is made, and exhibited, photographically, with a suicide note written on the work's reverse.

By contrast to this established tradition, Bacon (1909-1992) often painted himself, as he painted almost all his subjects, not from the posing life model but from photographs.[2] But if the photograph is fundamental to Bacon's œuvre, it is not in its making present an image of a body that may be transcribed. Rather, its significance lies in the absence of that image, its cancellation, often accompanied by the destruction of the photographic object itself. And in his peculiar and specific use of photographs as the origin of many of his paintings, Bacon raises a series of questions about photography – as one of the dominant media of art in the twentieth century – that relate to mortality. Death, it might seem, is not simply a question of subject matter. With photography as medium, death comes as an operating concept; death arrives embedded in those very uses of time and space that bear the image to us. Hundreds of painters, from the mid-nineteenth century onwards (Edgar Degas, Pablo Picasso, Georges Seurat, to name but a few), had used photographs; Bacon's uniqueness is in his

realisation of, and phobic reaction to, the unavoidable and, crucially for him, inaccessible 'death' bound up in every image.

Bacon's employment of found images, from medical textbooks to film stills and the motion studies of Eadweard Muybridge, is well documented, as is his commissioning from John Deakin of photographic portraits of subjects such as Henrietta Moraes and Isabella Rawsthorne. Bacon also used informal photographic studies in his self-portraits, however, taken most commonly by Deakin, Dan Farson and the artist himself in photo booths. Occasionally, as in *Four Studies for a Self-Portrait* (1967), the source of the painting is literalised, at the same time as the deliquescent faces transgress both the framing effect of the strip of images and the literalness of their subject. Michel Leiris has suggested that, for Bacon, the photograph was no more than a guideline.[3] Nevertheless, I would both agree with Dawn Ades, who remarks that 'Bacon is not so much using the photograph as attacking it',[4] and go much further, in suggesting why this violent attack takes place. Bacon assaults the photographic subject not only because the photograph represents death - a moment of lost time - but because this representation is a death that is beyond his grasp as an individual (a fixing of the self in the order of others). In this chapter I outline Bacon's attempts at the reclamation of the self through a call to life, a call to be something that precedes subjectivity – Heidegger's *Dasein*. In the self-portraits the essence of being that Bacon is trying to reclaim is not, distinctively, his own – that would be to argue for a revelatory, psychological disclosure of truth from the self-portrait that the whole history of the genre teaches us to approach with profound scepticism. Rather, I'd suggest, Bacon uses his self-portraits as another paradigm for the salvaging of essence from object, a strategy that he also deploys in his portraits of other models.

Bacon undertakes this project through representation and through a savaging of the representation that precedes *his* painting (the photograph) as somehow not enough, and therefore *historically* an inadequate substitute for painting. The violence that we find both within and against the image in Bacon's self-portraiture is not so much directed towards its annihilation but, rather, towards 'getting something out'. I suggest that what Bacon is trying to lay hands on is a form of being, after the manner of Heidegger's ideas about being and the authenticity of the self, otherwise encased in a photographic moment of death that is alienated from him *and* within the problematic construct of the stable self-portrait. Bacon's self-portraits, then, are not authentic declarations of self but, rather, the works of an artist in pursuit of such an authenticity, expressed here through the control over death, that would make him (and his other subjects) 'a being'. We might, then, concur with the judgement offered by Gilles Deleuze of Bacon's paintings in general:

> Life screams *at* death, but death is no longer this all-too-visible thing that makes us faint; it is this invisible force that life detects, flushes out and makes visible through the scream. Death is judged from the point of view of life, not the reverse, as we like to believe. Bacon, no less than [Samuel] Beckett, is one of those artists who, in the

name of a very intense life, can call for an even more intense life. He is not a painter who 'believes' in death. His is indeed a figurative *misérablisme*, but one that serves an increasingly powerful Figure of life.[5]

We must, however, distinguish Beckett from Bacon here. Though the Irish writer is often aligned with the Irish painter as a figure of existential thought and art, affirming an intensity of life through a textual and dramatic '*misérablisme*', I would suggest, as does Simon Critchley, that Beckett offers us

[a] paring down or stripping away of the resorts of fable, the determinate negation of social meaning through the elevation of form, a syntax of weakness, an approach to meaninglessness as an achievement of the ordinary without the rose-tinted glasses of redemption, an acknowledgement of the finite and the limitedness of the human condition.[6]

This is something very different from what Bacon is about. Whilst we might compare Beckett's attenuation of prose to Bacon's assault on his canvases, which involved a deal of erasure, Bacon's violence against painting's visual syntax (if we can allow such a thing) is anything but a pursuit of the ordinary, and cannot acknowledge finitude and limitation unless it is a property of the *extraordinary* self.

Roland Barthes claims that a condition of the photograph is the *coherence* between the 'having-been' of its subject, what he terms the *référence* of the image, and its referent, the address to the spectator of what we identify as its subject.[7] For Bacon, the stable referential subject disintegrates in the translation of the photograph into painting. Far from using it as a 'mere guide-line', Bacon's employment of the photograph both reveals and exploits a failure in the coherence between *référence* and subject. For Bacon, the photograph is - often literally, in his disdain for its material condition - an object to be destroyed. Bacon's ludic (and, in their occasional destruction of the painting, sometimes catastrophic) acts of addition and erasure to the representations of the photograph and painted canvas might be understood as aggression directed simultaneously against the clarity of his own discourse as a painter – especially the convention of representing 'character' - and against the clarity and fixity of the photograph. Within the studies for self-portraits this assault is effected by the introduction of foreign objects such as dust and dirt, by the use of lacunae and by multiple planes of representation, so that it seems as if the subject of the photograph had moved during a prolonged exposure, leaving too soon or entering the picture too late.

Bacon's self-portraits shift from the *référence* of the photograph to a partially-erased, deformed, aporia – a gap in knowledge, a site of doubt, and an impasse, a place from which the subject, and we as spectators cannot easily get out, partly because Bacon makes its limits so problematic in themselves. The brunt of that erasure and deformation is directed against that materiality which most confers identity, individuality and human relation: the

face. The thick, still-wet, paint of the image is smeared by rags, smudged and rubbed, partially removed and discarded, partially pressed into the canvas, blurring subject and space; elsewhere the head disappears, evanescent, into an impossible spatial field in the same moment as it is manifested upon it. In other works the head is cut through, reconstituted around conflicting planes of vision, or else the paint that renders it is so insubstantial, so provisional, that the shirt collar appears through its faint flesh haze. Whilst Bacon's self-portraits are not limited to painting of the face, whilst a similar question of 'liberation' from the spatio-temporal constraints of photography is at stake in both the full body self-portraits that I address in my next chapter, and more generally in his portraiture, and whilst death is, I'd argue, an almost overriding universal theme in his œuvre, I want to attend specifically to Bacon's treatment of the face here – whether his own or the faces of others. This defacement and disfiguring, this negation that seems, paradoxically, to be a step forwards (for the artist, at least), has an important resonance for the development of this study as a whole. It draws attention both to the question of the face and human relation, of community, in particular a relation articulated around the death of the other that is raised by the work of Levinas, and to the idea of the negation that is also a step beyond, and the step that negates itself, that is worked out in Derrida's *Aporias*, one of his central texts on mortality.

For Levinas, the other person's face, presented to us, is the opening to the field of ethical relation. Responsibility – and, as I've suggested already in my introduction, that includes both a responsibility for the other in death, and a concomitant political responsibility – emerges from the encounter of one to another, face to face. Levinas introduces his idea thus:

> For the presence before the face, my orientation towards the Other can lose the avidity of the gaze only by turning into generosity, incapable of approaching the other with empty hands. This relationship, established over the things hereafter possibly common, that is susceptible of being said, is the relationship of discourse. The way in which the other presents himself, exceeding the idea of the other in me, we name face.[8]

The face of the Other (not just any other person, but the Other, the possibility of anyone of a multitude, who we do not, cannot know) turns us inside out; it's like love at first sight, if we accept that 'love', in all its complexity, demands from us not just sentimentality or sex, but ethical practice. Love includes gifts that are, necessarily, forms of sacrifice; love includes actions as well as words. The word that Levinas uses here for the transformation of the gaze, its turning from possessiveness into giving, is *muant*, a participle of the verb *se muer*, 'to turn', which, as Jill Robbins points out, also implies a turning inside out, metamorphosis, and even a shedding of skin.[9] We are convulsed into responsibility by something far bigger than any idea we ever had of what our relationship to other people might consist of, of who someone else might be, of how they might simply be versions of ourselves. It is through the face that we deal with others in all their strangeness.

We are brought back here to Anna's cradling of her dying mistress in Bergman's *Cries and Whispers*. Anna, up to that point, has been the paid servant, her duties exchanged for nugatory reward; now she is 'convulsed' (and Bergman, we might add, emphasises the point by having her 'moult', shedding her clothes so that her warmth directly touches her former mistress who is now her 'friend'). Yet we know that Anna's 'generosity' is a gift that cannot be received. Dying, that moment when we might most crave the intervention of the other – an Elisha come to save us, a lover come to die in our place – is the moment when the other can do least for us. The responsibility that comes with love is, at its limit, profoundly irresponsible, for there can be no response to it, no corresponding gesture. It is this complication that is Derrida's subject, when he observes that all the propositions he can make concerning death, whether negative, interrogative or 'interro-denegative', involve a certain negation that is also characterised by the language of stepping beyond.[10] What is on the one hand a limit, that which 'terminates all determination, the final or definitional line',[11] is also a stepping through. Yet this is a step, which I take, of which I cannot speak, for it annihilates me.

There are profound implications here for our consideration of Bacon's work. It is not simply a matter of Bacon's partially exfoliated heads, the skull almost visible beneath the skin - as in his two portraits of Michel Leiris from 1976 and 1978 - nor of a rhetoric of convulsion in the style of his painting. It is not simply a matter that the negation of the object – the photograph's insistence on 'this was' – becomes an affirmative 'this is', even in his paintings of the already dead. (Though, as we shall see, that shift of tense is crucial to understanding both Bacon's relation to the photograph and a wider problem with photography as representational practice within art.) Rather, I want to stress a generosity of violence in Bacon's work – a strange, contradictory idea, perhaps – but, as Slavoj Žižek has pointed out, there are moments in our relation to the other when smashing his/her face *is* the necessary thing to do (whether as a matter of politics or representation), and this violence calls into question the limits and the possibilities of Levinas's ethics.[12] In his violent questioning of the relation of oneself to another individual through the photograph, a relation that includes 'smashing' his own face, Bacon phrases for the individual – in an awkward, smashed syntax - the question of relation that is raised in terms of community in Ralph Eugene Meatyard's photographic series 'The Family Album of Lucybelle Crater'. Where Meatyard masks himself and his community behind a grotesque, seemingly unbearable stereotype, Bacon wants to shatter the mask of realism that conceals the individual from him. I would suggest that Bacon comes to a different answer because, unlike Meatyard, he cannot pose the question of relation in terms that escape the constraint of 'the idea of the other in me' that Levinas proposes as limit in our imagination of the other. Bacon - and this is why I particularly want to examine his relation to the photograph and death in the light of Heidegger's idea of *Dasein* - goes beyond (or, rather, behind and before) objectification, beyond (or, rather, behind and before) discourse. But whilst he seems to yearn for an ethical relation to the other, achieved through the repossession of death, its reunification with life, he can imagine and enact this only in terms of individual agency.

The left-hand panel in *Two Studies for a Self-Portrait* (1970) is typical of Bacon's approach to representing the self: it is also characterised by an extraordinary use of 'unnatural' colours. The lips are purple, as though glossed by a lurid lipstick. Bacon's predilection for wearing make-up suggests that this element of the portrait can perhaps be understood as more natural in its unnaturalness than might otherwise be imagined. Escaping 'realism' and 'nature', the right cheekbone is defined by two swathes of red and blue over a white ground - each broad hook produced by a single protracted gesture of the brush. The red, still wet, has been picked up on a corduroy cloth and printed by two separate, cross-hatching, movements further across the face until it obscures one eye and half the mouth. Only the distorted, shocking white of the nose arrests this process. The subject's hair, too, its base a synthetic blue, is redolent of the made-up man concealing and defying age. There is a marked separation in the use of paint for the face and neck against that employed for the hair and the matt black of the figure's anonymous coat. Only the impasted and scumbled flesh has texture, depth, and, paradoxically, the now-fixed traces of fluidity achieved by paint applied neat from the tube or barely diluted by turpentine: the remainder of the painting is executed entirely in a heavily reduced, thinly applied wash of oils.

In *Study for Self-Portrait* (1980), a similar thinness of paint produces an emulsion that is almost photographic in its effects. The image resembles a photograph taken with a prolonged exposure in which the subject moved between positions. The apparitional, colourless face is seen in at least two poses. Neither face is superimposed upon the other, but each is present in separate dimensions that somehow fail to intersect. The chin and lower face appear *en face*; again the lips are rendered in purple, but here the thinness of paint means that they are without relief or texture. Their shape is accurately defined; indeed, with their monochrome ground they might be mistaken for encaustic additions to a black and white photographic print. The upper face dematerialises into a black ground. Only a vestigial nose acts as a pole of rotation around which another face appears, turned towards profile. This visage is more clearly modelled, yet it remains faint. Both faces are without depth or texture, both are pressed over with paint on corduroy. Behind them, in the ground where we might expect to see the left eye socket of the full face, its presence questionable, is the merest intimation of a third face.

Rather than signify authority and completion in the titles conferred on such works, Bacon most commonly offers a further indeterminacy, a displacement of the subject of self-portraiture into a never wholly achieved future. These paintings of the face are declared as '*Studies for Self-Portraits*', prefatory attempts that precede the moment of fixity, the guarantee of identity that is the portrait itself. Bacon most often, though not exclusively, deploys the title *Self-Portrait* for a few paintings in which the complete body of the artist is represented. The subject of the portrait that such studies promise will only rarely arrive; it always precedes us as it precedes the artist it might represent, displaced endlessly into the future. When it does materialise, the body is itself located within a disordered space that eliminates a coherent

relationship between figure and ground, and the facial features are as provisional and mobile as those of the smaller paintings.

As we've seen with Barthes, the photograph is commonly understood as a guarantor of materiality - a mechanically, chemically, derived trace that records presence. As Jean-Luc Nancy puts it:

> Every photograph is an irrefutable and luminous *I am*, whose proper being is neither the photographed subject nor the photographing subject, but the silvery or digital evidence of a *grasping*: this thing, that thing, this man here, that woman there was grasped, there at that time, by a click, and this *hic et nunc* eternalizes here and now, on this paper on which it was developed and printed, its sovereign hesitation immobilized and sublimated in the decision that took it, and grasped it, by surprise. This grasping presents itself and says to us, 'I am.'[13]

This question of 'grasping' is essential to our understanding of Bacon's relation to his own image and to death, in particular his relationship to *his* death as death-in-the-future. In his constant reference to this laying hold, Nancy is directing us back to Heidegger's conception of *Dasein* as an essence of being in the world that, potentially, has the totality of its existence, up to and including the singular specificity of *its* death, within its grasp. We might say, on the basis of Nancy's claims for it thus far, that the photograph is almost an ideal Heideggerian image, that there is within it an announcement of the successful activity of *Dasein*. Only thus far: the photograph, whether of the self or others, even as it makes this claim, renders itself antithetical, even repugnant, to the work of being-in-the-world. It does this firstly through the announcement of a multiplicity that challenges the singularity of *Dasein*, and secondly through its constitution of a complex temporality that completely undermines that relation to time which characterises *Dasein*, and indeed allows its being in the world. This is what Marrati calls 'the auto-affection of *Dasein*'s temporality, which opens the future as a *coming to self* in the projection of one's ownmost potentiality for being.'[14] Suffice it to say for now that, against this continual condition of possibility, this state of *being* in the present, photography always offers the temporal arrest of 'I was', even when it also, always, contains the promise of 'I will be'.

What the photograph also gives us is not just 'us' but always 'others', and accompanying that an 'otherness' that may be a property of someone else, but which may, not least because of those unique temporal properties the image contains, be a property of the self. Otherness in the photograph may be our self-alienation; it is this that allows Bacon to regard his face, as distantly as that of any other; the alienation is equal, regardless of subject and spectator.

> But at the same time this *I am* says 'nous autres': we who are grasped in the grasping, we who were surprised and caught together by this *hic et nunc*, which makes us others

together, others to one another, one through another and one in another...we who
are other (finally and above all) than you who regard us.[15]

Nancy's use of 'nous autres' ('we others') here needs qualification: we might contrast it to the
poet Arthur Rimbaud's famous nostrum 'Je est un autre' ('I is another'), which expresses self-
alienation through singularity; it is not l'autre, the other, to whom Rimbaud refers: otherness
belongs only to the self. The 'communal' property of the photograph will not even allow us to
look at our 'failure' as individuals, but establishes us within a social matrix that is predicated
upon death. Nancy defines 'nous autres' as 'the totality of human beings in the fragility of their
finitude.'[16] In the photograph we seem always to be in the domain of the other, even when we
look at what purports to be ourselves.

This is indeed something intolerable for the idea of the individual being as Dasein: as
Marrati says, 'Its mode of being, existence, is irreducible to the mode of being of other beings.'[17]
To announce its subjects as 'we others' – even when that subject is 'you' - is to place it within
the register of what Heidegger calls Mitsein, the condition of being-with in the world, rather
than the condition of individual transcendence over, and grasp of, one's unique essence in the
world. The relation of Dasein to Mitsein (of individual essence contrasted to a being-with
others) is critical to understanding Bacon's portraiture in general, since it pertains directly
to how we understand death. We might allow that the death of others opens to us the
possibility of such understanding. (Even Heidegger seems to do this when he announces a
notion of community based on a shared experience of death, though at the same time that
death and that communality would seem unbearable for the individual.[18]) Indeed - with the
complicating inflection that it offers no such possibility of understanding but nonetheless
solicits from us a responsibility that causes us to act as ethical agents in the world,
representing that agency in culture - that is an argument that I will develop in the later
chapters of this book. For the individualised essence of being in the world that is Dasein,
however, this is no help. It is this essence, I would suggest, that Bacon seeks to reclaim from
the photograph, to keep as an essence placed in the world rather than being a thing – a
subject – fixed in chemicals on paper or in oil on canvas. If anything, Mitsein hinders the
grasp of death that is the ultimate test of authentic being. Heidegger puts it thus: 'By its very
essence, death is in every case mine, in so far as it "is" at all.'[19] Thus, as Marrati remarks: 'Whilst
it is always possible to be with the deceased in the experience of mourning, it can in no way
constitute the experience of Dasein's authentic being-toward-the-end.'[20]

We might add that to pose Dasein in terms of subjectivity at all is inherently problematic,
since subjectivity might necessarily be an ordering of being from without, an ontology of
language and social relation. Dasein, by contrast, is conceived as a grasping of being 'from
within', as it were, a 'natural' sense of the self held by the self. The singularity of Dasein might
be understood as something, then, that precedes subjectivity. Critchley remarks: 'For Heidegger,
to posit the Being of being human in terms of the conscious subject is to reify the human

being and to oppose the latter to a world which is understood as an objective realm posited over and against the subject.[21] One of the arguments I want to make concerning Bacon's 'ethical' violence against the photographic subject is that he is, indeed, seeking to recover an authentic essence from a situation that promises a death beyond his control. Furthermore, that violence, and the essence of being that it seeks to liberate, is posited in terms of the unconscious, or at least of something that is 'not conscious'. Bacon – as we shall see in his remarks to David Sylvester - clearly understands photography in terms of a reification from which something may yet be recovered.

Even as he enacts an aggression towards the photographic image itself, in the translation from the image fixed in chemical emulsion on paper to the fluxive provisional *images* of the self on canvas, that image necessarily occupies an originating position for Bacon. This is the *supplementary* role of the subject of the photograph as a thing to be destroyed by painting as process. (I am suggesting here that the subject acts in relation to *Dasein* precisely in terms of the Derridean concept of the *supplement*, as that which allows us to understand or define its antithetical, privileged term. Similarly, for Bacon, 'essence' and 'truth of the subject' can be attained only by starting from an objectification that negates both 'essence' and 'truth'.[22]) Ernst van Alphen remarks that Bacon's painting is characterised by its 'losing subjectivity at the very moment that subjectivity is defined by its representation'.[23] I suggest that aggression creates here a different kind of subject. Critically, Bacon 'represents' a subject that is anything but 'photographic' and becomes anything but a readily defined 'subject'. Where van Alphen equates subjectivity with clarity of definition, Bacon's notion of being is located in the process of loss of definition and, perhaps more controversially, in a process of redemption. In an early interview Bacon remarks that his aim is 'to distort the thing far beyond the appearance, but in the distortion to bring it back to a recording of the appearance'.[24] At first hearing this might sound like a stereotypical claim for the practice of modernist painting to appear to represent the truth of a subject rather than to truthfully represent the appearance of the subject. In using photography, Bacon is working from a form of representation that has supplanted painting in the accuracy of its depicted forms. Certainly, with his indebtedness to Picasso, Bacon is well aware of modernism's shift of attention from realistic representation *qua* representation to the language (and therefore the ideology) of representation. Verisimilitude is not then the problem, rather, it is the phenomenological properties of the photograph, the insistence not only on a truth of appearances but a temporal and spatial specificity. The photograph is quickly theorised within modernism as a form of death at the same time as it is a form of representation precisely because of that specificity.

Bacon is, then, in Sylvester's words, 'bringing somebody back' through the practice of 'injury' - as the artist puts it.[25] This 'somebody' (whether the artist himself or another) is conceived as an authentic being ('immediately real' is Bacon's term)[26] in contrast to the recording of appearance: it is an essence of the self that precedes the subjectivity fixed within the photograph. This brings us back to Heidegger's idea of authentic being as something prior

to a reified condition of subjectivity, in a world of objective appearances – with this reification, for Bacon, lying within the literal, objective appearance of the photograph. Indeed, as Critchley observes: 'Who is *Dasein*? *Dasein* is the entity who comes before the subject, who exists prior to the division or separation of entities into subjects and objects.'[27] We might go so far as to suggest that Bacon is seeking to reclaim something 'human' that is otherwise buried within a medium, photography, which might be considered to create something 'inhuman' through its objectification. Roland Barthes writes:

> Every photograph is a certificate of presence. This certificate is the new gene that invention has introduced into the family of images. The first photographs that a man contemplated ([Joseph Nicephore] Niepce in front of *The Dinner Table*, for example) must, to him, have appeared exactly like paintings (there was always the *camera obscura*); he *knew*, however, that he found himself face to face with a mutant (as a Martian might look like a man); his consciousness positioned the object he encountered outside of any analogy, like the ectoplasm of 'something that had been': neither an image nor reality, truly a new being: a reality one could no longer touch.[28]

The photograph thus provides a guarantee of something that *has* lived (a certificate of presence; a kind of identity card) but is, itself, a 'genetic' transformation of that human existence, as much as it is a fixing of a moment, an event in space and time: the time and space of *being* itself. The photographic subject is a 'new being', encased in an intangible reality, like a crypt or a coffin, but not truly dead, rather, capable of being endlessly revived. Not only is the photograph a place of dead time: what it immures it also transforms beyond the human. Having recorded presence, what the photograph offers us is not the subject to itself, but a kind of mutation of matter. Bacon's 'problem' with the photograph, then, is multiple. Firstly, there is the issue of an alienated self, an alienation that expresses the self through otherness; secondly, there is within the photograph a temporal structure that encrypts a time and space of the subject that he wishes to reanimate as essence; but, thirdly that there is something wrong – a kind of sickness - with that subject itself as objective form.

That malaise, indeed that 'sickness unto death', is the historical relation of the subject to itself at any given moment as much as it is to the time and space of its depiction. That is, it is a consequence of alienation that inheres to the particular temporal complex of the photograph. Bacon may not theorise this, but I would suggest that it is what lies at the heart of his phobic reaction to the photograph, and his compulsive attempts to reclaim an essence that precedes objectivity. We may imagine that, in being photographed, we are representing ourselves to ourselves. What we 'represent' through photographs, however, is something other than the process of becoming (which is, of course, also a process of disappearance). Rather, what is made visible is a static moment – a moment that, having vanished, can never disappear. This is not the true form of the subject, since it is always a form of the subject that has been. There is, then, a profound alienation inherent to the photograph; despite its objectivity it is

characterised by what Bacon describes to Sylvester as 'a remove from fact'.[29] This is what Walter Benjamin sees, in his discussion of Eugène Atget's photographs, as 'a salutary estrangement between man and his surroundings'.[30] This estrangement, conceived by Benjamin between the subjects and structures of history, can also originate as a product of the temporal fissure between the moment of photographic representation and the moment of its representation. The subject which-has-been – Barthes's 'ce qui à été - no longer is, nor can it ever be. The image that the photograph returns to the present of its inspection, its representation, is indeed removed from fact because its relationship (what Barthes calls référence) is not to that presentation but always to one made earlier, a momentary hesitation which the subject of the image never saw. Bacon's remove from fact is manifested in the temporal split between the moment of référence and the moment of the referent, of the object of the image.

In a late commentary on his earlier ideas, Heidegger clarifies a problem of being and consciousness in relation to Edmund Husserl's phenomenological thought. Here he comes close, I would suggest, to making explicit a horror at the relationship of experience and mediation, paralleling that of référence and referent - as conceptual grounding for a philosophy of self - that Bacon works through instinctively as an artist.

> When I look at the inkwell, he says, I take it itself into view, the inkwell itself, without reference to some hyletic data and categories. It is an issue of undergoing a fundamental experience with the thing itself. It is impossible to undergo such an experience by starting from consciousness. For such an experience, one needs a domain other than consciousness. It is this other domain that was called Da-sein.[31]

There is, then, as a substantiating condition of Dasein, an immediacy of the self to presence that shuns, and is indeed horrified by, the (self-)consciousness of mediation. As the notation of Heidegger's thoughts in the Zähringen seminar continues:

> Thus, the radically different senses of being in consciousness and Da-sein are clarified. From this, one can measure to what extent, in a thought centred on Da-sein, the status of all it encounters is transformed. From now on, man is ek-statically face to face with what is as such – and no longer with the mediation of a representation (which, by definition, presents a shadow of what is). Heidegger explains by posing the questions: when, in my memory, I think of René Char at [les] Busclats, who or what is thereby given to me? René Char himself! And not God knows what 'image' through which I would be mediately related to him.[32]

This too is what Bacon wants: not the image of meditated relation, but the presence to mind and to art of George Dyer, or Henrietta Moraes or Isabel Rawsthorne, or even, especially, narcissistically, Francis Bacon, without mediation. In this sense all of Bacon's painting is an art against 'image', an attempt to deform it 'into appearance', as he puts it.[33] This violence

against the image is not, I suggest, simply because photographic objectification is a masking of presence to itself through the creation of subjectivity at the expense of being, but because the photo is also, specifically, a kind of death mask.

Eduardo Cadava understands the estrangement between man and his surroundings as a consequence of the photograph's capacity to fix time and subject in a kind of death. 'Read against the grain of a certain faith in the mimetic capacity of photography, the photographic event reproduces, according to its own faithful and rigorous deathbringing [sic] manner, the posthumous character of our lived experience. The home of the photographed is the cemetery.'[34] Our experience as subjects is, in a sense, lived in relation to itself through the past tense. We realise the present of experience, which the photograph represents and represents, only in the moment after it has gone; we do not, as *Dasein* does, as Bacon perhaps wishes to do, experience the present of experience first of all as immediately present. Cadava here is reiterating the ideas first expressed by Pierre MacOrlan in the 1930s, and subsequently more widely circulated by Christian Metz and, in particular, by Barthes: to be photographed is to die (a little). Metz effectively summarises this:

> Photography is linked with death in many *different* ways. The most immediate and explicit is the social practice of keeping photographs in memory of loved beings who are no longer alive. But there is another real death which each of us undergoes every day, as each day we draw nearer our own death. Even when the person photographed is still living, that moment when she or he was has forever vanished. Strictly speaking, the person *who has been photographed* – not the total person, who is an effect of time – is dead: 'dead for having been seen', as [Philippe] Dubois says in another context.[35]

This is, in some ways, a medium-specific development of Blanchot's general paralleling of image and corpse, where he suggests that 'the strangeness of a cadaver is also the strangeness of the image',[36] but it is also one that has its legacy in the Western tradition of portraiture, which emerges both from a myth of 'photographic' transcendence over death and time in the idea (and its medieval reproductions) of the *sudarium*[37] and the early Renaissance practice, in northern Europe at least, of painting the recently dead, directly facing the spectator as if they were still alive.[38] What photography brings is a material realisation of the imaginative transcendence of the *sudarium*; it demonstrates presence in a specific time and space, and this presence may be endlessly represented in the wake of that moment, and in the absence of its subject – an absence up to and including its physical death. As Barthes puts it in an often-cited passage: 'The photograph does not inevitably say *what is no more*, but singularly and definitively *what has been*. This subtlety is decisive...the essence of the photograph is to ratify what it represents.'[39]

Whilst alluding to Blanchot's and Derrida's meditations on mortality and language, Cadava extends this idea to reflect on the true cause of the uncanny, and alienated, relationship between the subject and its representation. We might say that the operating concept or *eidos*

of photography is fundamentally at odds with the *eidos* of the subject as it manifests itself to itself. The transcendent effect of *who we were* overwhelms who we *think* we are. What is worse, however, is that this *who we were* is brought home to us as *our* death. The condition that we cannot inhabit as subjects precedes us in the medium in which we might expect to find ourselves as beings. Writing of Benjamin's commentary on the calotypes of David Octavius Hill, made in Edinburgh's Greyfriars cemetery in the 1850s, Cadava observes:

> The portraits bear witness to the recognition that we are most ourselves, most at home when we remember the possibility of our death. We come to ourselves through these photographs, through these memories of a mourning yet to come. This experience of our relation to memory, of our relation to the process of memorialization [sic], is not at all accidental: nothing is more characteristic. We appear to ourselves only in this bereaved allegory, even before the moment of our death. [...] What is most striking about the strange situation that Benjamin describes here is that it allows us to speak of our death *before* our death. The image already announces our absence.[40]

I suggest that it is this specific gap between absence and presence that Bacon is trying to cross, and the *aporia* of the lost life of the pre-subjective (its process of becoming and disappearing) that he is trying to restore through a violent countering of the photograph's *depiction* of the subject by a painterly *representation* of the subject. This is not, simply, trying to bring back the dead; it is almost as if death itself were not enough, but that in one's death one is irreconcilably 'other'. Bacon is not, therefore, just trying to bring back the dead to life, he is trying to make a grasp on death, to relate it to life, rather than allow it to be separated into another register. His paintings in general, and specifically the self-portraits, are an attempt to maintain death in a fluxive relationship to life, as a kind of living-on, rather than recognise life and death as distinctive, self-contained, categories. We shall see in the next chapter that Bacon applies the logic of this restoration even to those who are actually, rather than metaphorically, dead.

I want to examine here, however, the forms of death that the photograph may contain, and the way in which, as sign, the photograph may communicate. I think that Bacon – even as he undertakes a project that is, perhaps, profoundly 'conservative' of a certain kind of subjectivity in its attempted redemption of presence – recognises an important problem with photography's address to the subject. Cadava sees the photograph's revelation of death in advance as a kind of 'bereaved allegory' – a term he takes from Derrida's commentary on Paul de Man.[41] Barthes, by contrast, describes photography's content as 'flat death' (*Mort plate*).[42] This paradigm of absolute separation seemingly leaves the one who looks upon the photograph with no capacity but 'to speak of the "nothing to say"' (*parler du 'rien à dire'*).[43] For Barthes, therefore, irony seems to be the only response to the death inscribed in the photograph, where for Cadava that meaning is, however mutedly, allegorical. I suggest that, for Bacon, the only meaning that can be redeemed from the photograph is also allegorical, but that, for him, allegory is not

a property of photography as *eidos* but something attained only by reclaiming the subject from photography.

The 'flatness' of the photograph's communication derives in large part from its distinctive relation of signifier (the viewed subject, or object) and referent (the real thing to which the signifier relates). Uniquely in chemical-mechanical photography and film, the referent is manifestly bound within the sign, in a relationship that elsewhere in language is both arbitrary and concealed. Here we both see the thing that supports the sign for it, unveiled to such an extent that it is in fact co-terminal with that sign, and we understand this thing as wholly natural, not an object and sign in forced, and mutable, relation. Barthes puts it like this:

> The Referent [*Référent*] of Photography is not the same as that of other systems of representation. What I call the 'Photographic Referent' is not the *optionally* real thing that sends back an image or a sign, but the *necessarily* real thing that was placed in front of the object, without which there would not be a photograph. Painting, like a woman, can feign reality without having seen it. Its discourse combines signs that, of course, have referents, but these referents can be, and perhaps most often are, 'chimerical'. In contrast to these imitations, in Photography I can never deny that the thing was once there. There is a doubled position articulated here, of reality and transition. And since this constraint exists only for it, one must grasp it, without reduction, to be the very essence, the *noème* of Photography. This is what I understand as 'intentionality' in a photograph...this is not Art, nor Communication, this is the Reference [*Référence*] which is the founding order of Photography.[44]

This is why Barthes can say that the photograph is 'a certificate of presence', but also why it can, seemingly, speak only of itself and only of a past moment – it cannot produce discourse because it bears no potential meanings. The photograph is inflexible.

The *référence* of the photograph is not the subject; it is the subject as it was, and in its representation thus a harbinger of what the subject will be - its *not*-being, its death beyond its being. The human subject of the photograph, apparently vivacious, is always already cadaverous. Derrida recognises this intimate relationship between death and the temporality of photographic signification in his essay on Barthes. Separating the function of the *référent* from the condition of *référence*, Derrida comments:

> in the photograph the referent is noticeably absent, suspendable, vanished into the unique past time of its event, but the reference to this referent...also implies irreducibly the having-been of a unique and invariable referent. It implies the 'return of the dead' in the very structure of both its image and the phenomenon of its image.[45]

Référence is thus present in two photographic tenses, which Derrida suggests are future anterior (the moment(s) of *re*presentation) and past anterior (the moment of representation). Within both it is always a signifier of death.[46] Barthes recognises as much when, writing of the

effect of the *punctum* [that which 'moves' or penetrates the spectator by identification with detail within the signifying content of the image] he remarks that its legibility is emphasised by the 'erasure of time' [*écrasement du Temps*] that the photograph contains.[47] This 'erasure' is effected in the return of *référence*, the aorist tense of the subject's pose, to the present, and the promise that it will always return into the future. But the erasure is accompanied by a *punctal* horror at the immutable meaning of this return.

Bacon's movement from the photograph's temporal and spatial certainties of what-has-been to the provisionality of the aleatoric, never-quite-achieved painting represents a resistance to the 'death' which the past tense that informs the photograph seems to confer upon its subjects. We might note that Bacon's refusal of completion within his titles, the continuous deferral of the self-portrait that might define him as its identifiable subject, constitutes a similar defence. Derrida, writing of Barthes, comments: 'The proper name...alone and by itself says death, all deaths in one. It even says death while the bearer of it is still living...the proper name alone and by itself forcefully declares the unique disappearance of the unique.'[48] To bear a name, a unique identity, at the same time as it is a mark of individuation, is also to continually bear the reminder that the individuality of human life will end in an individual death. Our name will accompany us to our funeral urn, our tomb, our crypt. Bacon's reticence in declaring a name, in painting a portrait that might say 'this is me', can be understood perhaps not as an erasure of identity but, rather, the non-declaration of it. His self-portraits refuse to constitute a unique subjectivity that might be capable of the ultimate disappearance.

Oddly, given Nancy's claim for the presence of '*nous autres*' in the photograph, the photograph does not bring to us the face of the other as Levinas understands it. Rather, photography, as a reification of the gaze, allows a reification of the other into precisely those forms of 'habitual economy' that 'would attempt to appropriate the other, to reduce him to the (self-)Same.'[49] We have seen how, for Barthes, the photograph is a limit to discourse (though we should bear in mind Derrida's point in *Aporias* that such a limit necessarily effects the discourse to which it becomes limit); for Derrida and Barthes, less explicitly, the photograph is a kind of naming (one that for Barthes can be escaped by the theorisation of a kind of deliquescent, infinite concept of the dialectic that has formal parallels with what Bacon attempts in paint).[50] For Levinas, the other, what he calls *Autrui*, does not exist in a relationship where a name is put to the face: '*Autrui* is not only named but invoked. To put it in grammatical terms, the other does not appear in the nominative but in the vocative,' or, as he also says, 'in the dative'.[51] The face 'speaks', but it escapes categorisation; it escapes that which would put it to death. Similarly, it is through the encounter with the face that a discourse emerges that is the relation of self to other, the response to the call to generosity. The photograph, however embedded otherness may be within it, does not reveal the other to us but, rather, allows only an inadequate glimpse. We may neither encounter nor experience the real effect of otherness, and it is this, paradoxically given their radically contrasting views

on death and identity, that both Heidegger, with his example of remembering René Char, and Levinas, with his general model, seem to desire. Both seek an immediate rather than a mediated encounter that contains the true revelation (both, if you like, need presence rather than icons or Eucharistic analogues as the substance of truth). What comes of this understanding of the centrality of death to culture is, of course, radically different: Heidegger's emphasis on the individual, existential being, Levinas's emphasis on intersubjectivity, but both are in pursuit of an experiential reality rather than mediation. It is in the response to death that we might begin to separate them. Death, after all, is that limit which has no experiential reality for those who cross it, even as it constitutes an experiential reality and a limit.[52] For Heidegger, Death will be both the making and the dissolution of *Dasein* – the individual, graspable death, the only death worth having. For Levinas, the very intangibility of death will be a call to community through work on behalf of the other.

Bacon is, I would argue, engaged in a concerted assault on the immutable structure of the photographic sign, on the architecture, if you like, of its communication (or, in Barthes's terms, its non-communication, its 'rien à dire'). What he seeks is the transubstantiation of the mediated, the analogue back into the reality that it has codified. If we were to compare the formal syntax of language with the far less formal grammar of figurative representation, Bacon is, however loosely, trying to part subject from predicate, to remove that which fixes it in a time and place. He wants painting to be replete with a potential for infinite meaning and interpretation – that is, beyond ending – except that such an ending is bound up with the work itself: its essence as end in itself. This has a consequence for the subject, whether of self-portraiture or portraiture. It locates being in a fluid chain of representation rather than in a static framework: in that sense it is, therefore, something other than subjectivity as objective condition even as it solicits objectivity. It is, or it would be in its aspiration, *Dasein*, that which always is in its own moment. Bacon thus seeks to restore time to the subject as a condition of its being, where photography would, seemingly, hold it static within the past. Bacon's refusal of subjectivity is a restoration of that which precedes and is even opposed to subjectivity – indeed, a kind of resurrection of essence that subjectivity annihilates.

Chapter 2

Damien Hirst –
Francis Bacon

Et in arcadia, ego.

Reviewing Damien Hirst's 1991 exhibition at the Institute of Contemporary Arts (ICA) in London, Marjorie Allthorpe-Guyton wrote: 'How does an artist make work that is, or seems, this literal and get away with it?'[1] I don't want to use 'literalness' here as a synonym for obviousness that allows a fairly straightforward critique of Hirst, nor to allow the easy shift that Allthorpe-Guyton makes: that behind the blatancy and shock tactics Hirst is a complex artist, that the works are not so easy to interpret after all. There is a complexity to Hirst, but it is, I would argue, a complexity bound up with his failure to be anything other than literal, a complexity that makes his work not so much difficult to interpret as almost completely resistant to interpretation. Interpretation, or 'meaning', if you like, emerges only from an inherent failure in the work's presentation of the literal object. Hirst's œuvre is marked by two determining issues: firstly, indexicality; and, secondly, Death. Marked with a capital D because it is the overriding thematic, where indexicality is just a matter of form and, not uncommonly, a form of matter. Hirst's being literal is, then, something we can see to have a relationship with the index, where, as Rosalind Krauss describes it, the object stands first of all for itself, compressing the signifier and its referent and, thus, seemingly closing off the possibility of any play of signs that might constitute discourse.[2] It is worth observing here that the subject of Krauss's consideration is, of course, Marcel Duchamp's ready-mades, and that Duchamp uses irony to escape from the negation of language that indexicality seems to impose. Irony is not unimportant for Hirst, and represents a similar stratagem for evading a similar linguistic constraint. In his case, however, what motivates that shift is a simultaneous fascination with, and phobic response to, death.

We might say that all of Hirst's work aspires to be literal and all of Hirst's work *is* indexical. This is not to say that the literal and the indexical are co-extensive: indeed, that Hirst's work is indexical is a mark of its failure as a literal thing. The index compresses signifier and referent (the real thing that the sign would otherwise stand in for and stand for on its own); the literal is, or would be, *that thing*; not as sign, not bound up to a sign, but as itself. What Hirst would like to show us, I think, is Death *as itself* (whether in the form of cows' heads, sheep's heads, whole cows, whole sharks, butterflies). What we get are forms of the index (cows' heads, sheep's heads, whole cows, whole sharks, butterflies...within vitrines, cases, cabinets) that offer us 'Death in a Box', because Hirst - seemingly out of a necessity that is as much moral or creative as it is both practical and venal – uses indexicality as framing device and mediating structure. 'Death in a Box' might be a convenient shorthand for describing the artist's commoditisation of the ultimate phobic limit in Western culture, where indexicality limits the otherwise excessive effects of literalism, and in particular of the literal 'real' of death. Richard Shone observed, early on in Hirst's career, that his use of the vitrine 'serves both as formal toughness and as a part of his method of displaying often unruly or irregular objects. He seems to use such formal devices as a means of control over otherwise threatening subject matter.'[3] Versions of the index - the real pressed into service as a sign and framed in signifying structures that tell us the thing is now a sign, even as it purports to be real - become alluring formal devices that 'portion-control' both effect and affect. They render the real as presentational spectacle whilst denaturing it just enough to make it acceptable, whilst still shocking. Indeed – though I am sceptical that Hirst's ironic capacities extend this far – we might see the early shelves and pharmaceutical cabinets full of drug cartons as a meta-commentary on his strategy of affect, with its sedulously calculated dosages of shock.

As they emerged upon the British art scene in the late 1980s and early 1990s, the young artists who came to be labelled as 'yBAs' did not gain a reputation for seriousness. On reflection, this seems odd: for if they did not concern themselves overmuch with the circumstances of their position as artists in history, death, either as thematic or more narrowly focused element of personal narrative, figured large within their work. Whether it was in the hands of Jake and Dinos Chapman, replicating Goya's *Disasters of War* with the miniature figures of the war-gamer, or Matt Collishaw, printing a close-up photograph of a bullet wound, or Marcus Harvey's portrait of the child-killer Myra Hindley, death repeatedly came to the fore. Amongst this group, the artist who most willingly announced death as a central theme was Hirst. *The Physical Impossibility of Death in the Mind of Someone Living,* (1992) helped to launch Hirst's public persona as 'Mr. Death' by fixing a dead shark in a tank of formaldehyde.[4]

YBA was often defined by ruptures both with previous traditions of British art and its peers, in the form of the BANK collective and some of those who gathered around the artist-run space at City Racing. Yet it was Hirst - so often understood as the founding figure of the 'movement' through his responsibility for the 'Freeze' exhibition of 1988 – who, through his insistence upon the significance of death within his work, did most to align himself with one

of the central figures of British art in the twentieth century, namely Francis Bacon. Bacon became, and has remained, a kind of legitimating presence in Hirst's work – made explicit in a large London exhibition where a group of his paintings shared gallery space with a set of new works by Hirst, produced as a response. One of Bacon's obituaries commented, in keeping with the myth of the artist as an existential outsider, that he had no close followers.[5] In Hirst he had one who (though they never met, and although Bacon perhaps saw Hirst's work only once) was both devoted and, I would argue, suffering from a profound misapprehension about the master's work.

Beyond the recitation of Baconian aphorisms (his 'I suppose art tries to resurrect the dead' sounding as if culled direct from the interviews with David Sylvester), Hirst's frequent recourse to cases and vitrines might be understood as aping those constructions that often seem to enclose the subject in Bacon's full-figure paintings. As Gordon Burn writes, his

> 'dumb boxes' with their silent aura, simultaneously fortress and cage, insulated against the lifegiving air, are obvious metaphors for individual isolation and corporeal construction – for the nearness and inevitability of personal death which is his overriding obsession.[6]

Burn here is actually talking about Bacon, but he wants to be understood as simultaneously talking about Hirst. Death certainly is Bacon's obsession, and when indeed is it anything other than personal? (Even though it can't belong to us.) What Hirst and Burn collectively misrepresent is Bacon's attempt to rescue the subject from isolation and restore it to a site that, if it is not a place of being, is certainly not a tomb, but a structure altogether more provisional and ambiguous, which Bacon describes as being a 'frame to see the image'.[7] The painter is not 'obviously' trying to present man as trapped inside some soulless, airless crypt. This indeed is the now tired reading of Bacon as 'existential artist of his time'; one dismissed by Bacon. 'Obviousness', manifested in the objective subject of the photograph, is in fact the very focus of Bacon's violence against the image. Where Bacon is, in the face of death, engaged in an exercise of rhetorical separation that is characteristic of allegory, Hirst, in the face of death, and very often with the literal objects of death, resorts to irony. Where Bacon wants to establish discourse through the opening up (or shattering) of objective depiction, Hirst is intent on a closure equivalent to that of the photograph. To such closure the only response can be nervous laughter. In Barthes's phrase, there is nothing to say about Hirst's work, because of its indexicality. There is nothing to say because the placing of the object as artwork tells us nothing more than what it is. Though he rarely exhibits photographs, everything Hirst makes is, in this sense, photographic. All his art bears the self-conscious trace of *référence* between object and signification; much of it bears an equally self-conscious trace between Bacon as an authenticating historical figure and the establishing of value in the art market and 'public' institutions.

In discussing Bacon's painting *against* the photograph I alluded to that image as a kind of crypt, a place where being was interred. I want to develop this argument here, in the terms

outlined in Jacques Derrida's essay *Fors*, for his analysis of crypts, as problematic containers both of dead bodies and information, is useful to understanding Bacon's larger paintings, and to untangling the relationship with Bacon that Hirst tries to establish. The crypt is, fairly clearly, analogous with those 'dumb boxes' that Burn imagines that Bacon paints, and with the 'dumb boxes' – the vitrines and cabinets - that Hirst has constructed. Each is a form of container; both Bacon and Hirst are understood to fill those containers with Death, whether in the form of meditation or in the form of objects that might provoke meditation. Nonetheless, just as Derrida demonstrates the crypt to be anything but closed – precisely because it relies on signifying what is absent, rather than displaying its contents – so we might discover that Bacon's spatial constructs, after the great *Heads* and *Popes* of the late 1940s and early 1950s, are anything but sealed boxes, and anything but dumb, and observe that, in insisting on the closure of space and the specificity of Death, Hirst refuses the possibility of the very meditation he seemingly desires.[8]

Fors was written as the foreword to a reappraisal of the analyses by Freud, Ruth Mack Brunswick and others of that remarkable psychoanalytic patient who became known as 'the Wolf Man'. Nicolas Abraham and Maria Torok reinterpreted these analytical writings in terms of their own theory of incorporative and introjective inclusion in the unconscious. Derrida understands this double action of incorporation and introjection as a kind of encryption, both an encoding of experience in language (and indeed, in the terms laid out by Paul De Man for autobiography, in allegory) and a burial of the experience (a hiding of it from view). To encrypt in a material structure, however is both to hide the secret of the body and to announce its immurement – a reciprocity that creates an aporia from which one cannot readily escape, as Derrida points out.[9] Cemeteries are places of concealment that publicly display the act of concealing. Nicolas Poussin's *Arcadian Shepherds* (1647) remains one of the most explicit formulations of this paradox, with its tomb as central motif, and its cryptic engraving traced by a rustic's finger: '*Et in arcadia ego*'. The paradox of presence extends to language here, for the nominated speaker ('I', *ego*) is absent, unable to speak from beyond death, but is, rather, articulating death in advance or having someone else speak in his name. Because, since it will be dead, because therefore no longer a subject, since death is an experience that cannot produce speech, the subject can only anticipate a future in which all its subjectivity is bound up in proleptic statements concerning its inability to communicate.

That crypts both immure and display, both interiorise and put onto the surface, is vital to Derrida's argument – and indeed to a general understanding of our relation to death through culture. Derrida uses the neologism *Fors* (originating simultaneously from the French expression *le for intérieur* or inner heart and the Latin *foris*, 'outside') to describe this relation. It is also, quite deliberately, deployed as a figure that destabilises relationships between other terms. In this it is like Barthes's 'third term' in dialectical thought – diagnosed by Derrida as introducing a play between linkage (*liée*) and uncoupling (*deliée*) that parallels Bacon's play between the same terms in his portraits, and allows both critic and artist a translation or suppleness

(Barthes's term is *deport*) that in Bacon manifests itself in the flow of paint.[10] We might see similar figures that unsettle relationships in the philosopher Georges Bataille's metaphor of the fly on the nose of the orator in his essay '*Figure humaine*' ('The Human Face') and Bacon's intentional, yet haphazard interventions on the face of the subject. In a discussion of Bataille's use of this metaphor and a photographic illustration of flies in a further essay, Denis Hollier comments: 'Both representations are instances of printing bodies foreign to the value system providing this same print with an exchange value.'[11] Bacon's violently ludic acts of addition and erasure to the representations of the photograph and painted canvas might be understood as a similar aggressiveness – in this case against a closed representational system, photography, that precludes *discourse* - effected by the introduction of foreign objects (or lacunae) that disrupt the formal system of the picture whilst setting up new possibilities of exchange, discourse, between its elements. Rather than being simple containers, Bacon's 'dumb boxes' are part of an artistic strategy that works against any simple idea of enclosure and obviousness: far from stifling the scream they create discourse.

As Barbara Johnson notes, *Fors*, in its referral both to the outside and to 'subjective interiority...means both interiority and exteriority'.[12] Meaning, as both the production of signs and the product of signs, is not only buried within the subject, as a dead object contained by a spatial field, it is also encoded. Those signs communicate something other than the referents that they represent. If we were to see the dead body, the originator of this plenitude, as literal thing, what would it mean? Would it not, in fact, stop meaning, or, rather, refuse to begin it? Death is that which stands for itself; it is, therefore, not a sign, even as it necessitates and guarantees the action of signs that precede and outlast it. I shall look at the idea of writing the self in my next chapter, but it is important to note here, as a general principle of signification, that not only do signs exist beyond the specific context of their inscription, it is perhaps only in this radical separation (the separation of death) between referential context and sign that we can even understand that a sign *is* a sign; only through the absence of the signified that a signifier actually produces meaning.[13] Death, that end to all things, is the ultimate producer of language, precisely because we are compelled to step round it, over it, and through it; and just occasionally to confront it, obliquely.

Derrida's concern in *Fors* is that, even as 'meaning' is drawn into the subject from these signs that stand in for the literal, the term that designates this operation reverses itself, returning to the surface those very proliferating, unstable meanings that have been encrypted within language. This dual action can be readily understood as a metaphor for the psychoanalytic exchange between analyst and analysand. It is equally useful for the interpretation of Bacon's paintings, however. In particular, this double action aids our understanding of those self-portraits that include the body and those larger works, often in the form of triptychs, which we might term 'history' paintings, in so far as they refer directly or indirectly to external aspects of Bacon's life. Derrida offers a material figure - the crypt - that not only associates itself to death (holding the body in space as the photograph holds its

subject in time) but also invites an opening of that tomb to resuscitate meaning, and in doing so disorganises the spatial ontology that apparently contains and creates the subject.

Bacon is engaged in a similar project of disruption. When he moves away from portraits of the face that disruption is achieved not through a disturbance of the *temporal* modes of photographic depiction but, rather, by a deliberate unsettling of the *spatial* organisation of pictorial representation. In a sense, Bacon moves here into the architectural, addressing the question of its framing effects, including the organisation of space and subject through perspective. Rather than build or draw vitrines that would fully encase his embodied subjects, however, Bacon 'neglects' to frame them in such a way that the spatial construction of the field supports or defines them. As van Alphen writes:

> The conceptual categories of inside and outside, or innerness and outerness, seem to be evoked, but they cannot be attributed to a specific space... Put more radically, we are not even sure if there is something that can be defined as 'space', in which the body can be framed or embedded.[14]

In a work such as *Self Portrait* (1970) the figure itself becomes the term translating between subjectivity and objectivity. Bacon's portrait is at once a painting of the artist, and a painting of a painting of the artist in which the body acts as interlocutor. It is present as a figure on the flat surface of the canvas, yet it is a body that creates, in the vigorous extension of the left leg, a rupture of the plane of the painting. The figure is apparently positioned between the surface of the canvas and a painted representation of a canvas. In the flatness of its depiction, in the absence of shadow, however, the body is seemingly present on both canvases, real and represented, simultaneously. The relationship of these two surfaces might be said to constitute the pictorial space of the painting, except that this is an impossible space. The left-hand edge of the represented surface runs parallel to the edge of the real canvas, the tacking to its stretcher clearly visible. The bottom of the represented surface lies parallel to the bottom edge of the representational surface. In the space between the lower edges of each canvas the seated figure of the artist intimates, contrary to the visual evidence of the upper body and head, that the artist is somehow wedged between two imaginary planes of representation. The relationship of these planes is subverted by the painting of the right edge of the represented surface. Rather than lying parallel to the right edge of the surface of representation, this edge lies at an angle to it. The effect is to eliminate the coherence of the two surfaces, so that the left side of the represented canvas seems to conform to the vertical plane of the painting whilst the right slants towards it, meeting it only at its lower edge. Such convergence, however, renders impossible the presence of the represented figure, since there is no pictorial space to occupy. The figure is thus present only in its already painted form on the represented surface, or else, if it is more than representation, it must not only protrude out of the field of representation towards the viewer - as the left foot suggests - it must also protrude away from the viewer, through the field of the represented canvas.

The figure thus exists in two separate conditions of representation; it renders equivocal both fields that would define it and problematises the subject to such an extent that we cannot say that it exists. If it exists, where does it exist? Figure is space, and space figure; Bacon brilliantly sets forth within the domain of portraiture a central thematic of modernist painting that was more commonly worked out in abstraction. The incoherence of this relationship deforms the figure, and yet it does not annihilate it. Rather, ambiguity here negates the formation of the subject, rendering it only as potential subjectivity. (And, if no more than latency it is therefore - if we extend the critique of subjectivity's 'announcement' that is worked out in the self-portraits - 'unnamed' and resistant to death.)

Bacon's handling of space thus creates a profound unease concerning the subject, which seems to be a prior constituent of the very terms that would produce it. Hirst sees these spatial constructions only as traps or containers, as 'tombs', with a clear distinction between vessel and contents. There is no question of production or exchange, no question of being both within and outside the ontology that would make and hold you. He can then equate these traps with his own vitrines, necessarily literal vessels for holding decaying objects apart from the world. For Bacon, by contrast, what constitutes a subject and what an object - the exterior material of the ground that should define subjective interiority and presence - becomes uncertain. Indeed, like the trope of the *Fors*, its terms may be reversed, so that inside becomes outside and exterior interior, with the body a disruptive element of spatial organisation rather than one that is encased and controlled. Space therefore becomes an aporia in which presence and absence are terms of uncertain value, an aporia in which the body is the unsettling third term. Just as Bacon refused the certainties of photographic representation (what we might term 'certain death') in the facial portraits, destabilising the temporal ontology of the image through his use of paint, here he refuses the certainty of pictorial space (the dumb space of the tomb, which includes the necessarily perspectival space of the photograph) as a defining characteristic of his subjects.

The incongruity of space to figure to space, and of the figure to itself, is explored further in *Study for Self Portrait* (1982). Here the seated figure is placed in the corner made by two adjacent walls. In its situation, however, the subject is posed across an impossible conjunction of space that it serves both to conceal and, in the act of concealment, to emphasise. Writing of the spatial properties of the crypt, Derrida remarks: 'The grounds are so disposed as to disguise and to hide... But also to disguise the act of hiding and to hide the disguise: the crypt hides as it holds.'[15] Bacon's 'decoding' or undoing of encrypted space is achieved through positioning the subject as a middle term within it – a gesture akin to Barthes's idea of *deport* in his fluid notion of the dialectic. Although their representation suggests otherwise, the bases of the two walls cannot intersect to form the corner; they occupy different planes, disestablishing the position of the seated subject, and of the viewer. A small pictorial surface is placed *en face* in the middle of the picture, across this impossible intersection. A facial self-portrait is painted onto this canvas within the canvas: half the head is missing, faded into

the surface or else, like a half-completed photographic print, not yet emerged. The full body, seated upon a cane chair, supports both head and canvas, yet in its emphasis on depth, measured against the flatness of the pictured face, it is a body that seems to exist in another dimension. Poised within a failure of space, the body and head, in their own impossible relationship, hold each surface in suspension.

I have dwelt on Bacon's spatial construction in these two paintings, where his own body is the central motif, because I want to show how the strategies employed here also occur in a work that might otherwise be considered only as a painting of a literally dead subject, rather than one 'killed' by representation. *Triptych* (1976) was made shortly after the death of George Dyer, Bacon's companion, in Paris in 1971. The outer panels of the painting are noteworthy, because Bacon makes them almost symmetrical in their basic structure, whereas more commonly his practice in triptychs was to develop each panel separately. Both of these wings have a motif of a painting within a painting: at its centre is a rendering of a canvas bearing a head and shoulders portrait of Dyer. Both the illusion of these canvases and the portraits they bear are particularly 'flat' in their depiction, as though there was only a minimal difference between the space that they might occupy as a subject and the space of their representation in the actual canvas on which Bacon works. Depth is endowed on the picture only through a play with the illusions of Albertian perspective; that is to say, depth is inherently problematic. From the bottom edge of each 'canvas' run square sectioned lines, painted in the same blue. They connect the illusion of representation with the real act of representation, reaching to the bottom left and bottom right of the panel. Bacon's careful distortion of the lines that define the edges of these structures allows them a dual function: they could equally be near-vertical easel supports for the illusory canvases, confirming the 'flatness' of representation, or they could be 'rails' – horizontal in reality and therefore angled towards the vanishing point of perspectival construction, bestowing depth upon the painting.

The facial portrait seems, though, to hang in space as a flat intrusion disrupting perspective, even as the 'rails' or easel might support it in different places within the field of representation. Bacon, although an autodidact, had a sophisticated understanding of the traditions of European portrait painting. Those traditions included the use in early modern Europe of flat images to disorder both the organisation of space within otherwise perspectival portraits and the notion of time as belonging to a human universe, and their simultaneously employment as *mises en abyme* commenting on the origins of portraiture. Indeed, one of the exemplary models of such painting, Petrus Christus's *Portrait of a Young Man* (1462) has long hung in the National Gallery in London.

In this work a reproduction of a Holy Face (the face of Christ as it was seemingly imprinted on the sweat-cloth (*suder*) of Saint Veronica, as he wiped his face on it, on his way to Calvary) appears on the wall behind the subject. As a miraculous, venerated object, this image (the *vera icon*) contradicts the perspectival space which Petrus constructs for his real, human, subject. It appears *en face* though it is hung from a wall that, on the evidence of the

windowsill to the sitter's left, runs at some thirty degrees from the plane of the picture to create a perspectival framework. Thus the 'real' space from which the human subject emerges, and onto which it casts its shadow, is revealed as a representational construct that the miraculous both disrupts and transcends. In the disjuncture between the transubstantive icon (that which would bring the dead back to eternal life, that which would substitute essential being for subjectivity) and substantive subject, Petrus illustrates the origins of his – and, one might, argue all Western – portraiture. Taking the *sudarium* as the dominant tradition of facial representation - one based upon a universal conception and representation of man - Petrus projects its tradition into the specificity of subjects in a world organised by depth and dimension, who nonetheless remain inextricably linked to the divine and miraculous. The space in which the subject emerges is proved, by the intervention of the icon, to be 'impossible' even as it is 'real'. This scenario resembles nothing so much as those equally impossible spatial situations of the subject in which Bacon often locates himself, in his full-body self-portraits, and in which he locates George Dyer.[16]

What, then, is Bacon doing with the triptych? The central scene, bracketed by Dyer's portraits, is yet another painting of a painting. In it a headless nude figure, the off-white skin drawn back to reveal the raw flesh around its spinal cord, is attacked by four birds that tear at the open neck. They are at once those figures of the Furies identified by Dawn Ades[17] and, I would suggest, a reference to the eagle tearing at Prometheus's liver in Ribera's extraordinary painting of the subject. As Ades observes, 'Prometheus is the epitome of the tragic hero, both winner and loser in a hopeless battle against fate and the gods.'[18] Indeed, this figure will become the central motif again in Bacon's *Triptych Inspired by the Oresteia of Aeschylus* (1981). There is something altogether ambivalent about this figure; beyond that it is – just about – human, beyond that it suffers in some sacrificial role, and indeed may still be living, though headless, as Ades suggests. It has no face; it has no identity. What it is not is a readily identifiable piece of dead flesh.

The portraits of George Dyer in this work also refuse the categorical conventions of portraiture and space. In the left panel Bacon has Dyer both painted head and shoulders on canvas and sitting in a chair that somehow occupies the space in front of this pictorial plane. His naked chest slips from the open collar of the portrait into the chair. Both arms, one naked, the other in a black suit with white shirt, grasp at a Gladstone bag filled with scraps of paper.[19] In the right panel, Dyer's left shoulder is obscured by a pair of naked male buttocks and a torso that extends across the chest into a coupled pair of figures grappling with each other either sexually or after the manner of Muybridge's chrono-photographs of wrestlers that Bacon would take up with *Triptych – Studies of the Human Body* (1979) and *The Wrestlers After Muybridge* (1980) – paintings in which he emphasised the homoerotic implications of those struggles. Again we have a refusal of space, the subject slipping from both perspectival organisation and surface of portraiture. We also have an ambivalence of identity, with Dyer sliding out of himself, as it were, into a union of 'two become one'.

Is this triptych then, on the one hand clearly a post-mortem portrait of a lover, actually about that lover's death? There is the evidence of the portraits themselves, emerging from a tradition where only the dead were the subjects of *en face* portraiture; there is the tormented figure in the central panel; there are, only in the outer panels, those almost ectoplasmic 'shadows' that are often cast by Bacon's figures in the 1970s. Here they are pink emanations with no relation to the body, which might as easily be pools of blood or semen, or, indeed, shed skin. Again at once spectral, they are, like ghosts, not so readily defined. Rather than being an 'in memoriam' *Triptych* (1976) is permeated with ambivalence. The coupled figures in the 'impossible' space of the right-hand panel suggest life, in particular a sexual engagement free of the ontology of subjectivisation. Similarly, Dyer's slipping out of his own portrait on the left-hand side implies something more than a static memorial to the past.

Rather, I would see the 'openness' of structure, the blurring of conditions in Bacon's posthumous studies of Dyer, as representative of a particular condition of what Derrida calls 'the politics of friendship'. Here Derrida rethinks the relation of the dead to those who survive. Indeed, he rethinks it in terms that are not mnemonic but, rather, those of forgetting. Derrida cites the closing paragraph of Blanchot's brief essay on friendship, and emphasises in particular its last sentence: 'It must accompany friendship into oblivion'.[20] 'It' here is the consciousness that we will not remember adequately in the absence of the other. Derrida reinforces this imperative: 'Oblivion must. Friendship without memory itself, by fidelity, by the gentleness and rigour of fidelity, bondless friendship, out of friendship, out of friendship for the solitary one on the part of the solitary'.[21] For Derrida, this friendship creates a 'community without community' that goes against the traditional relation between friendship and memory, and indeed between memory and representation. Rather than accept Hirst's 'I suppose art does try to resurrect the dead', in the case of Bacon's paintings, and especially this triptych about Dyer, we might see what he nominates as 'bringing back' as more like a simultaneous refusal to let go *and* a form of release. On the one hand Bacon is striving, and failing, in his attempt to establish essential being, on the other he is making what might be a radical move in relation to 'the other'. Rather than there being a categorical division between life and death (equivalent to a categorical division of space or a categorical division between being and representation) there is something necessarily haunting about the flat image hanging in space, something uncanny about the disrupted crypt of perspective, even something ghostly about those ectoplasmic 'shadows'. As Simon Critchley puts it:

> If *philia* is *necrophilia* in the classical conception of friendship, then this presupposes that a clear distinction can be made between the living and the dead and presupposes the appropriative act of memory as that which allows the dead to live. By contrast, *sur-vivance* [*'living on'; this reconfigured notion of memory's relation to death*] is for Derrida something irreducible to the opposition between life and death; it is the dimension of the spectral, that which deconstructs the line that divides the living from the dead. [...] One might say that *sur-vivance is the first opening onto*

alterity insofar as alterity opens in the relation to mortality. This is not so much *philia* as *necrophilia*, but, rather, friendship for the other *as* mortal, where the precondition for friendship is the acknowledgement of mortality.[22]

One might say that Bacon comes to this discovery late; indeed, he comes to it only through the death of the person he most loves. But then that is, perhaps, how we always come to it: belatedly, bereaved. There may be, in the foundation of friendship, a tacit acknowledgement that one or the other will always die before the other, but we do not understand or experience the effects of that – do not therefore begin to understand and love the person who we thought we understood and loved – until the other person dies. Bacon here is not treating death as an absolute closure but, rather, exploring the possibility that it might also be the beginning of 'something after'.

Hirst's most overt response to Bacon, and especially to his paintings of Dyer, insists on a hard and fast division of life and death in which death is always resolutely alien, and indeed in which that alienation in itself constitutes spectacle. Amongst the new works shown by Hirst in 2006 was a triptych, *The Tranquility of Solitude* (For *George Dyer*) (2006), an aggregation of responses to, and influences by, several of Bacon's triptychs. *Tranquility of Solitude* comprised three glass cases, organised with a rough degree of symmetry around a central axis in the central case. In the left and right cases a skinned sheep's carcass was arranged as if sitting on a white ceramic toilet. In the left-hand case the carcass was propped against a white ceramic sink, looking up at a bare light bulb that hung from the ceiling panel. In the right-hand case the sheep's head was propped over the edge of an identical sink, as if vomiting into it. In the central tank was suspended a partially butchered carcass above a pedestal sink. Here the animal had been dressed in such a way as to remove the hindquarters whilst the front legs, severed at the knuckle, were stretched and levered upwards. The belly had been slit and eviscerated, with the flaps pulled back and cut to reveal the spinal cord and rib cage. Accessories in the cases included a watch (a motif for temporality as blatant as any in a Dutch vanitas, and one regularly used by Bacon in his self-portraits in the mid-1970s).

The references here are strikingly explicit. The dressing of the carcass in the centre calls to mind not only the spinal cord and ribs exposed in the centre of *Triptych* (1976) but Bacon's first reproduced painting, *Crucifixion* (1933), which itself took its lead from Rembrandt's *Slaughtered Ox* (1655). Hirst's shift from bovine to ovine establishes an abundantly clear metaphor between the works by directly invoking the notion of Christ as sacrificial lamb. More generally, however, *Tranquility of Solitude* derives its organisation from Bacon's *Triptych May-June 1973* (c. 1973), a work intimately concerned with George Dyer's death. In the left-hand panel of this painting a naked figure is crouched, sitting on a toilet; in the right a naked figure, its skin intensely pale, is crouched vomiting what might be blood into a sink. In the centre a figure that we recognise as Dyer is shown seated in darkened space, eyes closed, beneath a barely illuminated light bulb.

What does *Tranquility of Solitude* tell us about death that Bacon's work does not? Does it indeed tell us as much as Bacon's œuvre? Or does it simply extract metaphor from painted figures by materialising them as pickled, rendered flesh? As I have suggested, Bacon's post-mortem paintings of Dyer are as much concerned with friendship, or even love, as they are with

3. Damien Hirst, *Tranquility of Solitude* (2006).

death. There is at times something pathetic, even maudlin, about them; even in the right-hand panel of *Triptych May-June 1973*, looking at a young man, pale as death, vomiting (and given Bacon's distortion of the face it is only in the central panel of this triptych can we be sure its subject is Dyer), we are aware of a certain tenderness, love even, by the painter for his subject. There is no such feeling - indeed, there is no feeling - in Hirst's simulacrum. Instead we are presented with analogues (sheep for human equates to sacrifice, equates back to Bacon's long-standing interest in the crucifixion as synecdoche of human suffering) and sensation. Hirst offers the not-to-be-looked-at (the contents of the slaughterhouse as marginalised by-product of Western culture) as 'forbidden' spectacle: a metaphor for the not-to-be-looked-at event of our own, and other's, deaths. For Hirst it seems as though death is not only something sealed off from us, but something profoundly alienating to, and terrifying for, those who witnessed it. It is as if our deaths were to be equated with those of the abattoir when, quite clearly, humans articulate their consciousness towards death very differently from animals – not least in the form of culture.

This presentational mode for death as limit, as an un-felt object, rather than a witnessed phenomenon, and producing only silence, was a well-established strategy by the time the artist made *Tranquility of Solitude*. One of Hirst's earliest major works, *A Thousand Years* (1990) was premised upon the exchange between a decaying cow's head and an insect-o-cutor, a commercial device used in the food industry to kill flies, enclosed in a glass case. In between these principal objects was lived the life cycle of the fly. Maggots fed on sugar solution, rather than blood, pupated into flies whose eggs, laid in the rotting flesh, pupated into bluebottles which, drawn by the fluorescent blue lure of the insect-o-cutor's lights, soon afterwards flew into its grid of electrified wires and were duly fried. For as long as the cow's head lasted the piece was motivated by a steady economy of life and death. Once the head decayed fully the cycle would come to an end, since the parasitic life of the fly supposedly

depended on the rotting meat. (It was, of course, actually dependent on the sugar supply...) The cycle was never allowed to come to an end, however – partly, I suspect, out of respect for more sensitive members of the gallery-going audience. At the work's reincarnation in 2006, according to gallery staff the cow's head was changed every week.

At one level the work seemed to be marked by a degree of childlike sadism; not perhaps as extreme, but equally as meditated, as that manifested by the troubled central figure in Ian Banks's novel *The Wasp Factory. A Thousand Years* was indeed a kind of factory, a ceaseless, senseless, production of life countered by its equally indifferent elimination. *A Thousand Years* had a certain shock value, however, when directed towards those of more delicate sensibilities in the art world unused to the sight of decaying flesh, and who might feel that to create life uselessly, only to eliminate it, was somehow distasteful. Hirst's provocation, therefore, might be understood as usefully confronting the timid pieties of identification with the other, maintained alongside, and paradoxically disabled by, a studiously maintained distance from reality. After all, his work literally enacted mortality and decay and rubbed your nose in it. Or, rather, it would have done if the packaging had not diminished the effect to the point where all one saw was the abject and offensive superbly presented; instead of death, one got 'Death in a Box', with the reality of death safely contained. Hirst's apparently extreme gestures were rendered palatable for the art market – indeed, were to an extent palatable gestures rendered *for* the art market – and institutions. For all its radical positioning, *A Thousand Years* was as atmospherically modified - as portion-controlled - as mince or liver on a supermarket shelf. It might have offended but, ultimately, it didn't actually taste or smell like the real thing on a butcher's slab.

As an economy of life and death, *A Thousand Years* literalised the indifference of a mechanistic world with the comings and goings of mere flies. The glass case was a hermetic, amoral universe, in which the events of birth, existence and destruction were conducted as brute facts. *A Thousand Years* suggested that Hirst might have consulted authorities not often considered for the reading lists of Goldsmiths' undergraduates: Jean Paul Sartre and Shakespeare spring to mind. Andy Warhol's serial car crashes, botulism deaths and electric chairs had successfully reported the apathy of mass culture towards individual suffering as anything other than repeatable spectacle. Hirst metamorphosed Warholian ennui into a determinism as rigorously solipsistic as that of *Huis Clos*. Within its framework those helpless flies lived out their vulgar, ephemeral lives for us spectators. The work seemingly exploited Gloucester's bitter line in *King Lear*: 'As flies to wanton boys are we to gods, they kill us for their sport.' (Hirst would have known about this remark specifically in reference to Bacon, since in a 1975 interview Sylvester cites the lines, commenting that the artist often quotes them.[23]) But Shakespeare, of course, made explicit the torment of human mortality and impotence in the actions and the language of his characters. Hirst sustained the ratio which Gloucester protested, but diminished its terms. Instead of men:gods we were presented with flies:wanton boys. In the cultural shift - Elizabethan tragedian: postmodern comedian - we

moved from a work that expressed a fundamental human agony to the presentation of remarkably unaffecting decay, no matter how shocking or distasteful this piece was meant to be. Another Elizabethan writer, Sir Thomas Browne, had his own dismissive commentary on the carnivalesque attitude to death: 'Antiquity held too light thoughts from Objects of mortality, while some drew provocatives of mirth from Anatomies, and Juglers shewed tricks with Skeletons.'[24] One senses that Hirst perhaps wanted to be more than this, but that, as a young artist in a culture pressing for immediate results, he had neither time nor opportunity to achieve anything more than ironic distancing.

There is another phrase that I cannot help recalling when I contemplate Hirst's work. It is the chorus's cry in *The Eumenides* – 'The reek of blood smiles out at me.' Hirst tried hard to make you smile (or at least provoke a cheesy grin) but *A Thousand Years* couldn't provoke the sustained contemplation of the paradoxes embedded in the cruelties of human existence. Far less did the work suggest that death might be something more than abject and scary, that human death might be something different from animal death; it never suggested that there might be responses other than fear, glib avoidance or plain indifference. Certainly there was no notion that death itself might be the beginning of ethical relation; and, for all his supposedly existential bleakness, I would suggest that it is some form of ethical relation towards which Bacon strives. Despite his fascination with death there is something liberating, and deeply serious, in Bacon's art.

By contrast, smiling glibly in (or, rather, alongside) the face of death appeared to be a routine tactic for Hirst, if his photograph *With Dead Head* (1981/1991) was to be given any cognisance. Made on a visit to a mortuary when the erstwhile art student was only sixteen, the picture showed the severed head of a bald man, his flabby jowls grotesquely compressed, resting on a table. Crouched beside it, grinning at the camera is Hirst, who expressed his thoughts on the moment in an interview some eleven years later. 'To me, the smile and everything seemed to sum up this problem between life and death. It was such a ridiculous way of, like, being at the point of trying to come to terms with it, especially being sixteen and everything: this is life and this is death. And I'm trying to work it out.'[25] Or was this photograph, in its re-presentation a decade later, one more example of an approach in which exposure to death was a cheap thrill offered to the art world by a young artist cultivating his credentials as an outsider figure, offering the rough treats of the real world? In its retrospective nomination as a work of art, the image (imagined as art rather than as document) presented a fleeting exposure to anonymous death as if it were a profound and illuminating experience that had determined the course of the subsequent career.

In reiterating Aeschylus's line, I'm also deliberately recalling its use, in that specific translation, by another critic, Dawn Ades, about another artist: Bacon.[26] One corpus of critical writing on Bacon takes his paintings as reflections of a historical moment forever characterised by mass slaughter, when the reek of blood dominated Europe. Typical of this approach is John Russell's description of *Three Studies for Figures at the Base of a Crucifixion*

(1945). Russell claims that in the understanding of his own moment in history, at the moment of the revelation of the Holocaust and the appalling consequences of total war, the artist 'was ahead of the Prime Minister, and ahead of the Foreign Secretary, and ahead of the Editor of *The Times*.'[27] In similar mind to place the work, and its creator, in a context where it represents a historic moment in which death - whether that of the self or of others, whether actual or imminent - is uppermost in the imagination, Grey Gowrie, relating Bacon's œuvre to what he terms an '[a]ge of anxiety and extremes', comments: 'Since the death of Picasso, Francis Bacon has, more than any other painter, provided the age with an image, in Ezra Pound's phrase, of its accelerated grimace.'[28] Perhaps that grimace too was what the spectator saw at the focal point of *With Dead Head*, not in the cracked smile of the teenaged student, his laughter suppressing terror at the illicit and unusual proximity of the dead man, but, rather, in the disengaged and accidentally ironic reflection on mortality into which those fleshy cheeks and lips of the severed head contorted. Hirst's terror was our terror – we could understand his reaction; the dead man knew nothing of us, and we, with the artist, knew nothing of him, except as specimen of incomprehensible otherness. Perhaps, rather than this moment being the initiating of a fascination with death as object that would so permeate and govern Hirst's œuvre, *With Dead Head* depicts the moment that meant the œuvre would be permanently flawed. Maybe, in this moment, looking into the face of what *was* a man in its most extreme circumstance, Hirst might have recognised and acknowledged otherness, have opened at its furthest contingency the field of ethical relation. But he does not look at the dead: he looks at us, for once part of the spectacle of death that he wishes to present.

The historical consciousness attributed to Bacon is similarly applied by Gordon Burn to the deathly themes of Hirst's *Party Time* (1996). To make this work the artist asked the cleaners at London's Groucho Club – a watering hole for media fixers – to save the contents of the institution's ashtrays. The resulting mess of cigarette ends, cigar stubs, dead matches, ash and champagne corks was used to fill a vast plastic bowl. Looking at what was, effectively, the pouring of a second-rate Arman into something that might have been abandoned at the back of Jeff Koons's studio, Burn felt moved to comment – in the light of Hirst's remarks about cigarettes – that a work which 'at first had looked so mischievous, so innocuous, suddenly looked like something more sombre: like an atrocity picture; the horrible record of a Srebrenica, of an Auschwitz or Belsen'.[29] Champagne corks. Cigars. Auschwitz.

Hirst, at least, steered clear of this meretricious nonsense by continually emphasising the cigarette as a more general emblem of death, both in its properties as 'cancer-stick', and, in its burnout, as a metaphor for human existence. Here the artist's insights sounded like extrapolations and reductions of David Bowie's living-equals-dying thesis in 'Rock n'Roll Suicide', that '[t]ime takes a cigarette and puts it in your mouth'. This was certainly a line with appeal for the sixth-form student, but scarcely the basis for art of any durability or depth. As motif the burning cigarette does slightly less than any of the emblems of a *vanitas* painting, with its butterflies, broken lute strings and decaying food. Hirst, of course, also used butterflies,

though without painting them. *In and Out of Love* (1991) juxtaposed modernist shock and baroque sentiment through the simple expedient of freshly pupated exotic butterflies meeting large, wet canvas, and the work not being simply butterfly on canvas – though that was the part which could be sold – but the creation of a space in which this process was effected around you in a specially designated place of breeding and annihilation.

Bacon is engaged upon a denial of the ontological effect of pictorial space through its illusory representation, and especially a denial of the perspectival construction automatically bestowed by the photograph. His paintings are no more killing grounds than they are tombs. If one set of Bacon's paintings can be understood as incidental historical commentary on mass slaughter, elsewhere the obvious relation of the subject to personal history (and especially death) is negated through a deliberate failure of painting's representational coding. Just as I have suggested that language collapses when confronted with death, here too visual rhetoric fails. I would argue that Bacon's 'failure', however, is in part deliberate: both a reaction to the photographic encryption of the self and a drawing of attention, in the manner of Beckett, to the impossibility of adequately framing mortality within language. However much the two differ in other respects, the Baconian 'crypt' is much like a Beckettian ellipsis: both *appear* to be enclosures yet neither is wholly effective. Both demand to be decoded, so that there is always a possibility of more speech, more silence; never a last word, never a full stop... Bacon's silence is effectively an aposiopesis, a rhetorical hesitation that, in the apparent inability of the speaker to continue, draws attention to the speech which has preceded it, and adds weight to what, eventually, follows. There is always a discourse to come.

Rather than Bacon's paintings, Hirst's sealed, inaccessible crypts look more like the work of the 1960s *nouveaux réaliste* Arman - especially when they are crammed with detritus, as in *Waste* (1994). Arman, of course, is nominated as often as Bacon – though usually by a different critical school – as equally reflective of the mass deaths of the twentieth century.[30] After all, some of those vitrines even look like the exhibits in Holocaust museums. (Or is it that those vitrines appropriate Arman's compaction of humanity's lees as metonyms of gassed, incinerated bodies? The vitrine is a convenient device for presenting what otherwise is impossible to present or comprehend.) Hirst's investment in that aesthetic of the accumulation and compression of waste – one shared by Arman, the museum curator, and incidentally the work of the one of the finest British artists of the 1980s, Helen Chadwick (1953-1996), in her 'waste' work, the reeking *Carcass* (1987) – is perhaps what brings him closest to the historical perceptiveness attributed to Bacon. Hirst's work 'fails' to deliver on its promised encounters with death because of the introduction of distance and enclosure. Hirst might want to talk about death – indeed, he seems to do so endlessly – but he doesn't want it to get out of hand, doesn't want to do more than deflect it by depicting it, doesn't want more than the mortuary humour of *With Dead Head* as an apotropaic guarantee that it won't really touch him. Far from dwelling upon death as ending, Bacon is continuously trying to escape the ontological trap, to relocate the corpse – whether his own or those of friends – in a space other than death.

Chapter 3

Tracey Emin

The œuvre of the British artist Tracey Emin (b. 1964) is generally understood as containing a frank confession of the artist's own experience, direct and intimate in its disclosure. Much of the work's formal structuring – the misspellings and scrawled scripts, the smudged ink of the monoprints, the detritus around an installation such as *My Bed* (1999) – suggests immediacy. Indeed, it suggests it to such an extent that the reception of *My Bed* at the time of its Turner Prize exhibition seemed founded on the belief that the installation had been transported, sheets still warm, wet with tears and spilled vodka, from the artist's home to the Tate Gallery. The implication of immediacy means that we continually overlook the meditation and distancing that allow it. We fail to notice that those misspellings - perhaps accidental in monoprints which are, of necessity, executed at speed - become a signature motif of much more slowly completed works, the appliqué blankets made for Emin by seamstresses working to a pre-established design. We fail to notice that Emin's handwriting, so often the guarantee of urgent and open confession, is repeated in the carefully shaped glass tubes of her neon pieces. (Once again, work that is made for the artist by craftsmen, following her specifications.) Most journalists even failed to notice that *My Bed* in its incarnation at the Tate - far from requiring Emin to make a shopping trip for an immediate replacement – was a modification of two previous installations in Japan and the USA.

Emin's work is altogether more sophisticated than its reception, or even the avowed status of its production by the artist, might allow. Indeed, it can be said to depend upon the strategic disavowal of meditation and reflection in artistic practice for its reception as authentic souvenir of the artist's life. However, Emin uses the insistence on immediacy, authenticity and intimacy to reflect precisely upon our expectations of those possibilities as structuring tropes of autobiographical art. In consequence, the reconstituted historical moment surfaces as the just-passed, or indeed, the still being experienced. There is, about Emin's work, no

sense of the archive; everything is at the surface, the trauma as fresh today as it was twenty or thirty years before, as if the artist were the perfect analysand, with transference achieved in the time it takes to make a monoprint. I have written elsewhere about the dizzying series of reflective motifs in Emin's prints. In these works recollection is presented as if it were immediate experience through a series of *mises en abyme*. These allow a critical reading of the autobiographical mode whilst appearing as unproblematic representations of the self. We might argue, therefore, that 'Emin's self-representation emerges not in image or text, but rather in a parsing of the relationship between them as differently tensed, but simultaneously articulated recollections'.[1]

Given the autobiographical nature of Emin's output it is inevitable that it should, at certain moments, touch upon death, and not surprising that death should, then, initiate such reflective doubling, producing signs rather than negating them. Indeed, death and the afterlife has been a dominant feature of the œuvre; we might even say that it underwrites it. Renée Vara has pointed out Emin's interest in spiritualism and séances, and shown how early works such as *There's Alot of Money in Chairs* (1994) engage with the legacy of the dead. In this project Emin objectified the memory of her grandmother in a piece of inherited furniture, in order to signify the burden of remembrance, and proceeded to 'carry' both around the USA.[2] I want here, however, to isolate one work within Emin's œuvre, which is unusual in its direct address to the life of another person: *Uncle Colin* (1963-1993), a memorial piece about her mother's brother, killed in a car crash. The work is overtly symbolic in its use of found objects from the subject's life to signify the transformation of the soul – as the artist would have it - but it also provides a reflection on the life of the man, and distinguishes him as an individual. It is, to give the work a tenuous relationship with a now-neglected 'literary' genre, an *epitaph*.

The epitaph, however, is both a speaking of the other within the community, and a speaking by the community on behalf of itself – that is, it articulates self-identity through the figure of otherness. This, of course, is also a defining trope of autobiography, that of *prosopopeia*.[3] In offering a memorial for her dead relative, Emin continues, perhaps *begins*, to speak of herself. Indeed, *Uncle Colin* is, in some ways, directly concerned with establishing a narrative of origin for the artist within its narrative of closure. In its meditation on death, the work thematises the material and conceptual transformations that will in future characterise Emin's art. That transformation, between the mundane and the exceptional, typifies the physical status of objects in the œuvre, but it is also the stuff of her autobiography – the life's experience that those objects *represent*, in the doubled sense that they both depict and intensify.[4] Emin's is the tale of the chaos and madness of ordinary life made special, of the ordinary, if troubled, person made exceptional. (And it is the telling of the tale, of course, that achieves this effect; it is the stupendous *obviousness*

4. Tracey Emin, *Uncle Colin* (1993).

of this transformation, perhaps, that explains the public fondness for Emin as persona, rather than, simply, as artist.) In *Uncle Colin,* however, this claim for differentiation, and its achievement in what we might see as 'redemption through art' from the mass, is figured through an epitaph for the dead, albeit in tropes that will be repeated in more overtly autobiographical works.

Uncle Colin consists of a group of six wooden frames. Three of these containers are 'pictorial': they contain, respectively, a handwritten letter, two colour photographs and a page cut from a newspaper. The three other 'frames' are smaller and deeper; open to the viewer, they hold objects. One of these is a Benson & Hedges' cigarette packet, crushed on both its long sides; another is a small plastic seagull mounted on a fragment of chalk, and the last is a tiny 'puzzle box' – ten metal balls and a rippled sheet of metal, with small holes drilled in it. The letter, on the far left of the work, is addressed by Emin to her uncle. It is phrased in the present tense – not only as if the addressee were still able to receive it, but as if the account offered were immediate, rather than retrospective as a letter must necessarily be, and yet it acknowledges his death. The letter is also written for the spectator of the work: it describes each of the other components in turn. It can, therefore, have been written only after the choice of these objects as representing their subject. Whilst these documents and familiar objects from the life of a man in themselves compose a kind of narrative, from which we might be able to make some relation, it is the letter that provides an explanation. It becomes clear that this is an address by the artist that can never be delivered to its intended recipient: Emin writes it to the man who is pictured in the photographs, who owned the objects she assembles, and who died in the accident pictured in a suburban London newspaper. All these things, these events, are separately identified as his, as if they were only now assembled *in memoriam.*

The two photographs are personal snapshots: one, dateable to the early 1960s, shows a young man in a dark suit, white shirt and red tie, posed beside a new, dark blue E-type Jaguar. Unusually, the car is a left-hand drive export model, and it carries a Limited Trade registration plate, rather than a conventional vehicle registration number.[5] It is parked outside a block of what appears to be local authority housing, of 1950s construction, with laundry hung on the balconies of its first- and second-floor flats. To the right of this picture is a photo from behind of a balding man, sitting on the grass at the top of a cliff. He is looking down on a sandy beach and the sea, with his attention seeming to fall on a small sailing boat near the shoreline. The newspaper is the local London journal, the *Walthamstow Guardian* of 5 February 1982. On page 3 amongst the editorial comment and column headers describing everyday life in London, our attention is drawn to the only piece accompanied by a photograph and a white on black banner subheading: 'Driver Dies in Horror Crash.' The text reports that the driver of a Ford Cortina died in a collision with 'a Volvo articulated lorry' at a major junction in Walthamstow on Saturday, 30 January. The driver is named as Colin Dodge, aged forty-three, of Westgate in Kent.

Much of Emin's appeal lies in the way that she makes art out of the emotional crises and catastrophes that we experience in everyday life. Her autobiographical disclosure of such events

becomes the subject of recognition (in *Uncle Colin* that we too have been through the trauma of the sudden, incomprehensible death of a friend or relative), or identification (that we would have a sentimental and/or psychic investment in the event of another's suffering). Indeed, in Western culture almost everyone writes letters that can never be received; everyone says things to the dead that can never be communicated. (Vara's observations suggest that Emin's avowed belief in a spirit world and afterlife would allow for such communication; the form of 'writing' to the spirits here is in the scrabble of the ouija board, not the epistle.) The letter in *Uncle Colin*, then, lies within the mode of the epitaph, the farewell address as speech, rather than as writing, and, at a further remove, within the tradition of carving on the headstone. As a 'last word' it suggests that there are no last words. We might understand such letters as condensations or expansions of the things we neglected to say or write when their erstwhile addressee was still alive. They are a kind of surplus to that last conversation, that last postcard, a reply in a seemingly infinite correspondence that remains innocent of the caesura in the relationship. (And it does not seem to matter if that break in the thread of correspondence was anticipated or unexpected; we find in the absence of the other the need to say more.)

Such an address to the dead (whether in the form of the never-posted letter, the conversations with the recently dead partner whose presence still seems to suffuse the family home) is futile, whether to the materialist or the devoutly religious. We cannot talk to the dead, only at the void behind them, only at their trace: their trace in photographs, in cheap yet infinitely valuable mementos such as a tiny plastic seagull, in the packets of seeds lining a garden shed, awaiting the next season, that you, the one left behind, are left behind to plant; only when we make them a cup of tea and remember, taking it through to them, that they have been dead for more than a year. Given the impossibility of such communication, to whom is it that we really address our remarks?

The first answer is perhaps to ourselves: the one-way correspondence with the dead becomes a means of affirming *our* identity. Indeed, it is perhaps a continuation of the way we knew ourselves in our relation with the other, needed them as a pivot or a lever on which our own identity turned; even, in disagreement, needed them as a necessary limit, a wall against which we hurled ourselves more in the wish for our own injury than with any hope of breaking through. The epitaph is as much about ourselves as it is tribute to the other; it allows us to continue the inscription of our own subjectivity through their absence. It may even be that such a correspondence is established *only* after the event of death, with someone who we never 'knew' except through their legacy, through one side of a correspondence read posthumously. Derrida, addressing both the memory of Paul de Man and his work, asks this of the epitaph:

> What do we mean by 'in memory of' or, as we also say 'to the memory of'? For example we reaffirm our fidelity to the departed friend by acting in a certain manner *in memory* of him, or by dedicating a speech *to his memory*. Each time, we know our friend to be

gone forever, irremediably absent, annulled to the point of knowing or receiving nothing himself of what takes place in his memory. In this terrifying lucidity, in the light of this incinerating blaze where nothingness appears, we remain in *disbelief* itself. For never will we believe either in death or immortality; and we sustain the blaze of this terrible light through devotion, for it would be unfaithful to delude oneself into believing that the other living *in us* is living *in himself*: because he lives in us and because we live this or that in his memory, in memory of him.

This being 'in us', the being 'in us' of the other, in bereaved memory, can be neither the so-called resurrection of the other *himself* (the other is dead and nothing can save him from this death, nor can anyone save us from it), nor the simple inclusion of a narcissistic fantasy in a subjectivity that is closed upon itself or even identical to itself.[6]

If the act of recollection, the memorial, is unable to bring the dead back to hear it, to who else but ourselves, then, is the epitaph first addressed?

Whilst *Uncle Colin* is dated as beginning in 1963 (that is, before the artist's birth) its completion, the date at which these materials are assembled into an object of public recollection and communication, is in 1993, when it was first shown at the Köln Art Fair, some eleven years after the death. The common reading of *Uncle Colin* is neatly encapsulated by Vara:

[T]he work...represents an act of spiritual transformation. Emin intended it to be a 'conscious' engagement with alchemical ideas: the ancient practice of transforming base elements into precious metal, or transforming 'the individual into spiritual gold – to achieve salvation, perfection, longevity, or immortality.' Thus, at the moment of impact, as Uncle Colin's cigarette packet was transformed into the material properties of gold – 'like real gold', as Emin says – his body transmuted into the immaterial properties of the immortal soul.[7]

Vara places this work in an allegorical tradition that includes taking death, in displaced form, as a subject. As Adorno observes: 'If, in the face of death's reality, art's rights lose their force, then the former will certainly not be able to be absorbed into the work in the guise of its "subject". Death is imposed only on created beings, not on works of art, and thus it has appeared in art only in a refracted mode, as allegory.'[8] We do well to bear in mind, however that this may not be the only use to which allegory is put, as Derrida cautions:

Allegory is not simply one form of figurative language among others; it represents one of language's essential possibilities: the possibility that permits language to say the other and to speak of itself while speaking of something else; the possibility of always saying something other than what it gives to be read, including [*crucially for Emin*] the scene of reading itself.[9]

I suggest that if *Uncle Colin* functions as allegory of the soul's transformation it is also an allegory concerned with the transformation of ordinary materials into art, and, furthermore, one that encrypts the production of the artist, as much as the art, through the other's legacy – that is, the origin of autobiography is established in the gift of the other's death.

In its originating forms the epitaph is a specific, profoundly restrained, oratorical mode in which the virtues of the dead are addressed to the survivors. The epitaph, in classical Athens, was 'a speech, scrupulously distinguished from...ritual laments'.[10] It was not a bewailing of the dead, delivered over the body, in the manner of the threnody that characterised Homeric epic. Indeed, in Athens the epitaph was delivered at an interment ceremony that took place some time after the death. It was specifically reserved for the eulogising of the sacrifice on behalf of the polis, of its subjects, slain in battle. The interment of bodies, wherever possible repatriated by the Athenians from the battlefield, took place in a public cemetery 'situated in the most beautiful suburb of the city'.[11] The audience for the speech would have been the fellow citizens of the dead, family mourning being isolated from, and preceding, the event. The epitaph was, therefore, a kind of claiming by the democratic community, the state, of those who had sacrificed themselves on its behalf. It was a cultural marking of participation in society, unlike the threnody which exalted a specific, aristocratic individual as a superior being, and where 'lyric poets made a gnomic form...in which consolation of the living was accompanied by a whole philosophy of life and death'.[12] As the classicist Nicole Loraux observes: 'An epitaphios is an odd form of speech; closer to the speech memory of aristocratic societies than to democratic speech-debate, this oration is nevertheless a political speech, marked with the seal of democracy.'[13]

Although only part of the work is text, and it is not delivered as speech, *Uncle Colin* works as an epitaph inasmuch as it addresses both its subject (here symbolic objects from the life rather than mortal remains) and – as witnesses to that address - an audience within the public sphere. Moreover, it makes that address at some remove from the event, and it makes it calmly. (As Emin writes in the letter, at the time of the death she did not cry, and the tenor of the work is surprisingly dispassionate, given the frequently misplaced criticisms levelled at Emin of being 'hysterical' and 'irrational'.) The epitaph, if not explicitly allegorical in its originating forms, is nonetheless always a way of talking about someone, or something, other than the dead. Loraux remarks that the funeral oration, in its praise of dead Athenians, was a way of praising 'all Athenians, dead and alive, and above all "we who are still living", the "we" who coincide with the city's present'.[14] The epitaph, in its evolution as a cultural form (one that comes to encompass funerary speeches and grave inscriptions as well as longer reflections on the departed), thus becomes a mode by which life and death are related rather than opposed. What de Man says specifically about Wordsworth's *Essays upon Epitaphs* might be taken as a more general characteristic of the form.

It is a system of mediations that converts the radical distance of an either/or opposition in a process allowing movement from one extreme to the other by a series of

transformations that leave the negativity of the original relationship...intact. One moves, without compromise, from death or life to life *and* death.[15]

The epitaph also becomes, as de Man also shows of Wordsworth, and as we shall see of Emin, a way of talking about the self, through the representative image of the other.

If *Uncle Colin* functions allegorically this is not only because death cannot be addressed directly, in that no signs for it can be found, but because allegory's mediation between life and death allows a convenient movement between the signs of other and self. Those symbols that treat the subject's transformation from life to death simultaneously refer to the transformation into artist of the author of the epitaph – a transformation wrought in part through the agency of its now-dead subject. The epitaph, then, has a radically different use here: it shifts from being an address to the community, extolling the virtues of the dead to being a conduit for the survivor's reflection on transcendence. Emin is thus able to preserve her personal memory of her relation while announcing the distinctive properties of both the memorial's subject and its author, the artist, who inherits them.

The seemingly infinite spacing between this personal reflection and an absent civic memory reflects an important concern within modernity concerning the status of the subject's death, one against which Emin might be said to protest. That is, the memorial embodies and enacts a certain anxiety about the anonymity of death. Emin attempts to restore dignity and individuality to the dead, and to maintain, *post mortem*, a relation with the other. That attempt, however, is grounded not in a 'democratic' dignity – one that might be accorded to all. Rather, I would argue, there is a shift of the funerary address towards its pre-democratic, pre-Athenian mode, as a mark of special distinction from all others, rather than as notation of the subject's role within a community. This is accompanied by a meditation on a particular philosophy of life and death that the deceased embodied. *Uncle Colin* comes to distinguish its subject from the polity – like the threnody - rather than, as in the originating *political* function of the epitaph, announcing the dead person as democratic, civic property that the whole society inherits.

One formal component within *Uncle Colin* is not only a souvenir of the work's nominated subject, but also directly representative of the artist. This is the tiny plastic seagull on its block of chalk. I suggest that Emin uses it to thematise her presence within the work even as she symbolises her dead uncle through his own possession. At one level this artefact's symbolism is straightforward: found on a beach, it is, seemingly, a souvenir of a seaside town, and the use of a specifically local rock - the soft white limestone of the North Downs – suggests one in east Kent. We are given a sign of locale that, even if it does not explicitly locate us in Emin's home town (the seaside resort of Margate, to which she continually refers elsewhere), at least places us in the right area. The bird and its base are therefore a point of location, in space and in a certain culture, for both its now-dead owner and the maker of his epitaph. At this level, one of origins, the seagull is as much a mark for Emin as it is of her subject. A remarkable

degree of symbolism is condensed within this small, prosaic model, for it also serves as a sign of the spirit. The bird as a symbol of the soul departing the body is common in Western culture – though it is more usually figured as a dove or similar bird with Christian connotations than a raucous gull. Nevertheless, in Richard Bach's immensely popular novella *Jonathan Livingston Seagull* (1970), we have an allegory of spiritual self-sacrifice and individual transcendence of an anthropomorphised gull that includes the passage from earthly life to another, 'higher plane of existence'.[16] As a populist mythologising of freedom and spiritual survival, I would suggest that Bach's otherwise dire story is important to *Uncle Colin* and, in the motifs it offers, of wider significance to the artist's œuvre.

Emin has frequently employed birds as symbolic motifs; she speaks of them as 'angels of the earth' and representing freedom.[17] Her use is most noticeable in a public sculpture, *Roman Standard* (2005), made for Liverpool, where a small bird on a bronze pole echoed the golden cormorants on the dockside buildings that are the city's symbol, and, crucially for my purposes, in *Self-portrait* (2001). Here a sparrow was suspended, as if in flight, above a structure that was, simultaneously, a mock-up of a seaside carnival helter-skelter and a citing of Vladimir Tatlin's *Model for the Monument to the Third International* (1919). The 'self-portrait' here is not the architectural or sculptural form, but the bird as token of artistic freedom. Avian symbolism allows Emin to transcend both the demands made upon her by her history (a strategically useful, self-inscribed tale of origins) and the legacy of modernist art.

A central motif of *Jonathan Livingston Seagull* is the solitary gull, expelled from the flock because of its insistence that there must be more to life than the endless, collective search for food. That 'more' is discovered in individual expression, in the perfection of flight that enables Bach's 'heroic' bird to transcend the capabilities of its own body and leave behind the everyday squabbles of the flock. It is also this transcendence of everyday routines and imaginations that leads first to a solitary life spent in the pursuit of personal achievement (better flight for its own sake) and then, via an initiation into a higher plane that might involve some form of physical death, a return as a pedagogue of elevated, and of course individualised, powers. In one of her most explicit autobiographical narratives, the video *Why I Never Became a Dancer* (1995), Emin uses the motif of a flock of seagulls fighting over food to symbolise at an overt level the competition for female bodies (and specifically *her* body) amongst men in her home town. At a more general level, however, we could interpret the use of this sordid struggle as a commentary on the community at large: this is what the flock (Margate) was like; this is all life consisted of, what had to be escaped from, *transcended*, in order to achieve higher things. In particular, those 'higher things' involve the making of art and what I would see as Emin's romantic investment in the myths of artistic bohemia as an escape from the conventions of everyday life into subjective 'freedom'. That this creative freedom is itself inherited is hinted at elsewhere in *Uncle Colin*, in its subject's writing of love poetry and playing of gypsy guitar – those habitual activities of the weekend bohemian. In *Why I Never Became a Dancer* this subjective licence is flourished by the artist gyrating alone to Sylvester's disco tune 'You Make

Me Feel (Mighty Real)' in a large sunlit room overlooking central London – as she sardonically identifies the men who used her for sex – but it is also manifested symbolically in the motif of isolated seagulls circling in a clear blue sky.

The claim for the transcendent self could scarcely be more obvious in *Why I Never Became a Dancer*, but it is a transcendence that has been inherited from the already-dead other. In *Uncle Colin* the virtues of that inheritance are retrospectively transferred between self and other through a symbolic figure of relation. *Uncle Colin* is not, *apparently*, a work of self-conscious autobiography in which the agency of the artist is of primary importance, nor indeed is 'Uncle Colin' an obvious '*Sta Viator*' figure who emerges in the work that bears his name, a returned spirit proffering advice to the innocent traveller on the road. Rather, the figure of the lone seabird is where Emin and her subject cross; it is one of those chiasmic figures, like the '*Sta Viator*', that characterise both allegory and autobiography, allowing the author the privilege of self-representation through the assumed guise of another.

If it marks the 'crossing-over' of the work's ostensible subject between the boundaries of the physical and the spiritual world, the bird also signifies characteristics that will belong, in future, to the work's author. (And it helps in this respect that Emin dates the work from 1963; it is as if the memorial and what it tells us of its subject had already begun then, as if those characteristics were always waiting to be inherited by the artist, even before her birth and her subject's death.) Indeed, one can't help observing that one of the most significant uses of such guidance from beyond in English culture is in Wordsworth's *Essays upon Epitaphs*, a work that, as de Man notes, 'turns compulsively from an essay *upon* epitaphs to being itself an epitaph, or more specifically, the author's own monumental inscription or autobiography'.[18] Emin, I would suggest, is doing something similar to Wordsworth and at least part of that strategy is embodied in, and revealed by, the figure of the gull.

In making a memorial to her dead relation, Emin also produces, then, an autobiographical reflection on her own, still-forming, life as an artist, and specifically a revelation of the production of that life through the now-absent figure of the uncle. In necessarily making that address to the dead in the form of allegory – in which case none of the documents in the work need be sustained simply as factual analogues of their now-dead subject – Emin also allegorises the autobiographical practice of writing the epitaph. That is, she provides a kind of overarching commentary on *her* production or inscription of the self (and here it is specifically writing) and *her* authorship as memorial to the self, realised in its inscription of the other. *Uncle Colin* presents, then, a prolepsis of the future substance of Emin's art, autobiography 'written' through the transmutation of ordinary things into gold. The crumpled Benson & Hedges packet in the work is, certainly, an allegorical symbol of spiritual alchemy for the dead subject, but it is also a kind of ready-made. It tells us that base matter may be turned to gold; dead subjects may be turned into transcendent souls; and everyday experiences and everyday objects – in their nomination as much as their representation – may become the stuff of art. *Uncle Colin* enacts precisely such a transformation. It contains, as one of its formal elements,

a text that explains - in its address to the dead relation - that this transformation, this alchemy, is not simply one worked upon dull, everyday things, but one that *elevates* the 'ordinary' subject into the exceptional, the figure of the artist. These documents are not all there is to say about 'Uncle Colin': rather, they are chosen because they may constitute a particular narrative about Emin's relationship with her uncle, or, indeed, about her posthumous understanding of that relationship – her inheritance from him.

The newspaper cutting in *Uncle Colin* describes an everyday event: accidental death on a nondescript street in a nondescript part of London, whilst driving a nondescript car. There is nothing glamorous or romantic about this death, and, despite the true horror of it for those who survive the accident's victim, there is about it nothing that might make it memorable for a larger community. The noteworthy death of a loved, valued man is consigned to a few columns of a weekly newspaper with a tiny readership. This is death in modernity: so multiplied that it is received with indifference or momentary horror by anyone other than close relatives and friends, if it is noticed at all. We are very far here from the kind of death that Heidegger posits in *Being and Time*, as an event that is decided by 'being', and which defines 'being' in that decision. As Derrida points out, there is a significant difference between 'the dying proper to *Dasein*' and the end of life.[19] Heidegger establishes this differentiation in his use of *verenden* ('perishing' as well as articulating a prosaic, common sense of dying), contrasted with the death (*der Tod*) or 'properly dying' (*eigentlich sterben*) of *Dasein*.

Indeed, we might see Heidegger's insistence on a grasp of death by the individual as something resembling the medieval or early modern notion of the 'good death', for which the individual prepares in advance and, through the medium of the *ars moriendi*, is even taught how to die. *Dasein*'s decision to take hold of its own annihilation is, then, something almost anti-modern, and is perhaps rooted in a phobic reaction to modernity on the philosopher's part. The general degradation of death is mourned by a number of writers in the modern era as both a loss of special quality and individuality. Rilke, horrified by the institutionalising of death, the removal of the individual from home and family, described a hospital as 'like a factory'. Giorgio Agamben notes: 'Rilke opposes "serial" death to the "proper death" of good old times, the death that everyone carried within him just "as a fruit has its core", the death that "one had" and that "gave to each person special dignity and silent pride."'[20]

Rilke's writing will, subsequently, be profoundly concerned with the restoration of the 'proper' death as one that is characterised by dignity and, above all, uniqueness, and he is far from alone in modern culture. Francis Bacon, as I have argued, is making a similar sort of claim for individuality and uniqueness – if not 'dignity' – in his attempt to reclaim the subject from the desubjectifying, proliferating 'death' of technological reproduction. A similar suspicion of technology will characterise Heidegger's thought, and in particular his concern with 'the danger it poses to the dignity of the human being as thinker'.[21] Whilst Emin never overtly references modernity as a threat to individual essence, we might see, in her consistent use of the only non-mechanical, non-reproductive form of print technology (the

monoprint), of the hand-sewn (the quilt and blanket) and the drawn, an emphasis on techniques that depend on individual, subjective gesture. *Uncle Colin*, then, could be understood as a work in a similar vein to Bacon's painting in its attempt to rescue the subject from the indifferent death (*verenden*) of modernity and accord its dying (*sterben*) a proper place in – and, rather, above and through – the world. *Uncle Colin*, however, undertakes this project even as it describes its subject as wholly intercalated into a world of technology.

This principle governs the selection of those mass-produced objects through which the subject is retrospectively distinguished, since they both perform a kind of naming and through their allegorical symbolism – the gold of the cigarette packet, the bird as figure of transcendent and migrating soul – allow the epitaph to establish its subject as a distinctive figure. This means, however that, even as the epitaph attempts to redeem its subject from the anonymous death of modernity, it does so through precisely those emblems of mass culture that condemn the subject to anonymity. The marks of distinction that Emin accords, or remembers, as figures of her uncle's own desire are those of mass reproduction (a Bob Dylan song, for example) and celebrity. Uncle Colin is described as 'looking like Peter Sellers', as he stands alongside the kind of car that the film star Sellers might well have owned. The glamour of such a vehicle is in sharp contrast to the prosaic Ford Cortina in which her uncle died, just as the point of reference for the man is not to his own character but his resemblance to the famous, 'produced', figure of mass culture.

Emin uses the autobiographical trope of speaking of the self, the origins of her special status as an artist, through the other (*prosopoeia*) to simultaneously distinguish, or redeem, the death of that other from the banal and quotidian and acclaim the other, in his/her death, as unique. There is even, in the line in the letter that quotes its subject's last conversation – 'When I die I want them to play "Lay, Lady, Lay" by Bob Dylan at my funeral'- a hinted attribution of that death in advance to the other, a kind of grasping in the nomination of his funeral music, before the immediate need for any funeral. The proper grasp of death is, however, achieved, or at least imagined here, through the very mass-cultural forms that would negate this unique status. *Uncle Colin* embodies a tension between an appropriated modernist strategy – the yBAs' use of everyday materials in mimesis of the claim for the convergence of art and life – and a thoroughly pre-modern sentiment about death. 'Everyman' can only be redeemed only as a unique being - and I would argue that Emin is making a claim for a special status of being here as something like *Dasein* – through the very modes (pop music, advertising, commodity culture) that, in their offering of illusory freedom and uniqueness, successfully negate it. Where Bacon attempts to retrieve the unique from the ubiquity of the photograph, relocating it in painting, where – as we'll see in a subsequent chapter – Shimon Attie subverts the conventions of painted portraiture by folding them into the auratic distinctiveness of the video installation, Emin faces an impasse between her overt thematic and the materials in which it is achieved. The reason for this impasse is that, ultimately, those materials also have to stand for her future and her artistic strategy, as much as they symbolise the death of the other.

Chapter 4

Nan Goldin

In February 1914 the Swiss painter Ferdinand Hodler (1853-1918) began the first of a series of studies of his mistress, Valentine Godé-Darel, as she lay stricken with cancer. The suite of pencil, ink and crayon drawings and gouaches would end only in January 1915, with a painting of Godé-Darel, as she had lain on her deathbed. Hödler is unusual for a twentieth-century painter in his representation of death, though we might compare this project with that extraordinary series of drawings made by Don Bachardy of his dying partner, the writer Christopher Isherwood. Although post-mortem portraiture had been a staple of painterly representation from the Renaissance, the depiction of the dead or dying subject had largely disappeared from artists' practices by the end of the nineteenth century. Such portraiture had been largely supplanted by photography – whether in the widespread demand for images of the dead relative, or in the historically inflected representation of the great man on his bed or bier.[1] Whilst such an extensive study as Hodler's is unusual in any era, we might add that the growing concern with the privacy of the individual and the institutionalising of care that had characterised the development of Western culture since the fifteenth century would also limit both access to the patient and the opportunity to display publicly the process of his/her demise.[2] Furthermore, the fondness for *photographic* post-mortem portraiture amongst the bourgeoisie in the late nineteenth and early twentieth centuries demanded the display of the image of the dead relative amongst, and sometimes indeed as if they *were still*, the living.[3]

Simultaneously, the immediacy and verisimilitude of photography was pressuring painters towards new rhetorical forms, particularly abstraction. Modernist painting is not rich in representations of actual death. This is partly because figurative representation itself had been rendered problematic, partly perhaps because of a certain phobia towards the domesticity that death, in home or hospital, implied. Even Picasso, faced with the death of *his* long-term mistress, Eva Gouel, in 1915, at a time when, already sensitive to the pressures of the market

and the spirit of retrenchment in French politics, he was making large numbers of conservatively figurative sketches and drawings, chose not to systematically and 'realistically' represent her last months, dying from cancer in a Paris clinic.[4] Rather, he produced a cubist drawing, *Eva on Her Deathbed* (1915), and a symbolic painting, *Seated Woman (Eva) Wearing a Hat Trimmed with a White Bird* (1915) – in which the bird can readily be understood as representing the departing spirit, and in which the foreshortening of the figure suggests, as John Richardson remarks, the influence of Andrea Mantegna's *Dead Christ*.[5] Instead, Picasso displaced his grief, and his relation with the dying woman, onto what might be seen as a haunted, allegorical self-portrait, *Harlequin* (1915), in which '[a]ll that is left of the girl is two or three layers of shadow'.[6]

If death, at least domestic, familial death, disappeared as a subject of painterly representation in the twentieth century, then we should note that the personal photographic record does not vanish.[7] The Victorian tradition was to exhibit the formally, professionally rendered image of the deceased in the home. The subsequent 'democratisation' of photographic practice – smaller, lighter cameras, the evolution of film technology, the growing sense that photography was something one did for oneself, as part of the everyday – did not end post-mortem photography. Rather, modes of depiction and forms of exhibition changed profoundly. The dead were photographed in the coffin or at the undertaker's rather than arrayed *in vivo* in the home; the snapshot was not accorded the same privileged place of exhibition in the home but, rather, secreted away, often in a wallet or drawer. Jay Ruby describes contemporary examples where post-mortem pictures have been taken either by family members, or by undertakers at their request. Such images may not even be circulated within the family.[8]

Despite this continued, usually covert, activity, images of familiar or communal death are hardly to be found in the public sphere. Therefore, to represent and exhibit one's dead, and their process of dying, is a gesture of profound difference. It might even be considered a profoundly archaic, backward-looking practice. It is in this context that I examine Nan Goldin's photographs of her friends, members of her surrogate family, as they died from AIDS-related illnesses in the 1980s and 1990s. Goldin (b. 1953) is not alone as a contemporary photographic artist in making and exhibiting images of death: productive comparisons may be made between her œuvre and that of another American photographer of an older generation, Emmet Gowin (b. 1941). Working in black and white, within the vernacular tradition, but with a profound formal sensibility towards composition and subject, Gowin similarly documented his family - one framed by heterosexual relations, child-rearing, economic, and legal obligations - and its wider circle. This commitment to an exceptional aesthetic of 'ordinary life' includes the portrayal of the dead. In a sense, my use of 'ordinary' here is perverse, because we do not, in our everyday existence, so record the dead. Gowin's work could be understood to hanker self-consciously after a mythic ideal of Victorian communal and family life - a 'nostalgia for normality' - just as Goldin manifests in much of her work a romanticised longing for the excesses and dissent from bourgeois normalcy – a '*nostalgie de la boue*' – that characterises modernist bohemia.[9]

Nor, of course, is Goldin alone in taking death from AIDS as one of her subjects: in the late 1980s Nicholas Nixon (b. 1947) made a series of portraits of young men suffering from the consequences of the syndrome; and, if not directly represented, elsewhere the question of AIDS and death has become an important thematic in contemporary art. (In a subsequent chapter I address the late work of the British painter and filmmaker Derek Jarman; I might equally have dealt with metaphors of disappearance and revitalisation in the late work of Felix Gonzalez-Torres.) Goldin's œuvre, however, is of particular interest here, because of its stylistic and historical difference from those other forms of representation, in particular in its relationship to the imagination and depiction of bohemia as a historical formation and to the way death is treated within it. Crucial to Goldin's studies of AIDS deaths (and indeed AIDS survival) is that their subjects are her *friends*; indeed, they are nominated as her family. Death, here, is given a context of intimacy and community, even as those deaths are embedded within a representational tradition of marginal, bohemian lives and avant-garde artistry.

These photographs do not exist, then, as isolated studies: they are part of a 'family' album which also attends, as family albums do, to marriages, parties and the events of everyday existence. Because this is a bohemian reformulation of the family, however, Goldin's themes are often rather different from the events that punctuate 'ordinary' lives, and we might understand the wedding pictures in particular as showing us parodies of 'ordinary' conventions. Goldin's 'family' came together in a network of friendships amongst young artists, musicians, filmmakers and hangers-on in New York's East Village and Lower East Side in the late 1970s and early 1980s. Goldin repeatedly cites this family as a community whose ties exceed those of conventional friendship; where role and gender definition challenges the hierarchies of the nuclear family and the social legitimising of sexual identity.[10] Goldin's subject, then, is life, including her own, at the margins of social convention and representation. As Mark Holborn put it, this is a family of 'strangers in America'.[11] Luc Sante describes its composition as '[t]he makeshift, the beleaguered, the militant, the paranoid, the outcast, the consumptive romantic, the dead-eyed...shifting and coinciding modes and poses played...against a backdrop of ruins'.[12] Goldin's pictures acted as a historical record and objects of cultural self-affirmation for this community.

Goldin's depiction of a bohemia peopled by struggling artists and marginal figures continues the modernist tradition of representing artists, and their bohemian peers, as outsiders. Her work is often pervaded by a melancholy that parallels the fey women and *saltimbanques* of Picasso's late Blue and early Rose periods (a period when the artist lived in impoverished surroundings in Montmartre, and when he and his companions frequently smoked opium).[13] Much of her imagery is structured around appeals that lead to sympathetic identification with her subjects as heroic victims of their marginality. The artist was, as it were, doubly tutored in bohemia: in 1971, studying part-time under Henry Horenstein at the Boston Museum of Fine Art School, she was introduced to the work of Larry Clark, through his book *Tulsa* (1971); at the same time, she was sharing a house in Boston with a group of drag queens.

Clark represented his own life and the environment of Midwestern American city in an informal, uncomposed manner, refusing any distancing objectivity between himself and his subjects. His milieu was that of street life, narcotic addiction and petty crime that had often been the focus of documentary work, but never previously represented by a participant. If Clark gave Goldin 'permission' to work from the inside, against the grain of documentary traditions, she transformed the aesthetic that Clark offered. *Tulsa* gives few points of reference to the Western art tradition; unlike most photographic treatments of bohemia (for example, Ed van der Elsken's book *Love on the Left Bank* (1956)), there is no redeeming glamour or sentiment. Indeed, *Tulsa*'s is a bohemia devoid of artistry and art. Through her parallel influence by fashion photography – including the then-neglected works of 1920s and 1930s practitioners such as Baron Adolf de Meyer and Louise Dahl-Wolfe, coupled with contemporaries such as Helmut Newton and Guy Bourdin – Goldin introduced a self-consciously subversive, dissident use of glamour to the prosaic matter of everyday life in one part of American society.

As I have shown elsewhere, however, in both the early pictures from Boston and the later colour work made in New York, Goldin, though bounded by the inverted conventions of informal photography that Clark helped establish, 'composes' her photographs to establish moral indices between her subjects and their *milieux*.[14] This is a strategy of portrait artists from the Renaissance onwards; the objects surrounding the subject are as much symbolic revelations of character that the portrait itself cannot convey as they are inventories of wealth or knowledge. Where the painter might have deliberately found and deployed such objects as a compositional ploy, Goldin's emphasis on the informal and the immediate means that such indices find their way into the photograph haphazardly. It *happens* that Bruce Balboni (*Bruce Bleaching His Eyebrows* (1976)) has on his floor a copy of Frank O'Hara's poems and a collection of *Vogue* fashion photographs that can symbolise his gender transformation and define his personal aesthetic. Similarly, the poster of Warhol's *Twin Marilyn* on the wall in *Ivy with Marilyn, Boston* (1973) encapsulates a history of icons within the drag community, not least in its allusion to self-replication and mechanical reproduction, and refers simultaneously to the importance of Warhol's Factory to the artist, both as an aesthetic influence and as a version of bohemia that can be nostalgically yearned for, never having been inhabited.[15] Since Goldin is a vigorous editor of her own material we might say that the observation of this moral equivalence is a form of retrospective composition, one achieved in the editing process.[16]

Goldin would also radically change the mode of exhibition of the photograph: indeed, it was she, perhaps more than any other artist, who first became interested in seriality and projection as narrative devices; and further, who emphasised exhibition as a rhetorical form in its own right, rather than limiting rhetoric to the spaces and subjects bounded by the frame of the image. The book was crucial to the dissemination of Clark's work (with copies of *Tulsa* quickly circulating as collector's items) and would become important to Goldin. The initial mode of exhibition of her work, however, was through the circulation of prints themselves

amongst the community that they depicted. As her Boston housemate and long-time best friend David Armstrong reflected:

> The major activity that went on was taking the pictures, and all of us looking at them, everyone stealing the pictures they liked of themselves. [...] Do you remember how everyone started making piles, how many pictures were taken of them, started competing about wanting the most pictures taken of them?[17]

Goldin first exhibited her work as a slide show for a presentation at the Boston Museum School of Fine Art, when she was unable to afford materials to make prints. Soon, she was producing slideshows in bars frequented by members of the gay and bohemian community, however. After the move to New York such shows became her principal form of exhibition, with the audience again drawn from the community that comprised their primary subject matter. This confrontation of the subject with the spectacle of its own image in a communal, but socially isolated, situation repeated the context of Goldin's early, domestic presentations on a larger scale. The slide show formalised the transfer of the image that had been subjectively controlled in the household activities described by Armstrong; Goldin kept the slides on screen for only four or five seconds, denying the possibility of protracted individual or collective meditation. With the incorporation of music, first from a live band and then with a taped soundtrack that also limited the length of the performance, coupled to the use of twin projectors, Goldin edged what gradually became stabilised under the title of *The Ballad of Sexual Dependency* towards spectacle, albeit one presented within, and for, the limited subjective spaces of New York's 1980s bohemia.

The reification that the book makes of the ballad as a literary form in the eighteenth century is pertinent here.[18] *The Ballad of Sexual Dependency* has more in common with poetic forms than its title; in its constantly shifting state in the 1980s we might compare it to Walt Whitman's *Leaves of Grass*. The ballad is a vernacular, oral form that resists its own transitivity through memory; nothing is ever written down. It is a performative mode that relies upon repetition for cultural continuity. There is a materiality to each performance that is reclaimed through memory by audiences and performers. The ballad's temporal continuation through repetition does not guarantee its fixity, however. The 'text' of the performance changes across time according to historical context. As a form, the ballad is therefore 'continually marked by immediacy - immediacy of voice, immediacy of action, immediacy of allusion'.[19] Wider cultural recognition, however, is dependent upon the fixing of transitive speech in authorised, stable written versions. In these the ballad becomes a souvenir of a lost culture for those who never belonged to it. There are clear parallels in this situation between the ballad as repeated, variable performance and Goldin's screenings to live audiences. The translation of *The Ballad of Sexual Dependency* to book format in the mid-1980s attenuated its scale as performance. Both size of image and the number of images were greatly reduced. The temporal relation of audience to the image was also dramatically changed. In the slide show each image was on

screen for three or four seconds, and each slide was held in a narrative relationship by the images that surrounded it. With the book - even more than in a gallery presentation - the individual picture became available for protracted scrutiny by an unfamiliar, spatially dispersed, audience. The narrative inherent to performance, which Goldin clearly valued, was discarded in the book. Instead, the individual print became an object of consumption. Furthermore, the soundtrack - fundamental to effect even as it controlled time within the work - was lost.

Of the ballad book as literary form Susan Stewart writes: 'The book offers a transcendent, if forever arrested, form of life once the body is itself a relic, the voice dispersed, and the organic made textual.'[20] The book of *The Ballad of Sexual Dependency*, much like the photograph, fixed life, memorialising the bodies of those it contained. For their originating 'family' the slide screenings had served as reflective surfaces, where their subjects, communally enclosed, could look at their posed images and self-identify. The act of inscription within the book signified a movement from this role to that of becoming objects of contemplation and incorporation by others.

Ultimately this process of stabilisation would lead to a BBC film (*I'll Be Your Mirror* (1995)) based on Goldin's life, and in which she was co-credited as director, that seemed in many ways to invert all that she was trying to do with her work by the mid-1990s. From the late 1980s onwards, Goldin's œuvre is informed by a passionate, political and ethical response to the AIDS crisis. Much of her work from that point on is also about living *with* AIDS and caring for those dying from its consequent diseases. *I'll Be Your Mirror*, although it set out to be a film about AIDS, had little time for such challenging representations of death and dying. In its nostalgia for the lost authenticity of the sexual hedonism of Goldin's generation in the 1970s and 1980s, the film constructed an aetiology of disease related to that culture's special practices, and contained it within eroticised moral boundaries. AIDS was envisaged as a disease that affected people who were 'different' in their sexuality, but also 'different' in their creativity, their way of life. Part of this collapse of meaning into simple, and misplaced, pieties about AIDS, sexual difference and the consequences of excess might, however, lie with a fundamental dichotomy that bedevils Goldin's work. Goldin sees her imagery as reaching beyond its localised community of production and address – which, if it is to survive as 'art' rather than as 'documentary', it must necessarily do.

> If you try to make 'universal art', you're going to make crap. If you talk, like [William] Faulkner, about where you live, your tiny little radius, you can make universal art. That's what I've always tried to do; by talking about the specific to talk about the general, or to somehow not even talk about it, but to touch other people who might come from different worlds, even if they don't live the same lifestyle.[21]

In order to reach beyond that 'tiny little radius' (a specific cultural community within downtown Manhattan) it was necessary to change not the content of the imagery but the form of its presentation. The reification of *The Ballad of Sexual Dependency* that begins with

the book can be understood as completed in the BBC's *I'll Be Your Mirror*. Goldin's attempt to move the specific to the universal involves a fixing of structuring forms that negates or, at best, compromises the content of the work. Thus, when Goldin explained her problem with the BBC's film she phrased it in terms such as 'We'd still be shooting'[22] or 'We would have made a 13 hour version'[23] That is, to maintain truth in the work as she saw it, whilst operating in a film format, Goldin would have returned it to those formal regimes with which her local audience, the subjects of the work, would have been most familiar. The tradition of avant-garde filmmaking, in which Goldin had been embedded since her youth, would have led her to make a documentary that was structured (or rather, unstructured) by its conventions. Both in style and duration, this would have been an accessible film for the community that Goldin was accustomed to address. This is not only her 'family', nor the original bohemian community that framed *The Ballad of Sexual Dependency* (now fragmented and dissipated), but now, rather, the extended audience for contemporary art. This is an audience familiar with the anti-aesthetic aesthetic of Warhol's *Sleep* and *Empire*, or Jack Smith's *Flaming Creatures*: it is not that of even an art-orientated television channel. Ed Coulthard, the co-director of the film, wrote: 'The idea of making a film with Nan started off very simply as an idea to let some of the people in Nan's photograph [*sic*] - including, of course, Nan herself - speak for themselves'[24] The constraints of the medium of representation - television - result, however, in these subjects speaking *of* themselves, rather than *for* themselves. In speaking *for* they would address themselves in forms that would be unintelligible to the general audience.

In photographs made shortly before the film, however, Goldin made a radical gesture that attempted to redress the problem of representing living with and dying from AIDS-related illnesses. She made two series of prints based upon the deaths of close friends, the Parisian art-gallery owner Gilles Dusein and the German writer and curator Alf Bold. The treatment of her subjects in these pictures - some of which were included as rostrum shots within *I'll Be Your Mirror*, accompanied by an edited interview with Dusein's partner, the French artist Gotscho - is very different from that granted to Goldin and her 'family', or to AIDS sufferers in general, in that film. They are also, I suggest, very different from those photographs that Goldin made about the death from AIDS illnesses of her close friend, the actress and bon viveur Cookie Mueller, in New York. In the narrative series about Dusein and Bold, Goldin does what television, as a mediating form of dominant discourses - including a punitive and judgemental one concerning the causes and consequences of AIDS - couldn't bring itself to show. This emphasis on death - and, if not glamorising it, then certainly treating it with an exceptional candour and investing it with dignity - was a departure from the modernist bohemian tradition on which Goldin had, previously, staked so much. There are 'beautiful' deaths in treatments of bohemia, but they are in its bourgeois reifications (Mimi in Giacomo Puccini's *La Bohème* springs to mind) rather than the modernist tradition. Goldin's 'postmodern' treatment of death, which I would argue is a profound work of love, is in stark contrast to Picasso's flight back to abstraction in 1915, and has more in common with exceptions from the modernist norm such

as the 'conservative' Hodler. One fundamental shift allows Goldin these effects, and it is a shift of presentational mode. She returns time to the spectator by making the photographs as exhibition prints; she allows contemplation rather than encouraging the momentary sympathy of screen-based identifications.[25] That is, she withdraws this work from the reifying modality to which it might previously have been subjected, and in doing so allows it a moral, even pedagogic, dimension it would otherwise have been denied, whether as slide show or incorporated into television film.

There had been little notice taken of death in Goldin's work before the late 1980s. As Goldin put it herself:

> It wasn't until the first year of my sobriety that I confronted the reality as I watched a number of my friends die. I photographed some of them while they were ill to try and keep them alive, and to leave traces of their lives. It was then that I realised how little photography could preserve.[26]

The celebration of a bohemia based upon hyperbolic sexual activity and narcotics use moved towards narratives attempting to preserve the memory of the dead and represent the struggle for life. Much of Goldin's output in the subsequent decade addressed AIDS. She was a prime mover in the exhibition 'Against Our Vanishing' at Artists' Space in 1986 and confronted right-wing politicians attempting to close exhibitions; in a conspicuous act of public resistance she refused National Endowment for the Arts funding where its conditions included the swearing of 'a censorious and homophobic oath'.[27] What followed this confrontation was a series of narratives of decline and eventual death. The first of these was a memorial to Goldin's close friend Cookie Mueller, exhibited in 1991. This new narrative tendency was replicated in her work with Gilles Dusein, intended to be exhibited serially. In later work Goldin mounted images of other dead friends into framed groups that constituted attenuated, but similarly accessible, narratives. I would suggest that in these presentational formats Goldin is striving towards an affect she had yearned for more than a decade before, in a remark to Mark Holborn: 'I'd like to find a way to show the prints that would have the same impact as the slide show.'[28] This is not only a search for narrative, it is a search for effect, and it is achieved through a transformation of presentational mode and of its context, its form of address to a specific audience.

In her response to death, in asserting the need to represent it, Goldin counters the discourse that marginalises human mortality. More importantly, I would suggest that she counters the refusal to accept death's significance to individual and social life by representing death within a community and death as lived experience that is part of a life, rather than as an unspeakable limit. Her pictures articulate anger at life lost, especially at deaths so far inside the expected span of life, but they also suggest how death from AIDS, and the social structures erected to accommodate it, became a reinforcing element in the gay community during the 1990s. This is a discourse that cannot celebrate the abjection it represents, but

draws upon the experience within and beyond suffering to define collective identity and a politics of loving that which is profoundly alienating and alienated. As Derrida discerns, this politics lies within the structure of friendship itself:

> Is it possible...to think and to live the gentle rigour of friendship, the law of friendship *qua* the experience of a certain ahumanity, in absolute separation, beyond or below the commerce of gods and men? And what politics could still be founded on this friendship which exceeds the measure of man, without becoming a theologem? Would it still be a politics?[29]

Goldin's work here is also work (both artwork and corporeal work on behalf of the other) that is, in a sense, fundamentally 'conservative'. As conservative in its relation to modern ethics as it is to modernist aesthetics, it harks back to the place of death in Western culture before, and in the early years of, modernity. As Ariès observes: 'Before World War 1, throughout the Western world of Latin culture, be it Catholic or Protestant, the death of a man still solemnly altered the space and time of a social group that could be extended to include the entire community.'[30] Death was both a public and a private event. Private mourning was enclosed within a larger social structure that both provided, and sought its own, consolation. Goldin's treatment of it is distinguished by her membership of that specific community whose time and space is profoundly affected by the loss of the individual.

We are far removed here from that existential ordering of the subject by death that is pursued in Bacon's self-portraits, literalised in Hirst's vitrines or found in Emin's writing to and of herself through the figure of her uncle. Rather, we are in that ontological regime defined by Levinas 'in which meaning would certainly still be attached to the world but in which the meaning of the world is profoundly tied to other men'.[31] Levinas, in his lectures from the mid-1970s, takes Ernst Bloch's idea of a subjectivity that is premised in labour on behalf of others, rather than on individual essence, and shifts its emphasis from Marxism, where Bloch had applied it to explain the revolutionary impulses of those who had no need of revolution, to a wider social domain. Levinas's commentary on Bloch, that 'it is not death that opens the authentic future' but, rather, that it is in the never-to-be-achieved utopia of 'the authentic future that death must be understood',[32] perhaps offers us a reading of a 'thanotocracy', a society that strives towards an understanding and equitable treatment of others through the event of *their* deaths, in anticipation of *their* deaths, and in anticipation of remembering *their* deaths. For Bloch, what motivates the bourgeois revolutionary is 'the spectacle of misery, the frustration of the neighbour',[33] and what defines subjectivity is a labour that can never be adequately completed.

> The intelligibility of being would coincide with its completion as uncompleted. It is a potentiality having to pass into act, and the act is humanity. But that by which the possible is determined is not an operation of spirit. The act is labor. Nothing is

accessible, nothing shows itself without being determined by the intervention of the corporeal labor of humanity.[34]

In Goldin's 'AIDS photos' we get a radical shift in the work that reflects this labour and this new responsibility assumed for others. We might also, in passing, want to contrast this both with the idea of self in the modernist bohemia and with its consequent codes of representation (or non-representation) of death.

The idea of the artist as subject within modernism is invested with notions of individual autonomy and agency that sit rather oddly alongside the political claims that modernism sometimes makes on behalf of the other. That is, in order to speak on behalf of those who have little or no liberty, autonomy or agency but are bound to the wheel of the world by capital, artists must (and *can*, already therefore assuming a prior agency) assume a subjective position of potential individual transcendence over the world not unlike that promulgated by the bourgeois capitalism they oppose. This myth of freedom extended to those parts of bohemia not inhabited by modernist artists, and it extended to those modernist artists not motivated by some notion of intervention on behalf of the other. It becomes a governing principle for the sexual and narcotic licence that will characterise what we might now see as a parody of bohemia, the 'East Village Scene' that Goldin depicted, which Craig Owens scathingly described as premised upon difference as an object of consumption.[35]

The myth of individual transcendence, of being able to grasp life for and by oneself, is also a disavowal of responsibility for the other, even as if it is assumed as a governing principle. This may be why an aesthetically radical modernist such as Picasso had such difficulty in dealing with the death of one mistress that he could only, ultimately, come to terms with it through a self-portrait inhabited by her successor, whereas the aesthetically conservative Hodler could depict his dying mistress with tenderness, even love. It is this subjective myth and its associated representational coding that Goldin breaches, at the same time as she breaches the parodic commitment of her own avant-garde generation to irresponsibility by both taking responsibility for, and depicting, that which cannot be loved, that which cannot be represented.

This fundamental and progressive rupture in Goldin's work has not always been recognised. Her early practice of adding a seductive veneer to what might otherwise be seen as a tawdry decadence led to some commentators praising her ability in the AIDS portraits to 'endow her subjects and their milieu with a certain glamour and dignity'.[36] Indeed, we might see some of the images of Cookie Mueller in this light – not least *Cookie in Her Casket*, New York (1989). Though, as Lisa Liebmann has observed, here Goldin seemed to borrow an aesthetic from that great photographer of the Harlem Renaissance, James van der Zee.[37] Is Goldin, then, bestowing on death a dignity that befitted an individual who might often have denied, or been denied, dignity in life, or is she commenting that Cookie took her beauty to the grave with her, and that a death from AIDS is not the ugly death it is so widely assumed to be? The latter position raises its own problems: even as it makes a valuable political point about the visibility of AIDS

sufferers, it returns us to the bohemian myth of living fast, dying young and leaving a beautiful corpse behind. Such ambivalence led to claims that Goldin not only glamorised and romanticised the deaths of her subjects, but also exploited them. Typical of such responses is that of David Deitcher:

> Now that so many of the individuals Goldin pictured have passed away, it is upsetting to see their images recycled as large-scale cibachromes or, even worse, clustered together as composites within a single frame where they coalesce into sexy, brutal and/or tragic narratives for a market that is now so hot for her work.[38]

Deitcher provides a critique of Goldin as continuing to represent a languorous, doomed bohemia, where death becomes unavoidably associated with homosexual practice and excess. (That is, she occupies a moral position close to that of the film *I'll Be Your Mirror*.) AIDS in this formulation is an equivalent to those nineteenth-century bohemian deaths that were a seemingly inevitable consequence of poor environment and dissolute lifestyle. There is, indeed, a wider problem here in the reception of Goldin's works around AIDS and death. To signify from a site of abjection is not only to articulate an identity; it risks signifying that identity as if it were constituted only by abjection. It is interesting to compare Deitcher's interpretation of these narratives to Elizabeth Bronfen's analysis of Hodler's depictions of Valentine Godé-Darel. Bronfen claims that the representation of the other's traumatic bodily experience mitigates its violence towards the artist (and by implication the spectator, through identification with the artist rather than with the victim as a seemingly impossible subject of identification), not its violence towards the affected body. In this analysis, representation acts as an apotropaic device, protecting the observer and reinforcing his/her sense of bodily integrity (much as I have argued for the denaturing of death's effects through parodic representation in Hirst's œuvre). 'The threat that real death poses to any sense of stability, of wholeness, individual uniqueness or immortality is antidoted [*sic*] through representations that "exteriorise" this real by transferring it to an image'.[39]

Both Goldin and Hodler share an intimate relationship with their subjects. However, what radically distinguishes certain of Goldin's narratives from Hodler's is their subject's relation to the exterior world. Hodler painted and drew his mistress in isolation. Her dying figure fills canvas and paper, excluding other referents. In Goldin's series relating the life, sickness and death of Gilles Dusein, for example, the art gallerist is consistently framed in relation to his lover, Gotscho, and to the bleak minimalist architecture of the hospital. In *Cookie at Vittorio's Casket, NYC, Sept. 16, 1989* the loss of the man – Mueller's husband Vittorio Scarpatti, dead from AIDS - is marked by the presence of the grieving widow, herself HIV-positive.

These images signify the effect of death in and to the social world. There is an objectification of loss and the effects of pain. The disappearance of the individual is recognised as affecting the society of others, the culture in which they have participated. Such a marking may not evacuate romanticism from the narrative – especially given the milieu of

the subject - but I suggest that it undermines Deitcher's criticisms. Whilst his commentary, like Bronfen's, provides a model of potential identification with Goldin's images, I would claim that there is a particular mode of association between subject and other that both authors neglect: this is 'love'. This emerges from the cultural recognition of the unloveable other, that 'impossible' identification with the victim to which I alluded above. Such identification is conditional upon its emergence into a language relating recognisable, if not analogous, experience. In the photographs of Dusein and Bold, the objectification of pain and loss through their social effects, through what we see as historical context, vitiates an aura of melancholic romance that might otherwise prevail. Perhaps the face of the slowly dying man is a face we would rather not see, but a face that, precisely because it makes us uncomfortable, because it tells us where responsibility lies, that we must see. Levinas writes: 'What we call, by a somewhat corrupted term, love, is *par excellence* the fact that the death of the other affects me more than my own.'[40]

Goldin shows us, in the referential content of the photograph, what it means to be part of a community and the loss that that death causes the community. She illustrates the response to the death of the individual by the collective. Goldin shows us how we may work towards the other, not knowing precisely what his/her condition is, what he/she is trying to tell us, but attending nonetheless. This is why I earlier described these works as in some sense pedagogic: they teach us how to love that which cannot be loved. This was something one learned quickly, if one wanted to work at learning, and work to care for the other. Goldin was far from alone; the philosopher Gillian Rose wrote of caring for such an 'impossible' other at, I suspect, much the same time:

> Even if you are holding his hand, you can never be sure in what spirit your friend has died. Jim spent his last hours in the triage ward of a city hospital for people without health insurance. His three closest friends by his side, I whispered to him, 'You are surrounded by friends who love you.' Speechless for days, shrunken and orange with death, his breathing shallow and laboured, he took hold of the bed sheet, saturated with bright hospital blue, in both of his unearthly hands, and pulled it right up over his face. He was beyond language, but not beyond the discomforts of love.[41]

One response to death in the fifteenth century was those picture books described as *ars moriendi*, instructions to the individual in the manner of dying a good Christian death.[42] There is some evidence that the plates from these volumes were sometimes separated out and displayed around the bedchamber of the dying person. Without wishing to push too far an analogy between Goldin and an even older form than the ballad book - and Goldin's work, for all its postmodern labelling, is often oddly preterite - there is something similar here in the pedagogical motive, if not its audience. Goldin knows that, however much we come, of necessity, to relocate death as part of life, as an element in a shared human process rather than an alienating individual limit, it cannot lose its sting; we cannot go back to an age where

death is looked to as the passage into a Christian paradise, and nor would we want to. An integral part of the effect of these pictures is the tearing sense of loss, of incomplete work and relation. There is little or no instruction here for those who will one day die about the manners of death; there is no such thing as a 'good death' as it is romanticised by Rilke. (Which might be understood as one of the unlikely, utopian outcomes of Levinas's re-reading of Bloch, if we pressure that argument too far.) There is plenty of instruction here to those who will one day choose to minister to the dying, because the economics and morality of neoliberalism have so disabled those facilities, erected in modernity, that were designed to do that job.

Rather than desiring images of death either to reinforce bodily integrity or as anthems for doomed youth - where pain follows its etymological root into punishment - I suggest that identification with these pictures relates to a common experience, the death of the other, regardless of the cause of death. We are interpellated into our death through our relationship with others. No matter how much we may occlude or marginalise the death of the other, a condition of the social – if there is to be a social sphere - is a sharing of that death and a loss as its consequence. Each death of the other is a failure of the subject because it also marks his or her own; at the same time, each death holds out the utopian promise that we might transform the world through it, (an imagination of our role as the neighbour that brings its own set of philosophical and political problems). We might, therefore, understand Goldin as withdrawing death from the increasingly sterile, synthetic public sphere of late capitalism; from a disavowal of the other except as source of profit. Rather than reinforcing an individual sense of immortality, Goldin's pictures of dying as process and of death return us to the pre-modern tradition of the contemplation of mortality and communal loss through our own labour, our futile, not-for-profit intervention on behalf of the other.

Chapter 5

Ralph Eugene Meatyard

Quid petis?

'He is going to die. I read at the same time: this will be and this has been; I observe with horror an anterior future of which death is the wager [*enjeu*].'[1] This is Barthes, looking at a picture of man now long dead, prefatory to comparing both image and experience with looking at a picture, taken in her childhood, of his mother, recently dead. What happens if we rewrite that sentence? 'He is going to die. He has died. He is filled with a monstrous horror, knowing that by the time an audience sees these pictures he will be dead.' This is perhaps what 'The Family Album of Lucybelle Crater', made by the American photographer Ralph Eugene Meatyard (1925-1972), leads us to say. In what other medium can the artist so knowingly disregard the temporal constraints of syntax to construct what Barthes calls the 'impossible utterance' 'I am dead'?[2] That this paradox was made possible by the medium of absolute fact was certainly the point of Bayard's *Le noyé* (1839) – but there the artist feigns his suicide. With 'Lucybelle Crater' we are confronted by the brutal fact of the artist's death before the series was finished; we know that he knew he was dying as he made the work; we know that the close friends, family members and intellectual associates who appeared, *who appeared concealed*, in the photographs knew that too. Yet there is nothing maudlin or sentimental here, there is no mining of 'memory', no archive to say these *were* my friends, my wife, my children.[3] Nor are these pictures a prolepsis of death, a fantasy of being's negation; rather, they establish the promise of living on through the other as a form of the self.

Simultaneously, however, these pictures question who that other might be, and what might be the relations of the self and other that constitute 'living on', because the forms of the self that they depict are simultaneously monstrous and bathetic. They are at once the establishment of a possible community and a problematising of that community. 'The Family

Album of Lucybelle Crater' is one of the most extraordinary explorations by an artist of subjectivity and intersubjectivity. Few other works of art ask so insistently 'Who is my neighbour?' *and* 'Why is my neighbour, like my death, so necessary, so intractable, so utterly impossible?'. Asserting himself only in the creation of the series, Meatyard 'dissolves' into a community of family and friends where singularity melds into a troubling sameness. 'I am dead' becomes possible in the prospect of the self's extension through the lives of others, in the prospect of lives that always, already, include death. Meatyard perhaps began the series just before he was diagnosed with cancer in 1970; but I'd suggest that the illness was responsible for the direction that the work then took. These are posed photographic portraits of other people, yet they are in their way self-portraits, taken over a year or more, of a man as his health slowly deteriorates to the point where he can no longer face the camera.[4] The series raises critical questions about the relationship of self and other face to face with one's vulnerability to death, however.

As self-portraits we cannot escape the personal articulation of the subject in these pictures. But what can 'I' mean in a statement where the artist-subject is always someone, or perhaps something, else? Meatyard is not interested in a straightforward record of social relation; that would be the path of memory and sentimentalism. If we have, in the photograph, an inherence of the body and identity so close that to be represented there is a kind of naming – and therefore, in that appellation, an announcement of our death - we have in 'Lucybelle Crater' a deliberate subversion of photographic fact; a subversion through defacement. 'To what face,' Meatyard asks, 'does the name belong?'

'Lucybelle Crater' is both a meditation on Meatyard's own dying and an undermining of the photograph's capacity as a tomb or crypt of a given moment of being. The artist knows that there will soon enough be a real caesura, not the shutter; rather than the print a real

space, in which what he once was will be confined as an object beyond iteration. The consequence is liberation from photographic literalism, achieved through props and performance, through a free play of signs in the space where those signs should be fixed. There is a translation from ontological distinction and fixity into a constantly sliding 'sameness'; a sliding that might be understood as Meatyard mapping his own sickness, his impending death, onto his family and friends. These photographs allow us to say that these things were there, in time and space, but we can no longer be certain what these things, these people, were. It is that doubt, realised through symbolic property, which proves so productive.

5. Ralph Eugene Meatyard, *Lucybelle Crater and close friend Lucybelle Crater in the grape arbor* (1971).

Meatyard at once allegorises his own death and questions his position in the intimate community in which that death will occur. The form this allegory takes has profound consequences for the medium in which it is achieved. Photography is one of those media, evolving in the Enlightenment's episteme, which brought distinction and categorisation to the world, separating the real from the illusory in what Alphonso Lingis terms its 'inventory of pure data'.[5] As an instrument of distinction it enforces a law of facts in a world of appearances; like death, the photograph is where the play of signification that is both language and the realm of images seems to stop, arrested in an unbreakable marriage of signifier and referent. Francis Bacon's individual challenge to this union, through a translation into paint, destroys the photograph and its image as object. In 'Lucybelle Crater' the medium bears the image of its own dissolution. Meatyard corrodes the boundaries of the photograph from within by creating a fiction about a real community that he has, to some degree, inhabited, and embedding himself within it – through the replication and displacement of forms – without ever being present.

This displacement is why I describe the images in 'The Family Album of Lucybelle Crater' as 'self-portraits'. There are sixty-four photographs, but Meatyard appears in only two. In neither is he readily recognisable; indeed, he is no more recognisable than anyone who appears elsewhere in the series. In the first image, *Lucybelle Crater and her 40 year old husband Lucybelle Crater* (c. 1970),[6] he stands beside his wife, Madelyn, looking at the camera. Both are wearing rubber 'fright' masks of the sort you might buy in a joke shop. Madelyn Meatyard's is that of an old hag, with only two teeth left in her mouth; the photographer's is that of an old man. Meatyard would ignore many photographic conventions in the 'Lucybelle Crater' series, and here he shoots the picture against the light: lit from behind by an early autumnal sun that renders the left cheek and chin semi-transparent, the mask seems for a moment the face of a ghost. The artist does not appear again until the final picture, *Lucybelle Crater and close friend Lucybelle Crater in the grape arbor* (1971). Once again he appears with his wife, but now it is she who wears man's clothes and has donned the mask worn by her husband some months before. He now fits easily into a woman's clothes, and wears the mask of the hag. All the intervening pictures are made by Ralph Eugene Meatyard; Madelyn Meatyard appears in all of them, always accompanied by only one other person – usually a family member or friend. In all the photographs until the last Madelyn wears the hag's mask and her companion, regardless of gender, the man's mask worn by her husband in the first picture.[7] All the photographs, except the penultimate, are captioned. The captions contain only one name: Lucybelle Crater, applied to all the subjects of the pictures. Each caption is structured so the name appears first and then is linked through a copula and modifying clause, giving scant, allusive details of character or job, to the repetition of the name. Thus we may have *Lucybelle Crater and 45 year old husband's 20 year old secretary Lucybelle Crater* (1971) (where Madelyn appears alongside the secretary from her husband's optician's practice)[8] and *Lucybelle Crater and secretarial, brotherly friend, Lucybelle Crater* (1971). Here Madelyn is partnered with Br.

Patrick Hart, secretary to the eminent Catholic writer Thomas Merton (1915-1968), in a picture taken when Fr. Basil Pennington, a noted scholar of Merton's work, was invited to Lexington to celebrate a Mass for the terminally ill Meatyard.

Though Meatyard knew Merton for only two years before the latter's death, the writings and thought of the monk exert a considerable influence on the 'The Family Album of Lucybelle Crater'. In particular, Meatyard explores Merton's ideas about community and being-in-common. Indeed, we might see in his systematic use of masks in these photographs - perhaps the ugliest that he could have chosen - a challenge to Merton's epiphanic dissolution into 'otherness' at the same time as he claims a singular responsibility for the 'other'.[9] Meatyard poses a question about the intractability of the neighbour that has a particular relevance to questions of community and responsibility, especially given the emphasis that I have placed upon the impact of the face of the (dying) other in turning us from self-interest to selfless generosity. How do we open ourselves to, how do we *love*, those who are impossible to love? What do we do when the neighbour, like death itself, is impossible to accommodate? What if our neighbour is monstrous or barbaric?

Thomas Merton became famous throughout the USA with the publication of a volume of autobiography, *The Seven Storey Mountain* (1948). This described his transition from a wealthy, dissolute lifestyle to acceptance of the Catholic faith, and his entry into the Cistercian order at the monastery of Gethsemani, near Lexington. The book became an unexpected best-seller. It was followed by a series of prose meditations and poems which, coupled to his strongly held opposition to the Vietnam War, meant that Merton, for all that he belonged to an order that maintained a vow of silence, was increasingly granted access to visitors and allowed to leave the monastery for visits in the local community.[10] Merton and Meatyard first met in 1966, and the monk was immediately taken with the photographer's work. The two corresponded – with Meatyard suggesting that Merton might respond poetically to some of his images – and Merton several times visited Meatyard at work and home, whilst the Meatyard family sometimes travelled to the monastery for picnics in the grounds.[11] Discussing the central section of 'Lucybelle', James Rhem suggests that Merton's is 'a controlling memory with metaphorical power, a "presence" connecting this world and the hereafter'.[12]

Meatyard includes several members of Merton's circle in the 'Lucybelle' series (Br. Patrick Hart, Br. Don Kane and the entire family of Tommie O'Callaghan, a prominent local Catholic matriarch who often accommodated visitors to Gethsemani in her large home). I agree with Rhem about Merton's importance as a connection between the present and what ever form of 'after-life' Meatyard believed in – he was not a practising Catholic and was probably as interested in Buddhism as in forms of Christianity. I would extend this influence to the whole of 'Lucybelle Crater', however, precisely because of the way that Meatyard creates a community and calls that community into question through sameness and intractability.

In *Conjectures of a Guilty Bystander*, Merton wrote: 'In Louisville, at the corner of Fourth and Walnut, in the center of the shopping district, I was suddenly overwhelmed with the

realization that I loved all these people, that they were mine and I theirs, that we could not be alien to one another even though we were total strangers.'[13] This, of course, typifies those epiphanies that characterise much Catholic mystical writing, though Merton is more down to earth than most. There is, however, something in common here with Meatyard's project. The photographic series depicts (or, rather, defaces) an existing community, Meatyard's intellectual and familial circle, even as it serves to demarcate a new community by including strangers whom Meatyard had only just met and immediately taken to. What Meatyard goes on to do is figure Merton's transformation of relationship. In the sameness of the series – everyone *is* Lucybelle Crater – one might say 'They were mine and I theirs' because there is no longer any distinct identity. 'The Family Album of Lucybelle Crater' is also, then, self-portraiture, because everyone becomes the photographer, appearing in his place, and he is mapped onto theirs. The name is central to this 'mapping'. It is notable that the last person to wear the old man's mask is Madelyn Meatyard, the woman who in marrying the man had also assumed his name. That transference is emphasised by this image being made on the couple's twenty-fifth wedding anniversary. Furthermore, whilst Rhem rightly sees the location of this portrait in the family's grape arbour as a symbol of blood and wine – therefore developing both the idea of lineament, or inheritance, and in his evocation of T.S. Eliot's *East Coker* and *Little Gidding* presumably Christ's promise of salvation through blood sacrifice – vine leaves were not uncommon motifs on pre-Christian Roman funerary monuments, framing symbolic portals to the other world, whilst reuniting couples separated by death.[14] Moreover, as Corine Schleif shows, a tradition within Judaeo-Christian symbolism associates the grapevine both with the wood of Christ's cross (realised most beautifully in a polychromed crucifix (c. 1430) in the Lorenzkirche in Nuremberg) and a more general idea of life emerging from death.[15]

If the photographs in 'Lucybelle Crater' challenge the photographic assertion of certainty and identification, then the captions further blur the issue. Bacon's response to photography shows us that it is a medium that alienates being – 'I' - from itself. Meatyard renders this alienation explicit by never figuring or naming himself as 'I'. Nonetheless, rather than opting for the provisional temporality of the 'study' that might gesture towards a completion of the self, endlessly deferred into the future, and thereby ensure a moment-to-moment grasp by the subject of *its* space and time, Meatyard uses a constrained, but nonetheless mutable title that places him, as subject, in a community of the same, amongst, as it were, *nous autres*. As the commonality of names transfers identity between self and other, so it undermines the photograph's capacity to unite name and face. Meatyard shows - through his titles - that the captioning of the image is a form of retrospectively imposed signification. In telling us what the stillness of the image *means*, the text initiates a further play of language that the photograph, in that very arraignment of subject and moment, would seek to prevent.[16] This is no self-willed erasure of identity as inscribed subjectivity, however. Meatyard does not evade the law of photographic naming through a fantasised investment in the other that might permit the subject's equally willed restoration elsewhere, in what I have termed the work of

identifiction.[17] Rather, I would argue that in establishing a community of 'sameness' Meatyard is examining a particular, mobile, interrelation of self and other. The ethical call this makes is, necessarily here, outside the 'law', the notion that all things must have an end point – whether the stabilised signifier of the photograph, linguistic meaning in general (and therefore the 'law' of the sign) or life itself. For Meatyard, the reformed ethical relationship involves naming death not as limit, the edge of your community and life beyond which you disappear, but as part.

The name 'Lucybelle Crater' derives from a short story by the American writer Flannery O'Connor, 'The Life You Save May Be Your Own', published in her collection *A Good Man Is Hard To Find* in 1955. The central figures, along with an exploitative ne'er-do-well named Tom Shiftlet, are an old woman called *Lucynell* Crater and her mentally handicapped daughter, also called Lucynell Crater. The sentence in which the old woman introduces herself is structured exactly as the captions are for Meatyard's photographs: 'Name Lucynell Crater and daughter, Lucynell Crater.'[18] In a talk he gave about his work in 1972, Meatyard admitted to having admired O'Connor for many years, though the copy of *A Good Man Is Hard To Find* in his library dated only from 1970. James Rhem suggests that Meatyard had known the story for a long time, however, and that his first encounter with it was probably through a television dramatisation in 1957.[19]

O'Connor constructs in her story an opposition between the simplicity and sameness of the Lucynell Craters, mother and daughter, and the feckless Shiftlet. The latter's name, in itself, specifies a fluxive identity that matches his behaviour. Indeed, we might say that the name is attached not to the person – since there is no legal entity 'Tom Shiftlet' but only a set of varying appellations – but, rather, to that behaviour. Where O'Connor perhaps hoped to contrast this mobility in avoidance of the law with a stable, and horrifyingly simplistic, sameness, Meatyard skilfully dismantles the relationship. He sees in the lineament, or inheritance, of sameness a movement between self and other that accomplishes what Shiftlet, in his abandonment and appropriation of names, would like to achieve in relation to the law, and yet can never manage, precisely because his need for distinction - even in variant forms of the self - conforms to the law of identification whose constraints he seeks to escape.

There is a second literary text that exerts a profound influence on the series. Rhem notes that in 1971 the photographer wrote to the publisher Jonathan Williams, enclosing a selection of prints and the dust jacket of Gertrude Stein's book *The Making of Americans*. His letter said that this text 'states exactly what I am doing.'[20] As Rhem observes:

> Like the semi-transparent mask on the figure standing beside *Lucybelle* in each image, the captions both reveal and conceal information about the subject. Without them, *Lucybelle*'s audience cannot easily experience the series as an unfolding narrative that, in the end, folds back upon itself. As the jacket copy had said of Stein's *Making of Americans* 'the complete characters of individuals [are] reflected not in the words and thoughts...but in the MOVEMENT of words and thoughts, 'endlessly the same and different'.[21]

This movement between forms of the same is the vital issue in 'Lucybelle Crater'. Indeed, I would argue that, whereas in Barthes's conception of photography it is always the foreknowledge of death in the future that is the guaranteed return for any 'gamble' with life, for Meatyard it is this mobile relation, because death is no longer a card that I know that I, as an individual, must one day draw, but an integral part of a community, a stake we all will one day play; death is in everyone's hand.

Nancy suggests that the community of 'we others' - that impossible construction - might be constituted thus:

> All of us, *nous autres*...if we want to identify ourselves, we need to construct an identity that is not at all given by this simple 'we'. Every time, then, someone says 'we' – and who could not says 'we' if not some*one*, a single person? Who can say it if not *I* or *you*? – he formulates a request for identification. For this request he proposes or suggests traits, indices, lineaments, whereas, however, he cannot confirm in their immediate and in some ways intangible positions, which the *I*, on the contrary, does confirm in them.
>
> *I* is distinguished without remainder, like every other. *We* lays the same claim, but with the explicit character of a solicitation, a demand, a desire, or a will to distinction. *We* must construct its alterity, which is wholly other only in a tendential manner.[22]

The will to distinction within the community is not, then, in the separateness of this identity (*I* or *mine*) from that which is other and to itself *I* but, rather, in the process of movement, *tendencies*, between forms of sameness.

The name is unique to us: it is that by which we identify ourselves, and by which we are submitted to the law, in the certification of birth and of death, in our submission to juridical procedure; in the process of our 'hailing' by authority it is, for Louis Althusser, that by which we are arraigned and interpellated into ideology.[23] (It is this statutory ordering that Tom Shiftlet seeks to evade in 'The Life You Save'.) Our name precedes our birth, in that our parents choose it, and, adult, we rarely bother with the legal procedures to alter it; it succeeds our death, as residue or trace, as marker on gravestone or casket of ashes, as name on a title page, as signatory on a letter or contract. Yet no name is unique; few names in practice are unique and none necessarily is. Strangers share my name; I willingly give my name away, to my wife, who assents to take it, and to my children. As a son I might not have my father's name, but perhaps that of a grandfather or great-grandfather. Lineament begins with the name, but the identity it confers is never singular; rather, it is singular and universal at the same time. What appears static in the relationship of the Lucynell Craters, mother and daughter, is, in its 'sameness', a motif of mobility.

As we are named, so we are given up to death. The processes are imbricated; indeed, rather than being in a static but intertwined relation we might say that they *move* together in the complex patterns of a dance. Death, like my name, is at once unique – *I* will die, my

death is particular to me – and universal: we all die, so how can death be particular? Derrida remarks:

> It [the name] says death even while the bearer of it is still living. While so many codes and rites work to take away this privilege, because it is so terrifying, the proper name alone and by itself forcefully declares the unique disappearance of the unique... Death inscribes itself right in the name, but *so as* immediately to disperse itself there, so as to insinuate a strange syntax – in the name of only one to answer (as) many.[24]

In working through the universality of the name, and a minimal facial difference of one to another, then, Meatyard is also photographing a community established in the movement from one to another, and the continual presence of death inscribed in and by that movement. Meatyard not only dissolves himself amongst this community, we might say that he places *his* death *as death* amongst it. Rhem rightly sees a circularity in the series, that the last picture is also in some ways the first; what this may mean is that the cycle of life will run without us as named, self-identifying individuals. Meatyard perhaps knew T.S. Eliot's poetry well enough to know the idea of eternal return that is presented towards the end of *Little Gidding*. If not, the sentiment is similar: that the death of others is our death also and yet we are, at the same time, born with the dead.[25] We begin, as much as we end, with a gravestone that is, through time, unreadable; even in the stasis of death we belong – *as lineament, as meaning* - to a mobile community (hence Eliot's invocation of the dance in his preceding lines) in the most tangential sense, once named and yet utterly general.

If I am, in some sense, already my neighbour, and my neighbour is me, 'Who then' – to resubmit the question presented by the lawyer to Jesus in Matthew's gospel – 'is my neighbour?' In its dispersal through the language by which we describe ourselves, *nous autres,* is death necessarily my neighbour too? Do the terms of the community of belonging that Christianity solicits in fact negate the possibility of neighbourliness as we might conventionally understand it? Framed thus, 'The Family Album of Lucybelle Crater' might be seen as testing a fundamental tenet of Merton's thought. Certainly, Merton's interpretation of Christ's parable is one that refuses distinction at all levels. The lawyer asks ostensibly that he may know who is, and who is not, an object worthy of love; in other words, he seeks the boundaries of his community. Such a definition is one of political theology: it is Carl Schmitt's, for example, distinguishing between friend and enemy on the grounds not necessarily of morality or aesthetics but of difference, alienation and estrangement.[26] Merton understands Christ's answer to the lawyer's question as abolishing the concept of distinction, and indeed the concept of the Law *as law*: 'Christ does not tell the scribe how to judge and classify but teaches him that classifications are without significance in this matter of love. For we do not and cannot love according to classifications.'[27] For Merton, love cannot be dependent on the reciprocation of an originating, external good, nor the condition of shared culture or beliefs. So, we cannot love according to Law, yet the first commandment of the Law enjoins us, in part,

to love. In order to obey it we must corrode the very categories of difference on which it seems to rest.

Merton uses a confusion of name and identity to undermine the discrimination that the lawyer seeks. He points to a community that exists, as it were, in the negative, for 'neither the Jew nor the Samaritan is our neighbor in any exclusive or comforting sense'.[28] Merton's conclusion, however, is that meaning in the parable of the 'good Samaritan' resides not in understanding that the 'other' may be capable of an act of love towards us, but in the recognition that through divine mercy (Merton emphasises the Hebrew *chesed,* which invokes not only mercy but fidelity and strength, specifically as a divine attribute) we may be capable of receiving it as much as giving it. The exchange with the neighbour is then with one who is as, or is, ourselves. Merton writes: 'In the end, it is Christ Himself who lies wounded by the roadside. It is Christ who comes by in the person of the Samaritan. And Christ is the bond, the compassion and the understanding between them.'[29] Neighbourliness, and indeed the very notion of community, is, then, a community of the same – in Merton's terms, the Christian community. Love here is not predicated upon an extension of its boundaries, or the boundaries of self, so that some others may be loved, but by an abolition of the concept of boundary, *as boundary between self and other.*

In the question this raises of hospitality and responsibility we can recognise a political dimension - relevant to the contexts of contemporary neoliberal societies - that will be a growing theme throughout the remainder of this book. Derrida's thought about ethical responsibility for the other develops and diverges from that of Levinas at precisely this point, and it does so in terms that Merton defines and Meatyard allegorises. This responsibility, expressed as 'unconditional hospitality' – a responsibility for the other without limit – is both understood and enacted by Derrida as a political one. This is reflected in his remark that his discussion of the 'stranger' is a 'to-and-fro' between the urgent matters of the present and the tradition from which we derived the concepts, vocabulary and axioms that inform Western culture.[30]

Derrida's argument hinges on the Athenian discrimination between the rights assigned under law to the foreigner, who is named, and those who are wholly other, outside the law, unnamed, or, rather, named only 'barbarians'.[31] Like the Lucybelle Craters, those who are completely alien to us have only one name between them and cannot, by name, distinguish amongst themselves. In accepting the other, then, in obeying the law of hospitality, there is a necessary breach of the Law which does not recognise the other. We can see this at work in the parable of the Good Samaritan, where the Jewish priest is, perhaps, not indifferent to the man's suffering but is constrained by the Law, fearing that he may be contaminated with impure blood. The Samaritan, outside the Law, acts unconditionally. Derrida remarks of hospitality that it

must not pay a debt, or be governed by a duty: it is gracious and 'must' not open itself to the guest (invited or visitor), either 'conforming to duty' or even, to use the

Kantian distinction again, 'out of duty'. This unconditional hospitality, if such a thing is thinkable, would then be a law without imperative, without order and without duty. A law without law, in short.[32]

A community that offers hospitality cannot define its hospitality in the political and juridical terms of community, for the same reason that, for Merton, love cannot be so constrained. If such qualifications are applied it is not only hospitality that fails; it might be said that it is community itself.

This offering of hospitality has profound consequences for the host. Reciprocity is established with the one who has nothing to give. What is 'given' is not an object or love in return but, rather, an effect upon the host, a rupture of self-identity. Discussing Sophocles's *Oedipus at Colonus*, Derrida highlights an ambiguity in the Greek *xenoi* ('stranger'), which describes both Oedipus and Antigone seeking refuge in the city, and their hosts.[33] This confusion reaches its apogee towards the end of the play, when Oedipus, guiding Theseus to the secret place where he wishes to buried, calls his host *philtate xenon*, which might be translated as 'beloved foreigner' rather than 'beloved host'.[34] Thus the identity of the host is contingent on the relation to the guest. Both have the same name; both are, in a sense, strangers. The reciprocity of hospitality unsettles the subject's definition of itself and its boundaries.

Levinas similarly sees the demand of the other in terms of an interruption to subjectivity, but does not argue this effect in a shift from ethical to political relation. As Slavoj Žižek observes, 'The responsibility for the other...is, for Levinas, asymmetrical and nonreciprocal'.[35] This bias allows Levinas's insistence on the separation of ethics and politics, where the latter is conceived as the ideal of equity, and the former is strictly a regime that makes a demand of me, without return. Derrida's introduction of reciprocity allows us, perhaps, to rethink the relation of politics and ethics. That reciprocity is not achieved through the agency of the other. To be a host one is already the guest, the stranger: as Anne Dufourmantelle puts it in her commentary on Derrida, above all hospitality can be conceived only if the host is 'without a dwelling from which this welcome could be conceived'.[36] This is both the condition of the Christian community for Merton, and Meatyard's photographic community of interrupted selves and shared name. The exchange within this community, the traffic of love and identity, is motivated by the equal vulnerability of its members, not by the demands of an ideally equitable justice.

This sameness challenges Merton's ideas of the impossibility of alienation from the stranger, however. What, Meatyard seems to be asking, if your 'everyone', your neighbour, is as ugly as death itself? Where is your love when your neighbour is monstrously alien? Žižek raises a similar challenge, seeing in Levinas's use of the face a 'gentrification' of 'the terrifying Thing that is the ultimate reality of our neighbor'.[37]

As Žižek asks:

What if the neighbor's face stands neither for my imaginary double/semblant nor for the purely symbolic abstract 'partner in communication', but for the Other in his or her dimension of the Real? What if, along these lines, we restore to the Levinasian 'face' all its monstrosity: face is not a harmonious Whole of the dazzling epiphany of a 'human face', face is something the glimpse of which we get when we stumble upon a grotesquely distorted face, a face in the grip of a disgusting tic or grimace, a face which, precisely, confronts us when the neighbor 'loses his face'?[38]

Meatyard might be said to strip the face of those ameliorating properties that Žižek sees in Levinas – not least because he is, in dying, 'losing his face'. Dying, he is exposed to the Lacanian dimension of the Real - yet his reduction is not to a binary of subject/Other, but to a coupling in which each is equally monstrous and yet demands to be loved.

Žižek lights on the 'Muselmann' - that figure of the Nazi death camps described so effectively by Giorgio Agamben as one of the 'living dead', surviving, yet wholly beyond life - as if it 'signals the limitation of Levinas'.[39] 'The *Muselmann* is a limit figure of a special kind, in which not only categories such as dignity and respect but even the very idea of an ethical limit lose their meaning.'[40] Žižek, rightly, says that it 'would be obscene to proclaim pathetically, "We are all *Muselmänner*!".[41] His argument is predicated on what he terms the 'gesture of identification with the exemplary victim'.[42] Nevertheless, the relation to the other in Levinas's thought (and, indeed, in Merton's and Derrida's) does not reside in any form of recuperable identification by a secure subject with the other. (That indeed would be a gesture of *identifiction*; one typical of narcissistic identity 'politics' in the 1990s.) Like Merton dealing with neighbourly love, Levinas dismisses the grounds of relation of self to other through identification: to see the other as me because of shared characteristics or because the other possesses characteristics that I too would like to possess.[43] The encounter is not grounded in the *establishing* of relation but, rather, through the *annihilation of all figured grounds* for relation. (And in that emphasis I am implying an annihilation of representation that is, of course, exactly that practised by Meatyard in 'Lucybelle Crater'.)

The *Muselmann* is, in its impossibility, precisely the figure *to be* loved, even if that figure can neither be loved nor reciprocate our love. This is the extremity, the impossibility of Christ's figure of the neighbour; a figuring without figuration – the neighbour is never outlined for us - and the 'impossibility' of a 'Christian' politics. The demand to love does not proceed from an interruption of our identity to say 'We are *Muselmänner* too' on the basis that we assume their characteristics from a privileged difference – any more than we may recognise our commonality of an African immigrant seeking access to Europe, or an Afghan imprisoned beyond justice in Guantanamo or tortured in some offshore prison, or the suicide bombers of Iraq, an Auschwitz guard or an imperial soldier faceless behind glasses, mask and body armour. Rather, it implies that there is a porous boundary between the historical possibility of 'us'

and *Muselmänner*, or refugees, or abductees, or soldiers, and that we therefore are as easily a killer as a victim, a stranger as a host.

At stake in Meatyard's work is not a community of *sameness* – that, after all, is what the lawyer wanted - but the question of what kinds of extreme difference might be accommodated under the rubric of a community of the same. The call that Merton makes is the 'impossible' call of Christianity, in contrast to the Mosaic Law, that there are no enemies. Meatyard challenges and enacts this by dissolving difference in favour of sameness, and establishing a community in which all are truly monstrous, both in the manner of their recognition (grotesque name and grotesque face) and *because* their sameness precludes recognition. The community could - *must* – include, must love, that which is monstrous to it, that which is its enemy. It thus includes that which would destroy it; it must acknowledge that death has the same name and the same face. To say 'We are all death' is not to make a gesture of illusory identification with the other but to recognise identity. In Merton's terms, and in Meatyard's, death cannot be estranged from us, for to accept the other as other is both to accept his/her death as my death and indeed to premise our labour in the world upon it. Meatyard seems to ask if this is truly possible: can something as monstrous, as alien, *as my death* belong amongst others? Can I give it the same name and the same face as them? Can I look at a face that is wholly repugnant to me, a face that is perhaps beyond vision, and acknowledge it?

Quid petis?
Misericordia.

Chapter 6

Derek Jarman

And thence retire me to Milan where, Every third thought shall be my grave. (Prospero, The Tempest)

In the early 1990s Derek Jarman (1942-1994) began work on a new series of paintings, paintings that he knew would be amongst the last art works that he made. Jarman was a ferociously talented polymath and provocateur. Having studied painting and drawing at the Slade in the 1960s (after pursuing the BA in history on which his father insisted), he developed into a painter, filmmaker, writer and stage designer whose aesthetics were often out of step with the fashions of the day, and whose politics angrily at odds with its dominant discourses. Few other filmmakers could have so successfully drawn together the Renaissance transformation of mysticism into science, the entrepreneurial nihilism of punk rock, and a dystopian yet fond vision of Britain as Jarman did between *Jubilee* (1978) and *The Last of England* (1987). Different elements of those films were often to be found both in Jarman's delicate Super-8 films of the early to mid-1970s – there are clear connections between *Journey to Avebury* (1971-72), *The Art of Mirrors* (1973) and *In the Shadow of the Sun* (1973/1980) and the temporal and spatial shifts that characterise the end of *Jubilee* – and in his paintings, whether the landscapes of the early 1970s, or the 'alchemical' works shown at Edward Totah Gallery in 1982 that parallel his fascination with the figure of the Renaissance magus in *The Tempest* (1979).

In spite of this diversity, as Gray Watson observes, 'there is a sense in which Jarman was always essentially a painter'.[1] It was his sensitivity towards traditional virtues of colour and form, rather than the theatrical straightjacket of storytelling, that informed his films. It was to painting that he returned at the end of his life: at the same time he would make a film, *Blue*, that, perhaps more than any other before or since, fully exploited the properties of colour and

explored the relation of form to narrative. Like the paintings, *Blue* would be a meditation on the artist's illness and impending death, but would also be a response to history. The paintings were an outraged assault on the crude homophobia of certain newspapers, and the emergence of a 'tabloid culture' in Britain in the 1980s that had largely erased what Jarman viewed (through particularly roseate lenses, I would suggest) as a more sensitive and tolerant British identity. *Blue*, by contrast, was intimate and delicate; despite the competing elements of its soundtrack, a piece spoken rather than shouted, a personal accounting for one's dying, and especially for the blindness that afflicted the artist in the last year of his life. I suggest, however, that both paintings and film are equally informed by the figure of 'writing' through colour: in the former by a palimpsest of printed text and monochromic paint, where further writing is incised into the surface; in the latter by the relation of the artist's diaries, used as script, to a single colour rather than to an image. I use the tropes of depth and surface that inform Jarman's filmic and painterly 'writing' here, amplified by the writing of his late notebooks and diaries, to exemplify a problematic relation of language to death: one of simultaneous access and refusal, of being there and not being, that is in all cases a being or not being in relation to others, to a community. Very often this is a community that is latent, one that is yet to come. Jarman, I would argue, understood something of this at first hand; dying, he knew that language could not grasp death, but also knew that its failure to name experience adequately nonetheless left open through allegory, always, the possibility of language that might come afterwards. For Jarman, this potential resided in the visual, in particular in colour, whether the flowers in his Dungeness garden or the angry monochromes of the 'queer' paintings and the quiet, iridescent screen of his final film. This is the point, or, rather, the surface inhabited by the artist's avatars of colour and voice, the tympanum that is *Blue*, a trembling, uncertain and finally unnameable boundary between vision and voice, before and after, here and there, life and death.

By the early 1990s, having been diagnosed as HIV-positive in late 1986, Jarman had developed a number of AIDS-related illnesses. These would leave him in acute pain, and would eventually lead to disablement and blindness. As a queer man who had already witnessed the deaths of many close friends through the previous decade, in the years before retroviral drugs had been developed that might almost wholly arrest the effects of the syndrome, Jarman was well aware of his own, impending death.[2] In July 1991 he wrote: 'I can never quite forget my illness, it gives a finality to every gesture.'[3] The late paintings are suffused with that awareness; Watson remarks that Jarman had several times spoken with fondness about the late *papiers découpés* made by Henri Matisse (1869-1954) in his last years, and suggests that there is a surprising affinity between him and Jarman in a common resourcefulness with deliberately limited materials.[4] Where the bedridden French master occupied himself in old age with formal experiments in colour and pattern, however, Jarman's late paintings are characterised by what Stuart Morgan called 'a scream of rage'.[5] That rage is not, however, simply directed by Jarman against his own death as unnecessary or premature. Rather, it is a rebarbative anger against

the characterisation of HIV and AIDS as a synecdoche for homosexuality by the media of the neoliberal public sphere, an anger returned to that domain through Jarman's visibility as public figure. The artist's own inevitable death, as one death amongst many, and a form of death that, in its specificity, had come to define and fissure a community, is given a political dimension: painting becomes a surface through which prejudice is revealed and in which a rejoinder may be incised.

Several of the most important paintings in what Jarman called his 'Queer' series (appropriating homophobic insult as an affirmative mark of identity) are palimpsests: they consist of a number of layers, in which one obscures another yet leaves it partially legible. In both *Blood* (1992) and *Letter to the Minister* (1992) the initial layer is composed of multiple photocopies laid onto canvas of a front page of the *Sun* 'newspaper', one of the principal British brands of the global media corporation News International. Morgan sees this grid of pages as an appropriation of modernist compositional strategy that Jarman then subverts and destroys.[6] We are familiar with this approach to the sensational mass-media text and image from Warhol's silk screens, with their attention to the commoditisation of human experience (including death in *129 Die in Jet* (1962), *Tuna Fish Disaster* (1963) and various manifestations of car crashes and electric chairs) and subjectivity itself (in the form of the star). Jarman,

6. Derek Jarman, *Letter to the Minister* (1992).

however, covers these prints with monochromatic layers of oil paint – in *Blood* with a dark red, in *Letter to the Minister* with a yellow laid over a heavily thinned patch of red that is limited to the central and lower left side of the canvas. These monochromes are so applied, however, that through dilution and application of the paint the newspaper headlines and subordinate titles remain visible.

This introduction of colour to the black and white documentation of the world is very different from Warhol's colouring of his silk screens in order to emphasise both sameness and indifference through repetition. Jarman's monochromes are profoundly expressionist, at odds with Warhol's cool parody of consumerism, the formalism of colour field painting and Frank Stella's brand of minimalism. The brushwork in *Letter to the Minister* is especially emphatic, with its red undercoat creating a flame-like effect across the surface of newsprint. Jarman becomes yet more expressionistic; both surfaces are covered with a

crudely scrawled writing. In the eponymous *Blood* the word is repeated again and again in closely packed lower case. It is inscribed into the colour field, rather than painted on, so that the artist's writing reveals the white page and text beneath. *Letter to the Minister* by contrast is written in charcoal in large, crude black capitals across the lower two-thirds of the painting:

COPIES SENT TO THE ARTS MINISTER
DEAR WILLIAM SHAKESPEARE
I AM A 14 YEAR OLD AND I'M
QUEER LIKE YOU I'M LEARNING
ART I WANTED TO BE A QUEER ARTIST
LIKE LEONARDO OR MICHELANGELO
BUT I LIKE FRANCIS BACON BEST
I READ ALLEN GINSBERG RIMBAUD
I LOVE TCHAIKOVSKY IF I MAKE FILMS
I WILL MAKE THEM LIKE EISENSTEIN MURNAU
PASOLINI VISCONTI LOVE FROM DEREK

Letters to establishment figures in newspapers are, of course, a characteristic of British public life, though they do not often feature on the letters page of the *Sun*. There one is far more likely to encounter crudely articulated sentiments that largely reflect the crudely articulated sentiments of its banner headlines. It is these sentiments that Jarman, in writing over, or defacing, the newspaper, might be understood to parody and invert. I would suggest, however, that there is a further and more complex process of parody at work in these paintings, one that reconnects the formalism of high modernist abstraction - which, if it *represented* anything, most often represented an abrogation of historical concern and commitment – with historical discourse.

Jarman indeed begins with the aesthetic foundation of the grid, but then extends into those other formalist strategies of modernist painting, the monochrome and calligraphy. Morgan suggested that the 'Queer' paintings seemed 'perilously similar to pastiches of Abstract Expressionism, the *lingua franca* of Jarman's art school years'[7] and close in their haste and spontaneity of execution to received ideas of Jackson Pollock's working practice (if not to its reality). The paintings for the 'Queer' exhibition in Manchester in May 1992 were made at speed; according to his diary, Jarman and his assistants made seventeen between March 2nd and April 21st, using ten for the show. They were, as the artist put it, 'painted...fast and loose through the popular press'.[8] Jarman would, however, carry on making this kind of painting for some months after the exhibition, for example producing *For Richer for Poorer* (based on a *Daily Mirror* headline) in July. As much as Pollock, we might see minimalism's disavowal of historical responsibility as one of Jarman's targets: at one point he executes an all-white painting (*Jason Death Threat Kiss*, 1992) in the manner of Robert Ryman, based on the pop singer

Jason Donovan's court case against the *Face* magazine after it mistakenly alleged that he was homosexual.[9]

'Writing' in late modernist painting – the not-so-spontaneous calligraphy of abstract expressionism and its successor movements – whether in the curve and break of Pollock's pours and splashes, the ponderous hieroglyphs of Franz Kline, or Cy Twombly's scribbled arabesques, is a figure of escape from the present moment into an artifice of foundation myths, and from responsibility towards one's historical circumstances. Twombly's writing, which often depends on exactly the kind of textual repetition that characterises *Blood*, seems to me to be a likely model for Jarman's parody and a target for critique even after the 'Queer' series, when he embarks upon his 'Evil Queen' paintings. This is not least because Twombly's aesthetic is sustained by a romantically distanced, dilettantish vision of the classical Mediterranean world that parallels a highly cultivated, and one might say characteristically gay, aesthetic sensibility equally distanced from history and activism. The lettering in *Fuck Me Blind* (1993) – made when Jarman was developing the pernicious symptoms of cytomegalovirus, which include blindness – is inscribed in the paint by the artist's finger. It is as if, deprived of the sense of sight, the artist must proceed by touch. Jarman uses multiple inscriptions for each stem and branch of each letter, so that each is composed of four or five offset and intersecting marks, in exactly the manner used by Twombly in *Apollo* (1975). Equally, a painting such as Jarman's *Scream* (1993) - which Morgan saw as a response to Edvard Munch's late nineteenth-century expressionism – could be understood as a paradoxical rendering of the formal experiments in colour relationships that characterised Kenneth Noland's circle paintings in the late 1950s. One is almost inevitably drawn to the theorisation of those paintings as somehow figuring abstracted points of origin in much the same way as Barnett Newman's 'zips' were read as representational gestures towards a primal human, with such claims being bolstered by Noland's own titles, for example *Beginning* (1958). *Scream*, painted some seven months

before his death, represented a closure for Jarman, a tunnelling of vision into a blinded, monochromic void. (As Jarman would put it in the script for *Blue* and the text of *Chroma*: 'We end in deathly grey.')[10]

These paintings are, however, neither *simply* formal responses to the disengagement of painting from the utopian aspirations of modernism before 1945 nor angry responses to their painter's illness and dying (though they do both those things). As Jarman wrote: 'My paintings are social realism – they show the collision between the unreality of the popular press and the state of mind of someone with AIDS.'[11] They are an address to history by a dying man. But what kind of history

7. Derek Jarman, *Scream* (1993).

is it that Jarman wants to deal with through his subversion of modernist aesthetics? It is at once one that is supremely local and connected to his own queer identity, and one that is general, reflecting on the debasement of the traditions of British culture by the economic forces of late capitalism. Jarman had never been afraid to identify himself as homosexual; as the full effects of AIDS on his community became apparent, accompanied by widespread homophobia, he became an increasingly prominent activist. With his own diagnosis, as he put it himself, his 'body was thrown into the struggle'.[12]

What was being struggled against is exemplified by the grid of newspapers that form the first layers of *Blood* and *Letter to the Minister*. The *Sun* headline ran: '"AIDS Blood in M&S Pies" Plot'. Jarman responds to the fear of contaminated blood, and the demonising of people with AIDS as potentially infective carriers of plague, with hyperbole; his painting and his text immerses the newspaper in symbols of that of which it is most afraid, and yet that which – in the manic reaction to homosexuals that the newspaper fostered – it seemed most to want. The *Sun* headline underneath *Letter to the Minister*, ran: 'Vile Book in School – pupils see pictures of gay lovers'. The broader context for this story concerned a wider discursive pressure on homosexual lifestyles, increasing throughout the 1980s, that had culminated in an amendment to the Local Government Act of 1988. This legislation forbade local authorities (and therefore schools) from intentionally promoting homosexuality or 'the acceptability of homosexuality as a pretended family relationship'.[13] Whilst the Conservative government of the 1980s was concerned to re-establish what it saw as proper moral values and emphasise conventional family life, predicated on heterosexual relationships, it initially resisted a privately sponsored bill to this effect. The eventual adoption of the interdiction could be seen as a consequence of an increasingly extreme discourse against gay lifestyles, however. The *Sun* was an important conduit for that discourse, and indeed helped to propagate it. The wider importance of the paper to the government made such a campaign hard to ignore. (The *Sun* had been crucial to Conservative election victories in 1979, 1983 and 1987, giving the party and leader Margaret Thatcher its complete endorsement, and had supported Britain's military adventure against Argentina in 1982 with a display of jingoism so forthright that the original Victorian opinions of G.W. Hunt seemed mild-mannered.)

In responding to the newspaper's headline in 1992, however, Jarman is making clear that the war on homosexuality that the *Sun* had been waging for more than a decade was also an assault on culture. Jarman's use of yellow in *Letter to the Minister* might refer, symbolically, to bile or to the jaundiced opinions purveyed by the newspaper, as much as it might be a metaphor for his own sickness. In *Chroma* Jarman consistently writes of yellow as a pernicious colour, and associates the British tabloids with the 'Yellow Press', that tradition of 'warmongering and xenophobic' mass-publication that is less concerned with the truth and the rational constitution of public debate than with events (or fake events) as cheap, entertaining, and profitable, spectacle.[14] Combined with the red under-painting and the diagonally aligned brushwork that runs across the painting from bottom left to top right

with varying density, it is hard to read this surface as anything other than the flames to which the newspaper's demagogues and their readers might happily consign both the 'vile book' and homosexuals – especially since, as Jarman observes, the charcoal used for the lettering muddied the still-wet paint, creating an effect of smoke in the lower half of the canvas.[15] Nonetheless, as Jarman's 'letter to the minister' alludes - albeit in the style of a 'corrupted' fourteen-year-old schoolboy – the prohibition of homosexuality, whether as practice, as culture or as family relationship, involves an interdiction, or a best a highly selective reading of culture, because so much of Western culture depends on the homosexuality of its producers.

Jarman sends this written address to a government minister as a painting rather than as a letter. That is, it is sent in a form unlikely to have any discursive impact. The neutering of art in the 1980s meant that it existed as an economic object (whether as entertainment within a growing culture industry or as high-value token of wealth) but could not be acknowledged as a cultural form with any relevance to history. The sardonic virtue of Jarman's gesture must be emphasised here, especially since it is expressed not in the carefully modulated phrases of a conventional letter of protest or dissent in the public sphere, but in an inversion of the sentiments, and a parody of the writing styles, that one might find in the *Sun*. It could not have escaped Jarman's notice that the *Sun*'s parent company, News International, had also since 1981 owned the *Times* and *Sunday Times* – the traditional papers for the publication of letters that contributed to debate in the public sphere – and was gradually turning them from journals of political debate into organs that popularised a neoliberal business ethic. A letter to the minister, written by Jarman or similar publicly visible homosexuals, was unlikely to be published in the *Times* in 1992, and, had it been, little notice would have been paid because the minister in question was more likely to be attentive to headlines in the *Sun*.

If Jarman palimpsests mass-media and modernist formalism as a structure for historical intervention, one might say that that palimpsest is mirrored in the paintings' themes. He manages to lay, one upon the other, the marginalisation and persecution of homosexuality, the neoliberal debasement of the historical agency of culture (itself a largely illusory, utopian notion) into commodity forms, a concomitant erasure of British culture and identity, and his own death. His artist's statement for the exhibition 'Queer' suggests that the paintings are simultaneously personal and political, a rediscovery of the need to 'paint large and public'.[16] They are both about Jarman's life as a queer man, persecuted and marginalised in a society from which he felt ever more alienated, and a witness to the deaths of others, persecuted and marginalised queer (and gay) men, harassed, and transformed into a demonised spectacle, by the dominant discourses of what was passing for the public sphere in a neoliberal society.

My spirit guide is Goya, 'I saw this', this is the present in which my friends were lost, they died in these headlines behind the cups of sugary tea. Which blood? Which books? What revenge? What vice? What virtue? [...] Tears fall behind the headlines.

'Discover yourself' they said at school, I found a terrible subject. Was my sex ever safe? There were no queers in *Coronation Street* which had nothing to do with my life, I lived in other and better Englands, this is no soap.[17]

Those 'other and better Englands' are a clue to Jarman's vision of a country whose cultural values had been corroded and finally destroyed by the arrival of neoliberal economics in the 1980s, with the governments of Margaret Thatcher, and the parallel subsuming of the public sphere – once a potential arena of rational exchange - into a site of cheap spectacle, with the *Sun* and commercial television as exemplars of this degradation. As he would put it in his diaries: 'All the good and honest England is betrayed.'[18] For Jarman, the tabloid war on homosexuality – and especially the war on 'queer' identities – degrades culture. The loss of that older England is already being bemoaned in his diaries of the mid 1980s:

In the short space of my lifetime I've seen the destruction of the landscape through commercialisation, a destruction so complete that fragments are preserved as if in a museum. (...) The land of England was once the home of dryads and nymphs. Every now and then you can feel the last of them lurking around a corner at Dancing Ledge, at Winspit.[19]

A line from Cardinal Borgia Ginz (who owns the media in Jarman's film *Jubilee*) sums up the effect of neoliberalism on the public sphere – the substitution of entertainment and profit for communication and culture. 'This is the generation who forgot how to lead their lives. They were so busy watching my endless movie. [...] The media became their only reality, and I owned the world of flickering shadows – BBC, TUC, ATV, ABC, ITV, CIA, CBA, NFT, MGM, KGB, C. of E... I bought them all and rearranged the alphabet.'[20] Elsewhere, the betrayal is identified as a broken promise to a generation who might have redeemed what was to Jarman, in many of its aspects, a 'rotten privileged imperial society'[21] and 'a degenerate establishment.'[22] In a diary entry from May 1992, written after a trip to St Bartholomew's Hospital, Jarman writes tenderly of the elderly people in the waiting room of the X-Ray department:

The Ediths and Bills fascinated me, their struggle to maintain a threadbare gentility under the assault of the last years of their lives, values and pockets made me sad. I imagined them as young men joining up in 1939 and their vibrant young girlfriends and wives struggling to make do with hope in their hearts – you could see that hope betrayed.[23]

Here Jarman is writing of his parents' generation (the previous day's diary entry deals with his father's wartime service in the RAF), but Jarman uses scenarios drawn from hospital waiting rooms to construct mirror images of himself – that is, to write autobiographically through others. Here he not only projects himself back into his father's place, he creates a figurative compression that allows him to mark the betrayal of *his* generation by repressive

moral values and an impoverished National Health Service (that great beacon of post-war social reform). This preceding generation is also a kind of moral refuge for Jarman against a growing alienation from his own time.

It is worth remembering that Jarman began as a landscape painter – albeit with non-naturalistic landscapes. In films such as *Journey to Avebury* (1972) as much as with his paintings (or engravings such as *Archaeologies* (1977)) he would mark himself as a successor to Paul Nash in his imagination of time embedded in the environment. It is perhaps too easy to criticise his vision of 'Albion' as manifested in *Jubilee* or *The Last of England* and the painting series 'GBH', for it is fomented by oddly conservative, and at times naïve, nostalgia. There is a construction of myth within his œuvre, based on a highly particular reading of history (at its most obvious in parts of *Edward II*), a love of landscape and traditional architecture, an oscillating relationship with religion, especially Anglicanism, that contrasts its historical legacy with authoritarian hierarchy, and a profound investment in the culture of Elizabethan England. Discussing his film *The Angelic Conversation*, based on the sonnets, Jarman would describe Shakespeare as 'the essential pivot of our culture'.[24] Albion, as synecdoche for a wider tradition of classical culture, is always in decay, under attack by modernity. Jarman would date the moment when 'the Renaissance...at last succumbed to the air-conditioned nightmare of Pop' to 1965, when the Slade dismantled its antique room, but that was only one stop along the way.[25] His body may have been committed to the struggle only with the onset of AIDS, but, intellectually, Jarman had always opposed the encroachment of a banal, capitalist modernity on educated, sophisticated culture – even if that culture could be framed only in idyllic terms. The 'Queer' paintings are the most explicit statement in that opposition, precisely because of their embodiment and frantic response to historical events, but they are in continuity with the whole of Jarman's œuvre.

Jarman's comment about the dryads and nymphs that might still haunt the cliff edge paths of his beloved Isle of Purbeck evokes a marginal survival of the magical spirits of the older, better, England. We see a similar flight to the margins at the end of *Jubilee* when Elizabeth I and her magus, John Dee, leave London and the random violence of modernity for the Dorset coast. Jarman's interest in Dee and other Renaissance figures who dangerously (for both Church and state) combined spiritual researches with scientific practice is important to *Jubilee* and *The Tempest*, and surfaces in an alchemical influence on his paintings.[26] We might consider Dee as a linking figure through which to understand Jarman's own 'flight to the margins' and his final scientific and mystical - that is to say, 'alchemical' - film, *Blue*. The early modern era was a moment when the garden became an expressive form, often designed with symbolic meaning in its arrangements. Jarman's own garden, on the Kent coast, is another and better England. Founded in the shingle beside a beach cottage at Dungeness, it would become both the site for his marginalisation and a source of meaning, through colour, that would infuse his final film as much as it did the paintings.[27] We get a hint of this in the final scenes of *Jubilee*:

Dee: I signed myself with rosemary, true alexipharmic against your enemies.
Elizabeth: And I with yellow celandine, true gold of the new spring of learning. [...]
You laid a path through treachery...
Dee: Sweet Majesty, to me you are the celandine now as then before, balm against
all melancholy.[28]

With the progressive deterioration of his sight, by 1993 yellow would be a perilous colour
for Jarman, with few redeeming features. In a diary entry from June 1992, however he notes:
'The bees have settled and bring back three types of pollen, deep-yellow, mid-yellow and
almost white, the green pollen has disappeared – it must have been the crambe that produced
it.'[29] There is an important degree of specificity here, in the discrimination of the exact tones
and colours of pollen, and its relation to nature. Again and again the diaries of the last two
years of Jarman's life (and the book that would be published posthumously as *Chroma*) pay
detailed attention to colour. In interpreting the 'Queer' paintings as monochromes, then, we
should perhaps pay heed to this sensitivity. For Jarman, colour has a spiritual or symbolic
meaning that can be traced back into the films of the 1970s.[30] Whilst the formal property of
colour in the paintings may be resolutely modernist, it is endowed with a set of latent meanings,
which are by the early 1990s particularly associated with the artist's physical condition.

I want to draw attention here to two remarks that impinge on sickness and painting. On
24 June 1992 Jarman writes: 'We all returned to London at three. Ken and I had cakes at
Bertaux's and visited Cornellison, buying some bright pigments – rose-madder was sold out,
but I found a rare permanent-green that dazzled the retina.'[31] Jarman's comment about being
dazzled by a green pigment is prescient. By August he is describing the blinding effects of an
examination for lesions on the retina. At that point he confesses that he had imagined this
moment (the diagnosis of eventual blindness) ever since the confirmation in 1986 that he was
HIV-positive.[32] It is possible that, even in late June, Jarman was experiencing some of the
first symptoms of the lesions, but 'dazzling' here may well have a double meaning, playing
between the beauty of pure colour and the crippling of vision. Perhaps more important,
however, is the analogy Jarman makes between paint – 'permanent-green' - garden and
health. Later in the same day he writes: 'I plant the garden and will be here next June.'[33] The
permanence of the pigment is also a permanence of cultivated nature and its cultivator. If, in
their design and careful planting, their subtle symbolism, we might understand Renaissance
gardens as a form of art shaped by the constraints of courtly discourse as much as any
portrait, we might equally see those English gardens of the modern era fashioned by a single
figure – Jarman, Christopher Lloyd at Great Dixter, Gertrude Jekyll at Munstead Wood, Vita
Sackville-West at Sissinghurst – as forms of personal expression. Ultimately, Jarman's
Dungeness garden does endure after his death, a communication of abstract and symbolic
values that goes on after the deaths of the gardener and all those who he might have imagined
seeing it: in this sense Jarman's garden is a form of 'writing' that parallels his writing in film,

in paint and in his diaries. Here the garden becomes a point of resistance to death and a way of going beyond it. Jarman would have known that, even if he endured into June 1993 (he would die in February 1994), he was likely to die within a few years. He would, equally, have known that both garden and diary entry would survive him in the public domain.

The film *Blue*, initiated in August 1992 though older in its conception, is in some ways a self-consciously late work, in the manner of artists nearing the end of their lives. Although Jarman had been quick to ridicule previous commentaries on his 'last film' or 'last painting' – where critics assumed that anyone with AIDS must necessarily be at death's door, or in some cases perhaps wished the artist already dead – he eventually understood *Blue* in this way. In an interview he commented: 'There are no plans to do another one. It's a good end film.'[34] *Blue* is in some ways a summation, containing many of the ideas that informed Jarman's œuvre. It addresses ideas of alchemy and spirituality, describing itself as 'an open door to soul, an infinite possibility becoming tangible';[35] it offers the violence of contemporary history as a context for the struggle for survival by a marginalised group (queer men) that to Jarman represent the values of an older, forgotten England, and presents us with a young male witness to events (the boy 'Blue') who is in many ways an avatar for the artist. Like some artists in their late works, however – and I'm thinking here of Beethoven in his late string quartets and Philip Guston's return to figurative painting – Jarman deliberately breaks with formal traditions that he has established for himself over a lifetime. Like those artists, Jarman relates this innovation (an innovation that is in many ways a laying waste to the conventions of his medium) to the catastrophe of history. *Blue* is not a film in which the artist reconciles himself to death, in which that act of reconciliation – the recognition that one must die, leading to a kind of laying hold of one's death, as Heidegger might have it – allows for a final, uninhibited expression of subjectivity.[36] Where Beethoven introduces dissonance where once he would have used harmony, Jarman, with so much invested in the composition of his filmic images, makes a film without images at all - a film with a monochromic blue screen, which is, therefore, a film without movement. Jarman wrote of *The Tempest* that 'we paint pictures, frame each static shot and allow the play to unfold in them as within a proscenium arch'[37] – and one might, often, describe his films as figurative painting, either in their reference to a historical tradition (Nash in *Journey to Avebury*) or specific subject matter (*Caravaggio*). By August 1992 he would write: 'I decided to make *Blue* without images – they hinder the imagination and beg a narrative and suffocate with arbitrary charm, the admirable austerity of the void.'[38]

Jarman had toyed for some years with the idea of making a film about Yves Klein's fascination with blue as pure colour.[39] Klein's 1957 exhibition 'Monochrome Proposition, Blue Period' had used eleven identical ultramarine panels, hung from stanchions rather than on the gallery walls, differing only in texture and price. This was not, however, a formal statement about colour by the artist along the lines of minimalist presentation. Klein was profoundly interested in Rosicrucianism, and we might see him as investing the monochrome with claims to spiritual value that attempted to legitimate abstraction within his own ultra-conservative

politics, whilst negating the formal and historical terms proposed for it by modernism.[40] Jarman's own knowledge of Rosicrucianism – as an esoteric practice in Renaissance Europe, rather than of the modern cult to which Klein belonged – seems to have derived in part from the work of the historian Frances Yates, and it is probable that the details of Klein's version of Rosicrucianism, and certainly his politics, would have been anathematic for Jarman. Yates's detailed study of Rosicrucian thought and its cultural effects[41] suggests that 'the history of the occult philosophy in the Elizabethan age is really the history of Rosicrucianism, though not called by that name'.[42] Jarman's research for *The Tempest* probably led him to concur with Yates's suggestion that the play was 'almost a Rosicrucian manifesto' in which 'Prospero represents the Elizabethan occult philosophy, revived, and about to be exported as Rosicrucianism'.[43] The monochromic screen of *Blue*, derived from Klein, might be interpreted, then, not as a refusal of signification and 'meaning' that compels us to concentrate on the soundtrack that accompanies it but, rather, as an embodiment of spiritual value. The screen is not simply a portal to the infinite, however, though that is indeed proposed; it could be seen as a much-displaced sign of the artist's own presence. *Blue*, here, is the artist as magus; successor to a hermetic, anti-establishment tradition (albeit one well embedded within the establishment) represented by John Dee, and by Shakespeare's Prospero as a *representation of Dee*, with which Jarman profoundly identified. Tim Lawrence suggests that the monochromic screen allows Jarman to evade the problem of depicting himself, given the autobiographical nature of the film.[44] Lawrence sees the screen as a negation of meaning, rather than as a formal displacement of the artist's subjectivity into allegory. This negation does not sit well with Lawrence's next proposal – with which I would concur – that the character of the boy 'Blue' on the soundtrack is the 'screen spirit of the director', a witness to history who represents the 'beginnings of a gay genealogy'[45] and indeed constitutes, I would argue, the potential community that is to come, that learns from the deaths of the artist and those like him. Both screen and 'screen spirit' are allegorical forms by which the autobiography may be extended, in which what cannot be represented may be presented. As Jarman put it in a diary entry from January 1993:

> No ninety minutes of cinema could deal with the eight years HIV takes to get its host. [...] Even documentaries cannot tell you of the constant nagging, of the aches and pains. How many times I've stopped to touch my inflamed face even while writing this page. There's nothing grand about it, no opera here, just the daily grind in a minor key.[46]

Images would be too easy; either failing to tell the whole story or, worse, making it into the stuff that affects an audience, for a moment, without effecting change. As Blanchot observed, 'The gratifying aspect of the image is that it constitutes a limit at the edge of the indefinite'.[47] The last thing Jarman wanted for *Blue* was such a limit. Far from being a zero statement, in the sense proposed by Kasimir Malevich for modernist painting, or a Kleinian void, the screen is replete with autobiographical reflection and historical latency. It is a strategy for avoiding

the sentimentalising strategies of commercial cinema; at the same time both an opening into the infinite and a mirror that captures and condenses the past.

Thus far we might understand *Blue* as one of those career summations that readily offer themselves to psychological interpretation. The saturation of the screen perhaps accords with a saturation of personal expression in the work as a whole. But Jarman's significant act, and what makes *Blue* into a powerful example of late work – one of profound importance to a notion of a community and its culture that recognises itself through the death of the other – is to take that saturation so far that it has catastrophic effects upon the medium of film. *Blue* does what Adorno asks of the late work when he writes:

[S]ubjectivity...in the name of death, disappears from the work of art into truth. The power of subjectivity in the late works of art is the irascible gesture with which it takes leave of the works themselves. It breaks their bonds, not in order to express itself, but in order, expressionless, to cast off the appearance of art.[48]

Here the artist's gesture is 'catastrophic' for the artwork; it breaks its boundaries, refuses the limit that Blanchot identifies, annihilates art as 'art'. Indeed, we might compare what Jarman does here with what is claimed for Paul Celan in Phillipe Lacoue-Labarthe's commentary on the poet's only major statement on poetry, 'The Meridian', in a study of singular importance for our understanding of the possibilities of death for subjective agency within culture.

What does 'The Meridian' actually say?
Not, exactly, that art is the stranger of poetry, but that, yes, poetry is the interruption of art. Something, if you will, that 'takes art's breath away' (I am thinking here of the motif of *Atemwende*, of turn-of-breath, which makes its first appearance in Celan here). Or, to recall another of Celan's words, the 'step' (*Schritt*) outside art; in French one could say, closely following Derrida's reading of Blanchot, *le pas-d'art* or *le pas-'de l'art*. The event of poetry...is thus a 'setting free', a '*Freisetzung*'. It is a liberation, not in the sense, common in German, of dismissal, but in the sense of deliverance. And, as we shall see, in the sense of free action. This is perhaps, in a phrase I leave to its own ambiguity, art liberation. And very probably, a certain kind of 'end of art'.[49]

Lawrence sees Jarman's refusal of cinematic 'representation' as itself characteristic of late work.[50] The abstract, 'non-objective' film is, in fact, a familiar avant-garde tradition. I believe that *Blue* is a late work that answers Adorno's definition because Jarman does something far more shattering, and liberating, than simply negate the image. If film has a singular rhetorical property that defines it - in the modernist sense, where painting equates to the flatness of canvas, for example - it is temporality. Filmed objects move on screen because the medium allows for duration like no other. It was this characteristic that interested modernist artists in film, whether in proposals for abstract films such as Léopold Survage's *Le rythme coloré* (1914)

or realised projects such as Walther Ruttmann's works of the early 1920s. As Ruttmann allegedly remarked, 'It makes no sense to paint any more, this painting must be set in motion.'[51] The abstract film is marked by the yoking of filmic temporality to the forms of abstract painting; it allows a yearned-for dynamism to overcome the stasis of painting. By making that abstract form a monochrome, the purest form of modernist abstraction, Jarman utterly destroys the temporality of film itself, not simply the screened filmic-photographic image, because it is a form that defeats time.

Blue plays these shattered conventions of modernist abstraction against the equally shattered conventions of the theatrical narrative film. For coherent narrative and thematic development, Jarman substitutes aphorisms and diary entries. These are fragments of convention, but they reside in the soundtrack, in writing, never in acting.[52] The diary turns for a moment into film script and we half expect the blue screen, with its intimate voice-over, to part and reveal an image of Soho streets and cake-laden cafés, where the blinded artist stumbles between clichés: cycle couriers and bag ladies, policemen and professional drunks. Then we are bought back to reality: we are always expecting the screen to part, and it never will. There can be no images; there are only these fragments; no sensible trajectory, no reconciliation at the end of the rainbow. But these fragments are fragments of relation, of possibility, not simply in the redemptive journey of the 'Blue' boy (which ends in a Twomblyesque idyll of the Mediterranean) but in the exchanges between men on the way to death. For, if Jarman sees a hope for the future, he also uses the film to talk about a community of the present, one structured around an acknowledgement of one's helplessness that is dependent on the recognition of the other. The blue screen obscures one vision of the city and it allows for the concentration upon another whose concerns are specifically justice and injustice. With Jarman's pursuit of a still-sexualised, yet responsive and responsible, community, one is drawn back to Adeimantus's reply to Socrates's question, in the *Republic*, about where justice and injustice would be located in the 'city of speech': 'I can't think...unless it's somewhere in some need these men have of each other.'[53] 'Need' has now taken on a very different meaning from that of sexual desire; it has not been replaced, but it has been supplemented by the need of, and for, constant commitment.

In August 1992 Jarman observes in the waiting room at St Mary's hospital a

little grey man...fretting as he had to get to Sussex; 'I can't read. I'm going blind.' A little later he picks up a newspaper, struggles with it for a moment and then throws it back on the table.

My eyedrops, which sting, have stopped me reading, and so I'm writing this in a haze of belladonna.

The little grey man's face has fallen into tragedy. He looks like Jean Cocteau without the poet's refined arrogance. The room is full of men squinting in the dark in different states of illness, some barely able to walk, distress and anger on every face and a terrible resignation. [...]

Jean Cocteau takes off his glasses, he looks about with an indescribable meanness. He has black slip-on shoes, blue socks, grey trousers, a Fairisle [sic] sweater and a herringbone jacket. The posters that plaster the walls above him have endless question marks, HIV? AIDS? [...]
As I left St Mary's I smiled at Jean Cocteau. He gave me a sweet smile back.[54]

This passage is also included in the soundtrack of Blue, and I would argue that it is a vital moment in Jarman's imagination of a community that emerges from its mutual understanding of death, and which can only be found in the artist's refusal of any attempt to lay hold of death as something unique, distinctive and subjectively foundational. What would once have been the smile that presaged a conversation, a pick-up perhaps, becomes an acknowledgement of mutuality in finitude.

I suggest that this scene is also Jarman engaging in a form of self-reflection. Jarman too has somewhere to get to, back to Dungeness (just over the county boundary from Sussex) and to the safety of his garden. Cocteau is one of the first homosexual writers whom Jarman reads as a student, and as a writer, painter and filmmaker outside the conventions of narrative cinema is unusually close to Jarman in his own practice, so might be considered something of a role model.[55] Like Jarman, the little grey man is going blind. Jarman, chosen for a trial with a new drug, is lucky enough to be told that his retina has (for now) healed: 'The result stable eyesight, worth a hard twelve pills a day'.[56] The little man is, maybe, not so lucky, but as the diary entry begins neither man is capable of reading, though Jarman is, oddly, able to write through the haze of medication, and provide both a close description of the man's appearance and the waiting room. Mundane and middle-aged in his dress he is, perhaps, all that Jarman (himself aged fifty) might have become had he been tentatively 'gay' rather than choosing the radical path of being flagrantly 'queer'. He is also, in his greyness, a figure of death; recalling the artist's remark about ending in deathly grey, the little man is perhaps a harbinger of Jarman's death as he lives out his own dying. He is, perhaps, a way of seeing death. Indeed, seeing and the impossibility of seeing structures this exchange. For, if, in leaving, Jarman's eyes have sufficiently recovered to see the little man smile at him, the other, half blind, smiles without knowing that he is being smiled at.

The soundtrack of Blue is composed of autobiographical fragments, and many derive from recent diaries. As the voice of the screen in Blue, Jarman becomes the symbolic figure of the magus poised between immanence and extinction. As the boy in Blue he is the future (a future that will remember him despite all the self-effacing claims to the contrary); as the grey man is his own blindness, his own death, he is a shared and collective being. If Jarman is suffused through the film both historically, in the alchemical figure of the screen, and proleptically, as a member of a community that is to come in the figure of the boy, he is also scattered through the film in the figure of his own writing. The autobiographical self, confronted with its death, is dispersed into allegory; it replicates itself in otherness and objects – a strategy

of self-representation and the constitution of community that we also witness in Meatyard's work. And, as writing, the subject extends itself in ways that it cannot anticipate because absence or 'death' (whether the death of the self or of the other) is a structural condition of any mark that communicates.[57] It is this formal 'shattering', and the possibilities that it harbours - begun in the painting and opened more fully in *Blue* - that perhaps have a greater historical import than any immediate political efficacy for which Jarman might have hoped. I now address how that politics might work, how it might be achieved beyond the specific trauma that is AIDS, within a wider and yet narrower community.

Chapter 7

Shimon Attie –
Aberfan

We know death not as an experience or event but, rather, as what comes after. We know death only through what anticipates or survives it, but even our anticipation of the other's death comes to be understood only in retrospect. All, in a sense, is memory; even as we know that we never remember adequately our experience of that death. Elsewhere, we discover the other afterwards, through documents and legacies: the diaries, letters, journals that are published posthumously. And, of course, we know of the other's death through the memorial: the painted portrait, the funerary architecture of those centuries when the European world still had space and intent to harbour its wealthier dead in monumental structures. What we know of death, then, is known through the aftermath. In particular, we know it socially, as a group of people who survive.

How do surviving and remembering, the 'what comes after' of others' deaths, fashion a community? Our individual encounter with others' deaths may transform our relationship with them, the inevitability of their death precipitating our response. How does a community's encounter with death – not here the singular, predictable death of the other but the unforeseen, if foreseeable, catastrophe – shape its relation to the wider world? Since the immediacy of the catastrophe denies the enduring relation to the other that might be manifested in a *process* of dying, does that relationship manifest itself instead only amongst survivors? And, beyond a denied ethical relation, is there then an 'impossible' turning to the political, an agency within history that is put into motion by death?

My subject here is a memorial to mass death. It is, consciously, not a memorial to the unspeakable deaths of the Holocaust, which nonetheless demand that we attempt to speak of them. Rather, I want to deal with the localised catastrophe, where the number of deaths was relatively limited, though each was a shattering loss. This is because those deaths were so concentrated on part of a community – its children, its future – that it might, in the

subsequent passage of time, have destroyed it. My approach to that catastrophe is through its memorial – a multiple screen video installation made by the American artist Shimon Attie. Attie's work concentrates not on its victims nor on the event, but on the community now. He does not attempt to represent what is beyond representation but, rather, attends to 'what came after', on the shaping of a village by death, and on the way that community has, perhaps, come into being within history *through* death.

At 9:15 on Friday 21 October 1966 a landslide engulfed the school and surrounding houses in the south Wales mining village of Aberfan. Loosened by an underground spring and heavy rain, one of the slag heaps produced by Merthyr Vale colliery, where many of the men from the village worked, became a massive slurry of stone and water that flowed down the mountainside. It first of all engulfed a farm cottage, and within seconds, unstoppable, and before any warning could be given, hit Pantglas Junior School. One hundred and forty four people died in the disaster. One hundred and sixteen of them were children, with one hundred and nine of these killed in the school; this was about a half of the children of school age in Aberfan.

Because of the closeness of the community there was hardly a family unaffected, that did not lose a son or daughter, a brother or sister, or a relative or friend in another household. In the subsequent tribunal, the National Coal Board (NCB – then the statutory authority for the management of coal production) was excoriated for the neglect and ignorance that had caused the disaster. No official resigned or was prosecuted, however and compensation was limited; £500 per child was paid by the NCB in what it termed 'a generous offer'. As Iain McLean and Martin Johnes note, this was little more than local farmers received for the loss of individual livestock in the catastrophe.[1] In 1968 the government compelled the charitable trust established by the villagers to contribute £150,000 from donations towards the cost of removing the remaining waste tips. (This despite these tips being shown as incorrectly sited in the NCB's own documents, and a probable breach of its own regulations by the Charity Commission in sanctioning the payment.) Despite the dreadful trauma experienced by the survivors - whether children who had been trapped in the crushed school building or bereaved parents and relatives – only one social worker was seconded to the village by the local statutory authority, for one year.[2]

As McLean and Johnes wrote in 1997, Aberfan remains 'a place of tears', yet it has also put itself in a new relation to the disaster and the trauma that it caused. The site of the devastated school has become a memorial garden; where the demolished houses of the village once were is now a community centre. Denied official and expert assistance, the community found its own ways of coping. Aberfan has perhaps managed, collectively and individually, to incorporate loss and grief whilst bearing still the marks of the disaster on its surface. One might say that because of the event, and the manner of its dealing with it, the village occupies a different relationship to its history from the world that surrounds it. History is both imminent *and* incorporated into memory. In contrast, for the surrounding world, or at least for those who mediate its representations, it seems always to be the day after the disaster in Aberfan.[3] Whilst

the advent of the fortieth anniversary of the disaster increased the numbers of media industry visitors, there is a sense in which Aberfan has always remained in the spotlight, in which its inhabitants have always had to respond to questions concerning their trauma as if the catastrophe were yesterday, rather than something with which they had dealt, however ill or adequately. The village is continually presented as a spectacle of loss and suffering, a subject that might provoke momentary pathos in the television viewer, rather than being understood in the complex terms of a history *after* the event that still very much defines and names it.

In 2005 the American artist Shimon Attie was commissioned to produce a work commemorating the fortieth anniversary of the disaster. Attie's previous work, in both photographic and video projections, was concerned with the memory of death and catastrophe. In the early 1990s he began to address the European past, and in particular Nazism and the Holocaust. Where the work of contemporaries, such as Jochen Gerz, approached the Nazi genocide in terms of absence and anonymity, however or where an older German artist such as Anselm Keifer dwelt upon on the uncomfortable problem of race and home in German romantic thought, Attie returned to the image of the ordinary citizen. His modus operandi was defined in his first piece – The Writing on the Wall (1991–93).[4] Having found an archive of Jewish life in the Berlin district of Scheuenenviertel before World War II, Attie used its photographs to make a series of night-time projections onto buildings in that area. Scheuenenviertel had been completely rebuilt after the fighting that devastated it in 1945, and before that, of course, its Jewish population had been sent to extermination at Auschwitz and Treblinka. Attie's project, as James Young has observed, was to return the memory of individuals – and indeed of places, of a specific architecture – that no longer existed to places that they had once inhabited or which they had constituted.[5]

In subsequent projects Attie would develop this theme. In *Trains* (1993), made with Matthias Maile and installed in the railway station at Dresden, he projected the faces of Jewish victims of the Nazi genocide onto the tracks that had carried them to their murder. Whenever a train passed along the rails the projection was then onto its carriages, however, in what was simultaneously a reference to the transport that had borne Europe's Jews to annihilation, and projection of that historical legacy onto us, the citizens of a new, united Germany and of a – hopefully – changed Europe, to bear witness to it in the present. In *Portraits of Exile* (1995) in Copenhagen, Attie started with the laudable action of the Danish government and people, when in October 1943 – learning of the German forces' intention to round up the Jewish population – they secretly and quickly ferried almost their entire community in fishing boats to neutral Sweden. Nevertheless, Attie's work illuminated (and, in using light boxes suspended a metre under the surface of the Børsgraven Canal, that illumination was almost literal) Denmark's reluctance to admit Jewish refugees from Germany during the Nazi persecutions *before* World War II. At the same time, he established a correspondence between the country's then-current policy on the admission of asylum seekers (many of whom were kept for protracted periods in crowded refugee hostels and 'hotel' ships

whilst their right to residence was established) and the historical reception of refugees, and contrasted this with the noble way in which Denmark behaved in wartime.

Attie had, therefore, established himself as an artist addressing historical memory. He had also shown himself as one whose work paralleled history (and its writing) with contemporary circumstance. He had not, however, confronted a situation where the alternative to an already over-mediated archive was the embodied community of survivors. The Aberfan disaster was *only* forty years ago: some of the children who survived are adults still living in the village; parents who lost children on that day, then in their twenties, are now only just pensioners; so too are those who dug desperately and largely without success to save victims from the landslide. In the same period, however, the area around Aberfan has undergone massive shifts in its economy and population. The traditional forms of employment in south Wales, industries such as coal mining and steel production, have largely disappeared, replaced by a typical 'neoliberal' service and sales economy of low-paid, part-time, 'flexible' work established in the 1980s and 1990s. Given that Aberfan's existence was predicated on mining, the closure of these industries and the shift in emphasis within the economy called into question the very identity of the community.

Attie's project, working as much with the villagers as taking them as his subject, was to fashion Aberfan in its own image. Death, as the experience of losing others; as the memory of disaster; as the inherited history of a place, has shaped the response of Aberfan's citizens to each other, created a community from the traumatic event of history. It is this that has allowed 'Aberfan' – as community, as well as the place that community inhabits – to respond to historical change, to negotiate a path through events and time. Two important issues spring from this situation. Firstly, we find in Derrida's proposals for a future politics of friendship the possibility of a 'thanotocracy'. His 'politics beyond politics' is underpinned by a radical conception of hospitality towards the other. This hospitality hinges on the inevitability of the other's death. It is mediated into a kind of work on behalf of the other; that is, the 'politics of friendship' is rendered practical by an assumption of responsibility, initiated by our encounter with the other, but developed in the manner put forward in Levinas's reading of Bloch. Furthermore, responsibility does not end with the other's death. Whilst both Levinas and Derrida theorise relation through the death of one and the survival of the other, I want to extend this argument, as Derrida did in his opposition to French immigration policies, to find a 'reality' to this politics beyond politics. Such a politics might be, in Kenneth Reinhard's terms, a condition of the ethical, rather than the one grounded in the problematic, utopian call of an ethical politics.[6] Secondly, we encounter the question of agency. What Derrida and Levinas seem to suggest within philosophy, and what I have just claimed for the people of Aberfan within history, would seem to imply the restoration, or, indeed, perhaps the bestowal 'for the first time in the history of humanity'[7] of a capacity to determine one's place in, one's response to, history. If death is the universal horizon of experience, what has changed in its contingency to history to produce this unique possibility? Or is this 'for the first time' a

possibility we have always carried with us through history, always to some extent enacted, and perhaps abrogated through the historical circumstances of modernity?

Two problems arise from these questions: one is the separation and confusion of ethics and politics, insisted on by Žižek, which I introduced in my discussion of the monstrosity of death and the other. How do we distinguish between love and justice? Is a politics founded on love, rather than justice, possible, either philosophically or practically? How do we move from the convulsive relation to the singular other theorised by Levinas to a relationship with the many? Does love for the singular stand in the way of a just relationship with the many? Secondly, the question of agency also raises a question of autonomy. Death may knit the village of Aberfan into a community; it may make individuals aware of their place in history; it may engender new and powerful relationships with others; such awareness does not give either the individual or the community transcendence over subsequent events. The death of the other does not guarantee autonomy for the survivor. The boundaries of historical agency are, therefore, limited. I want to show, however, through Attie's representation of community, how a response to catastrophe might enable a kind of politics of death and a limited, finite, engagement with historical circumstance.

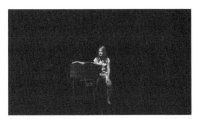

8. Shimon Attie, *The Attraction of Onlookers*, (2006).

Attie's five-screen installation, *The Attraction of Onlookers* (2006), offers us intimate portraits of individuals. Filmed rotating slowly on a platform in front of the camera, each now interacts with others on the four other screens around them and with the others that succeed them. They seem to float in space; isolated and shorn of location or context, they are identifiable only by the tools of their trade, the accoutrements of study or play, their uniforms of office. Each is marked not by name but their socially distinguishing characteristics. They are not alone, however: their 'look', the field of their gaze, intercalates us as spectators to their space, and it periodically engages with the fields of vision from each of the other screens through eye-line matches. (Indeed, at an extreme, we might say that 'Aberfan' is *not* its citizens but, rather, a capacity for looking at others that is radically different from the mediated, conditioned spectatorship of modernity, premised as it is upon unconscious regimes of identification and desire.) To become understandable - by us and in order to

understand each other and the history to which they belong - these individuals have to be related both between images, one to another, at the same time (*as event*) and in series - one after another (*as history*). This presentation is, then, simultaneously one of singularity (*the ethical relation to the other*) and multitude (*the relation of politics and justice*).

Where these individuals, these citizens, belong is not Aberfan as a place, though that is where they all live; it is, rather, in the sight of others. In their isolation Attie strips them of place and context; they are the monadic 'other' of Levinasian thought, but at the same time they are legion, and they are transitory. They cannot, then, belong to Aberfan as event, or, rather, not to a specific historical trauma, even though that is a history that they all live, whether it has been lived through, in some cases survived, or, for the newcomers and those born in the last forty years, inherited. Where they belong is in the *community* of Aberfan that they establish through their difference as multitude as much as their individual relation. That is, they belong in Aberfan not as place or history, but as a network of friendships and antipathies, as networks of trust and support, caution and scepticism, as lives lived, every day. It is, then, a community that has at once faced itself, through facing each other and turning away, and yet gone beyond the individual call of the other to the subject, shifting that ethical summons from the singular, unique relation towards the universal. This community, distinctively, has found itself in a void, been made by and through a catastrophic event and what came after. The 'what came after' here is *not* a continuation of the event, however, not a series of events and after-effects imposed on those who already suffer. Rather, it is because of that void: what came after was a 'spacing' within history that, by neglect, was given to the people of the village.

Each of Attie's portraits entails a degree of scrutiny that we, as 'ordinary people', rarely receive. The portrait is not a genre of the multitude: before the advent of the camera it is rarely concerned with the mundane or the collective.[8] In many ways, as Louis Marin showed, whoever the portrait is of, always the portrait is the king; it is a form of representation that embodies and disseminates hierarchical power. All subsequent portraits, whether those of aristocrats, clerics, soldiers, scholars, seek resemblance with the image of the king, their ruler, and therefore to convey whatever degree of power and influence the sitter may exercise in that hierarchy. The subject of the portrait may be an isolated individual, but through portraiture they are exposed as belonging to a network of relationships – *they are, paradoxically, part of a community of power*. That community is predicated upon a death that is to come. The portrait is always a kind of emblem of death, since the 'ontological transformation' that is the image and its power will circulate long after the demise of the monarch's body.[9] The portrait 'of the king' announces itself, in life, as already a kind of aftermath. As Derrida observes, this 'founding power of the image…did not exist before death. This power comes to it from this imaginal [*sic*] representation, from the 'exchange between the cadaver and language', from the 'ontological transformation of the body'.[10]

The subject of the portrait is also exposed to 'politics'. Indeed, the portrait of the king might be seen as the beginning of a kind of democracy. Marin's argument concerning portraiture

is not simply that representation is produced by the king as a prior, governing presence but, rather, that representation, as a narrative spectacle of power, produces the governing effect – kingship. We might say that power here is both an illusion of autonomy and a qualified degree of historical agency put into play by the coming death. Derrida sees in this dual system of the corporeality of the king and the imaginary status of his representation a logic presupposing a 'sort of death of the king...*in advance*'.[11] This logic separates the individual from the fictive, and parallels the division between image and reality in the understanding of Christ's eternal presence in Christian doctrine. Even as the portrait of the king bespeaks absolute power, Derrida sees this division as a foundation of Western political traditions.

> One could readily show that this logic [Derrida is commenting on the Pascalian logic that the portrait of the king is the king and that it is the mimetic effect of representation that *makes* the king] remains at work wherever there is a monarchy in a Christian country, even in a Christian democracy, I mean in a democratic regime with a Christian culture, as soon as the unity or independence of the nation-state is represented in the body of a monarch or a president, no matter what the length of the term or the forms of inheritance by election (filiation or succession), indeed, no matter what the mode of election.[12]

What we have in the portrait is a separation of the individual from his/her representation, and a representation, premised on the death of the individual, inscribing him/her within the public sphere. Indeed, we might see the public sphere as constituted by such representations and a certain dissemination of representation as a mark of the success (or failure) of its reach.

It is unusual - even in the age of democratic representation - for that representation to possess the kind of scale and accord the subject the kind of dignity that characterises *The Attraction of Onlookers*. We might see the portrait of the king as a way, as Agamben puts it, in which 'public dignity survives death in the form of an image'.[13] The ordinary citizen is the subject without dignity, or, rather, one 'compelled to live up to an absent dignity'.[14] The bestowing of dignity in *The Attraction of Onlookers* is significant, however, initially because it gives a status to those - the mourning, the bereaved - who might be understood to have been robbed of dignity by their response to the death of the loved one, if they were ever recognised as possessing it in the first place.[15] This raises the issue of the dignity of grief. (As Picasso's *Weeping Woman* (1937) makes plain, perhaps more than any other work of art, there is no dignity in our expression of emotion, in our manifesting of the interior condition on the civic surface.) We must, necessarily, include a caveat here that the whole project, commissioned, funded and disseminated by statutory agencies, might be seen as the bestowal of an illusory dignity. A generation after the catastrophe it is safe for the institutions of a previously neglectful state to make token gestures of amelioration and commiseration. Even if this were the case - and such an argument neglects fundamental shifts in the nature of governing institutions for the community between 1966 and 2006 - we might add that the

officially 'appropriate' gesture, together with its artist, is appropriated by the community to contest the 'official' version of Aberfan which exists in the mass media. What we see in the artwork is a portrait of relation and a portrayal of a community as a 'dignified' agent within the public sphere, however constrained, in some ways, that agency might be.

Attie's portraits, then, are of historically significant figures, perhaps more significant in the relation of the mundanity of their daily lives to the events of history than *nouveau-riche* Dutch burghers or Renaissance princelings. The darkness that surrounds them might be understood as symbolic as much as it is a quietly spectacular framing device, but it is not a symbol of the moment. The blackness is not there to describe the caesura in history that we might take 21 October 1966 to have been. It is not to say that the only context for these people is a non-context, not to say that on that day the village of Aberfan ended in catastrophe, not to say that the only way in which its citizens can now be envisaged is in emptiness. Nor is the darkness there to *literalise* the blackness of coal, nor of burial, the blackness of memory, nor a perpetual sense of mourning – though it might invoke all those things. Aberfan does not go daily dressed in mourning wear. The catastrophe is an event that is lived through and lived with; that at once shapes Aberfan and is constantly reshaped by it. The event is not one of the past tense that determines perpetually the future; it is an immanent property of the community, behind it yet ready to mind. In sharp contrast to the media version of history as spectacle of powerless, undignified subjects, this is history as lived experience. It is the particularity of this experience that shifts ethical obligation from singular relation into one grounded in the politics of experience, an assumption of responsibility not for *the Other*, but for others.

Here I want to invoke a hypothesis by Jean-Luc Nancy, important for Aberfan as place *and* people:

> History...does not belong primarily to time, nor to succession, nor to causality, but to community, or to being-in-common. And this is so because community itself is historical. Which means that it is not a substance, nor a subject; it is not a common being, which could be the goal or culmination of a progressive process. It is rather a being-*in*-common which only *happens*, or which is happening, an event, more than a 'being'.[16]

This is not, conventionally, how we think of history: history is 'events in time'; it is 'one-thing-after-another'. A conventional view would have it that Aberfan only exists after the visible, representable event, and that that history begins in October 1966 at the same moment as it comes to a catastrophic end. Such convention conveniently fails to account for the possibility of a critical analysis of events and an aetiology of statutory irresponsibility, and ignores the fact that, even the day after the event, the event changes. History is always being resumed, even in the moment of the disastrous happening, even as the world around us ends.

But how is history resumed? How does it come to belong to 'us', to a community in the world rather than to individuals in portraits? In Aberfan, history was resumed by a group of

people who were made by the event and who took that history to be theirs. To quote Nancy again: 'The happening consists in bringing forth a certain spacing of time, where something takes place, in *inaugurating* time itself. Today it is the resumption of history that takes place as our historical event, as the way we *eventually* are in history.'[17] It is not, not exclusively, perhaps not at all, the disaster of 1966 that is the historical event that gives us a timescale by which to measure things, to say that this is the fortieth anniversary of the landslide and the loss of so many lives. The event is what gives us 'our time', or, as Nancy says, 'by its spacing, the possibility of being we'. But it is the resumption of history, the next thing and the next, that the community does within 'a certain common space of time'[18] that is the historical event.

What is this resumption, then? I would say that it is what Attie shows us in its dignity. It is the matter of relation, face to face, one to one and one to many. It is work on behalf of each other through which the self comes to history. It is the daily business of running a sweetshop or a café; where one is maintained by newcomers to the village and its culture who are nonetheless accommodated to it, as an event, and accommodating of it, as an event, and where the other is run by a woman, a child of 1966, who explains her survival by the fortune of being assigned to one classroom rather than another. It is the daily business of being a schoolchild, forty years on, in a village that once lost half a generation of its children. How can such a child, his or her parents quite probably born after the event, have any consciousness of that legacy? And how can they not? Being a child in Aberfan means being a symbol for other members of the community: those who remember, those who lost children, those who looked at each other in the ordinariness and tormented grief of their faces and lived on. Attie illuminates the dichotomy of the present and the past that is lived with, seating the girl at an old desk, as if she somehow occupied different times within the same space. It is at once 1966 and 2006 and tomorrow.

Aberfan has not become a community *because* of death – a living mausoleum - but it has become a community through the unspectacular, *dignified* work that human beings do for each other in response to calamity and to death. I think that Attie, through his attention to his subjects, through the way in which they turn towards and away from each other, lays plain what this is. There is, however, a problem in this symbolising of relation. How do we turn from the one to the many? As Reinhard puts it, in his critique of Carl Schmitt:

> The political emerges in a process that seems to have, on the one hand, the characteristics of a formal logic, the 'union or separation' of two groups, friends and enemies; and on the other, an intensely personal, existential moment of 'recognition', 'understanding', and 'judgement' for the particular subjects involved.[19]

If the latter condition brings us back to Levinas, the former removes us from notions that would deny rational bases for our relation with others. We have already seen in Meatyard's 'Lucybelle Crater' series how the command to love one's neighbour as oneself can be both challenged and ultimately endorsed through the responding question: 'What if my neighbour is as monstrous

as my own death?' In Aberfan, on the day after the disaster, and for every day since, the *encounter* with the neighbour, as much as the presence of the neighbour as *other*, is this monstrosity: one bears (and bares) for the other the monstrosity of his/her trauma. There is, seemingly, no dignity here; and yet there is.[20] It is in this revelation that we might find the basis of a politics of filial love, or perhaps, as Levinas put it, 'holiness'.[21]

Both Reinhard and Žižek suggest, however, that such a move is impossible if we start from the question of ethics as Levinas frames it. One cannot move from the asymmetrical relation to the singular other, whose demands may be infinite, to a system of universal equity. As Reinhard comments: 'This fundamental disjunction between the conditions of ethics (and the neighbor) and politics (and the citizen, on the model of "fraternity") should preclude any attempt to draw political consequences from Levinas's theory of the neighbor.'[22] Where Reinhard proposes a model whereby politics might condition ethics, in Aberfan we have a model of a politics beyond the political, emerging from the ethical precisely because trauma creates a significant overlap between what might be theoretically considered as discrete sets of philosophical propositions. (Reinhard's argument for politics as a governing law for ethics rests ultimately on Badiou's assertion, based in set theory, that 'politics is love's numerical inverse...love begins where politics ends', and therefore hinges along a preconceived boundary between the ethical and political and privileges the ontological over the metaphysical.[23]) We have in *The Attraction of Onlookers* a model of those very conditions of politics that are laid out by Reinhard on Levinas's behalf, presented precisely as questions of ethical responsibility.

We begin, as Aberfan began again, in its resumption of history, with the face-to-face encounter. These can be no ordinary meetings in the wake of disaster, but only meetings with the face stripped bare of artifice, reduced to a point where it is unbearable. The encounter here, however, is not with one, alien to me, who *will* die. The encounter here is with first a one, and then a multitude, who have, to some degree, as survivors, *already died* through the deaths of friends and family. Where the politics of community that is manifest in Nan Goldin's photographs is contingent upon a death that is going to happen, here we have a foundation in the death that has already happened and which will always happen, every day, into the future. Moreover, this encounter is not between 'me' and an *other*. There are no grounds for identification or discrimination. I too am as bereft as those before me – they witness my torment. In Aberfan, on the morning after, each was face to face with the grief of others that matched their own; not the death of the one, but of the many. Each was face to face with the others' shame: that I survived and my friends, my children, did not. We might say that, for the first time, the citizens of Aberfan were alone with each other. As survivors they were naked before each other, *without dignity*. Indeed, they bore, for each other, all those distortions and disgusting traits that Žižek would see as disqualifying the possibility of ethical relation, and it was precisely this 'loss of face' that made both ethics and politics possible.

Being 'our' community – and, at a pragmatic level, if you have ever lived in a small village you will know exactly the kind of generation-enduring enmities to which I refer – it will

contain people who, in the ordinary scheme of things, I hate, from whom I am estranged. I will 'hate' them at a political and an ethical level. Even though they have, perhaps for years, shared much of my civic space, they are as strangers to me. Historical catastrophe trumps this hatred, this alienation. If I cannot recognise others through the anticipation of their ordinary and inevitable death, in the convulsive encounter that for Levinas opens the ethical field, I now recognise them because they too must recognise me *without face*. In the mutual survival *of death* we recognise each other in our nakedness and shame. There is, on the day after the disaster, no clear distinction between the living and the dead except in this shame, that the survivor must go on bearing witness to the dead. (And historically, we can extend this argument, as Agamben does with the legacy of the Nazis' extermination camps, to include those – the *Muselmänner* - whose condition might preclude the possibility of love or witness, of ethics or dignity. An otherwise imperceptible testimony takes place in the lacunae, the interruptions of history.[24]) *Sur-vivance*, as Derrida has it in *Politics of Friendship*, summons us to love those whom politics might call on us to hate, or ethics to fail to recognise as human. *Sur-vivance*, whilst it might contain the seeds of renewed dignity, and therefore of agency and community, should not, however, be misconstrued as healing, nor necessarily of giving the surviving subject the power of speech. For those who survived Aberfan, even as history recommences, it is still the morning of the disaster. The difference that *Sur-vivance* makes is that history is never only the morning of the disaster; the disaster will be integral to the community that comes into being.

This is why the disaster is present in *The Attraction of Onlookers*. The portraits show us not only what it means to be a survivor of someone else's death or the inheritor of the death of people you never knew; in their attribution of dignity as a property of inheritance they show us what it feels like to see the face of a survivor. It is this vision that is the call to a generosity beyond *calculation*; that is the source of community and the possibility of a stake in one's own history. I am thinking here of the faces of the older members of the community that Attie shows us: those who were young, bereaved, distraught mothers and fathers, forty years ago; those who raced from the colliery to dig their children out, and failed, and the faces of those who lost no child, and yet had to look at the faces of their friends and neighbours and say that in recognising you, for the first time, I too have lost everything. These are now the faces, beatific, intense, resigned, or maybe simply tired, of those who have given a life of service in supporting one another, in learning how to survive on one's own. They may also be the faces of those whose pension for a life of work in the pit is the daily wearing of a mask, just to be able to breathe. Is it too much to say that it is the traumas of history, experienced as real, not as mediation, that compel us to love one another? Is this what Aberfan learned to do? Is it too much to say that in the faces of that community, even when they are estranged from each other, Attie tells us something about love as historical process, as work, rather than sympathy or pathos as momentary event?

Levinas makes clear that the ethical call is not simply singular but that it is, rather, always an attention to the multitude. In answer to the challenge that the model he presents is not 'the real social situation', he comments:

> But what then about humanity in its multiplicity? What about the one next to the other – the third, and along with him all the others? Can that responsibility toward the other who faces me, that response to the face of my fellow man, ignore the third party who is also my other? Does he not also concern me?[25]

Levinas's answer to the 'politics' of the state that would dispense justice and rights is an appeal to 'resources that cannot be deduced, nor reduced to the generalities of a legislation. Resources of charity that have not disappeared beneath the political structure of institutions...'[26] In Aberfan, the state abrogated its responsibility to dispense justice. The villagers were left to fend for themselves, to depend upon their charity to each other and the benevolence of individuals outside the community. Where those whose negligence caused so many deaths might have been prosecuted, the state did nothing; indeed, it 'prosecuted' the survivors in demanding that they use charitable donations to ensure the future safety of the village. Where the state might have made adequate reparation, it did almost nothing; where it might have provided adequate counselling and support, its contribution was nugatory.

The Labour government of the day, in its shielding of its supposedly social democratic agencies, might be seen as anticipating the contemporary neoliberal state's disavowals of responsibility (shielding the liberated capital with which it is now intimately associated in the name of 'freedom'), in that it assumed that individuals were responsible for their own recovery from a catastrophe in which its institutions were complicit. (As David Harvey candidly puts it, faced with a choice between the market and the well-being of its population, the state will unhesitatingly choose the former.[27] Instead of Aberfan, I might have chosen New Orleans...) There was, then – if history was to resume – a need for precisely those 'resources of charity' that resist political structuring; a private, though not 'privatised', agency of individuals ministering to others. Such action is, as Howard Caygill points out in his study of Levinasian thought, not necessarily congruent with the assumptions of liberal politics about the role of the state.[28] Indeed, even as the abandonment of marginal urban populations to their fate by neoliberal governments has led to theorisations of political renewal predicated on local resources, so the enforced embrace of self-sufficiency by the dispossessed has seen the emergence of more atavistic forms of care by radically conservative religious groups, whether in evangelical Christian projects in the USA or Islamic ones in the slums of Beirut, Istanbul or Gaza.[29] Such, indeed, is one risk of Levinas's insistence upon an ethical endeavour that rises above the level of the institutional, even if it is an endeavour *exposed* by the abrogation of statutory responsibilities.

Ethics, then, seems to engage politics through the self-ministration of the dispossessed and the abandoned. Žižek suggests that '[i]n contrast to love, justice begins when I remember

the faceless many left in shadow in this privileging of the One', and that 'justice and love are...structurally incompatible ... [I]t [justice] must disregard the privileged One whom I "really understand".[30] Leaving aside the reading of Levinas as privileging 'the One', and the mistaken assumption that this privilege proceeds from identification, this presumes an idealism of the political as a form whereby justice may be dispensed to the many rather than one that will always seek first to preserve its own status at the expense of either justice or ethics. Žižek presumes it in an era in which, as Anne Dufourmantelle acerbically comments, 'exhibiting man as a political being strikes a note of sovereign insolence, to the extent that our culture seems to be in the process of making the political vanish completely into a theatrical effect'.[31] What we have in Attie's portraits of Aberfan's citizens is a study of individuals whose reformed relation has, in part, been formed around the void left by that vanishing act. Death is not, then, the only absence that shapes this community; it is moulded too by the absence of politics as an intervening agency in their lives. We may say perhaps that it is this void that then allows the ongoing inscription and re-articulation of death in the form of a community predicated on the aftermath of the disaster.

Conclusion

From the House
of the Dead

The only historian capable of fanning the spark of hope in the past is the one who is firmly convinced that even the dead will not be safe from the enemy if he is victorious.'

(Walter Benjamin, 'On the Concept of History')

Given the critique I have so far presented of his work, it may seem odd that in closing this study I should come back to Damien Hirst. In doing so I want to emphasise that Hirst, for all his literalness, for all his misprision of Bacon's central themes concerning death and the subject, perhaps comes closest of all contemporary artists to mirroring in art a particular conception of the relationship between the subject and power in modernity. This relation is figured in philosophy as the governing condition of our culture, as the ordering term of history. In other words, whilst it is at one level a conceptual construct, at another it is lived experience. Or, rather, it is a non-experience, a death experience, since it fundamentally concerns the question of boundary or border; the limit between life and death, between 'I' or 'we' and 'other'; the limit between subject and power that is defined in law. What is ultimately at stake here, articulated in aesthetics, is a political question of the right to 'ownership' and disposal of the subject, and, as significant, a regaining – or sustaining - of the subject's relation to history through its representation. Hirst's literalness may help us here, for some of his artworks may do nothing more than imitate the structures of this relationship of subject and power. Rather than in themselves reflecting on these relations, their mimesis of them allows us the opportunity for critical reflection.

Let us imagine, for a moment, a device resembling one of Hirst's 'death machines'. What might our machine contain? As its basis there must be a condition of 'bare life' over which the living being has no agency. By 'bare life' I mean precisely this, that life exists only as biological

function, as reproduction and existence, without agency in determining its future. This would be an equivalent to the status of the flies in *One Thousand Years* or the butterflies in *In and Out of Love*. That bare life must then be submitted to an instrument of power that disinterestedly disposes of life simply because it is there and the life is there. The insect killer in *One Thousand Years* is a literal instrument of such power, one that kills insects simply because they are insects, because their biological structuring is such that they are compelled to fly towards its optical lure. Let us remember also Gloucester's bleak dictum about flies and men, boys and gods. What happens if, in this machine, we substitute men for insects, but nonetheless retain a device that exercises an automatic and dispassionate agency of disposal of the lives of men?

This machine gives us a paradigm of the relation of the subject before power, and in particular the claims of state power to abrogate the legal systems on which it depends, in order, ultimately, to have absolute sanction of life and death over its citizens, and even to create these subjects in order to have them die. In imagining this device we need to remember the governing principle of Hirst's 'machines': that there is no sovereign power within the structure, only an exchange of states in which the emergence of one (life) predicates the annihilating force of another (death). Power, in Hirst's work, is present only in the external agency of the artist, the *deus ex machina* who sets the components of the system in place, throws the switch and puts it into motion; everything else is part of that closed system. Even when it contains life, that life is purely mechanical in that it is submitted to the system without choice. The death that it administers is utterly dispassionate; the act of killing is 'nothing personal'.

Such a machine is at once 'unthinkable' in its amorality and yet, at the same time, it is clearly, at a historical level, 'thought'. Indeed, such a machine could be seen as foundational for and of modernity. It is the guillotine as conceived by Hegel in his analysis of the Reign of Terror, during the French Revolution, in *The Phenomenology of Spirit*. As Jonathan Strauss puts it, Hegel reads the Terror 'as a sublime and annihilating mediation between absolute freedom (freedom as absolute) and the concrete particular individual'.[1] The French Revolution might be understood as a foundational event in the emergence of Western democratic society: it introduced a universal franchise, it marginalised the power of the Church within the state, it introduced a new legal relation between the subject and the state – one in which the subject might be said, through its enfranchisement, to have a stake in the production of the law and yet one which might also be understood to 'produce' the subject. And it sought to put an end to those practices of spectacular and particular punishment that characterised the *ancien régime*, so effectively characterised by Foucault in his description at the beginning of *Discipline and Punish* of the public torturing and execution of Damiens. Even in their cruelty, what Strauss sees as their reproduction of the crime on the body of the criminal,[2] such punishments emphasised their victim as individual. (Indeed, in the visibility of their annihilation of the subject they might be said to establish the uniqueness of that subject for the first, and only, time.) Though it did not abolish the death penalty, the Constituent Assembly of 1789

introduced proposals whereby punishment for transgression of the law was to be rational, systematic and universal. This reform represented a fundamental shift in the understanding not only of the relation of the subject to punishment, but of the imagination of the state in that relation. It was not simply a matter of technology that checked the introduction of the scheme until 1792. As Strauss remarks, 'Guillotin's proposal called for a death that was simple, uniform and mechanical, which would do away with the class distinctions and symbolic individuations associated with torture-executions. As a machine it would deliver the same death to all...'[3] The transformation of the mode of despatch into a universal, dispassionate technology represents a fundamental shift in the way in which state power - and the relation of that power to the individual - is understood by those who administer and constitute it.

Something more is happening in the submission of the individual to this system of punishment than his or her physical annihilation; indeed, the characteristic of the guillotine is that it does not acknowledge the individual, any more than does the inchoate democracy of which it becomes an icon. At the same time as one is accorded by the state a membership of it – given a subjectivity 'before the law' that may play a part in establishing that law – one's individual identity, one's being, is sublimated to the demands and decisions of the collective. The experience of the particular, the subject's sense of its uniqueness in being in the world, *even when it is not recognised as such*, is both abstracted and negated in the subject's identification with the notion and historical achievement of universal freedom. If this is the logic of democracy, it is a logic that is perfectly embodied in the first democracy's first apparatus of ultimate legal sanction. One's death no longer 'belongs' to oneself as a property by which being is defined but is, rather, wholly alienated, abstracted, from it. As Strauss comments: 'Hegel's analysis of the Terror...is an application of the relation between state and individual of the relation between sensuous particular and abstract language – it is in this sense that the individual becomes a mere expression of the language of the law.'[4] And it is notable that, for the most part, those arguments raised against the death penalty in debates both preceding and after the revolution were articulated in terms of the use value of criminals to the state through forced labour – that is, the suborning of the individual to the state in more protracted but equally abstracted terms, those of alienated toil and slow death.[5] Death, in this reduction of the individual to a product of juridical power, becomes, in Hegel's words, 'the coldest and meanest of all deaths, with no more significance than cutting off a head of cabbage or swallowing a mouthful of water.'[6] The death of the subject possesses no meaning greater than the death of a fly on an electrified screen.

As art, Hirst's death machines might be seen as precisely embodying and enacting Foucault's view of state sovereignty after the nineteenth century – a century and a condition ushered in by the French Revolution.

One of the greatest transformations political right underwent in the nineteenth century was precisely that, I wouldn't say exactly that sovereignty's old right – to take life or

let live – was replaced, but it came to be complemented by a new right which does not erase the old right but which does penetrate it, permeate it. This is the right, or rather precisely the opposite right. It is the power to 'make' live and 'let' die.[7]

Sovereign power here is a mechanism that endlessly produces life and which can either take life (the old right of the sovereign) or let it run its course. Its new 'meaninglessness' (and there remain, of course, moments when the deaths of individuals are hugely charged with symbolic meaning at state level) does not mean that death goes unrecorded. As Foucault observes, the modern state develops a concept of its constituent population as an object of knowledge and documentation, to be efficiently managed, to the extent that 'the population as a collection of subjects is replaced by the population as a set of natural phenomena'.[8] The subject's body, dead, engages the state. The subject's death, as individual being, does not concern its apparatus so much as does the management of the transition between being – as useful instrument – and not being. What's pre-eminent here is an accounting for the loss of the instrument, a certifying that the subject is no longer of value. In modernity you are not recognised as dead until certified thus by a state official. Such notification is not an act of mourning, far less an epitaph on your relation to others in the discourse of society. It marks the passing of your usefulness. This registration – on the one hand of immense value in the preservation of life through the urban public health programmes of the nineteenth century - simultaneously strips the subject of its own being. It is, effectively, another mark of that decisive subordination of individual experience to an abstraction that here is statistical as much as it is linguistic.[9]

Foucault's analysis of the changed relation of the subject to power is extended and rewritten by Giorgio Agamben in his *Homo Sacer* project. This explores the consequences for the subject of what Foucault calls the 'threshold of biological modernity' – where 'the species and the individual as a simple living body become what is at stake in a society's political strategies'.[10] Agamben's concern is with the relation of the subject to power in contemporary life, and the manner in which politics shifts from being what we might term a field of discourse (however problematic and constrained), in which the subject announces itself and has a political existence, to one of assertion (both in terms of public manifestation as spectacle and, more tellingly, of sovereignty, through the claim of power to an exceptional right of disposal of the subject's body), achieved through the proroguing of once-assumed, mutually engaged rights and responsibilities by the proclamation of states of exception or emergency. Such 'rights of disposal' might include the copyrighting and 'ownership' of an individual's genetic patterning by private corporations or the state's assumption of an exceptional and presumptive right to decide on the medical status of death of an individual – for example in the cases of comatose patients.[11] We move here from death understood as an absolute condition that *belongs* or inheres to an individual to its constitution as problematic, and extendable and contractible 'zone' decided by experts and the law. But we see the effects of this presumption of abstracted right by the 'state' (and by 'state' here I mean a particular

ideological and material complex of institutions and capital that is largely constituted by
capital, rather than the state as an autonomous entity that might regulate capital) in the
pressing back upon the subject of a personal responsibility for the maintaining of health before
state-sponsored medical intervention is provided. That is, a 'free' subject of the neoliberal state
must be of some value to the state (or, rather, to the capital with which it is complicit) before
the state is prepared to spend money on the extension of its life.

Central to Agamben's argument here is the claim made in 1942 by some of the leading
German specialists on health and eugenics, together with 'other figures responsible for the
medical politics of the Reich',[12] that a new political economy is grounded in the accounting for
a population as 'living wealth'.[13] In such an economy 'the care of the biological body of the
nation' (which might be understood as the responsibility of the social democratic state through
national health services) is coupled with the establishment of a 'budget to take account of the
living value of people' in a 'logical synthesis of biology and economy'.[14] Such ratiocination might
seem limited to the grotesque intellectual architecture of National Socialism, but it also
informs the mental calculus of contemporary capitalism and the political administrations that
provide its institutional framework, for example in the triage that determines access to scarce
resources of public healthcare.

Rather like one of Hirst's machines, therefore, sovereignty, for Agamben, 'is constituted in
its power over bare life, in its production of bare life'.[15] Agamben, however, presses his claim
further. If the Nazis' understanding of the body in legal-medical terms produces a radically new
subordination of the individual to state-sanctioned instrumentalism, the ultimate, 'logical'
development of such thought is the concentration camp. In such circumstances, for Agamben,
the 'state of exception' – the proroguing of a subject's legal definition and right in favour of
the assertion of the state's needs – 'becomes the *nomos* of modernity, functioning within and
in place of the normal political order'.[16] 'Auschwitz is precisely the place in which the state
of exception coincides perfectly with the rule and extreme situation that becomes the very
paradigm of daily life'.[17] For Foucault too, the 'play between the sovereign right to kill and
the mechanisms of biopower' – taken to its extreme by Nazi Germany – 'is…inscribed in the
workings of all states'.[18] Agamben's argument, then, in terms of Foucaultian 'bio-power', is, as
Andrew Norris puts it, that 'the camp is the as-yet-unrecognized paradigm of the modern'.[19] We
might then say that Hirst, in his literalness, allegorises after all; say that his death machines
allegorise the condition of modern life as extension of the camps.

If we acknowledge that Hirst is in some sense producing a paradigm of the Nazis'
relation of the subject – presumed by them deficient or subhuman – to their sovereign
power, and then of the enactment of that relation by the neoliberal state, what is especially
revelatory is the degree to which the machine as construct exposes that first relation not
as wanton, irrational massacre (a resurgence of the medieval pogrom enacted with the
technology of modernity) but the degree to which it was, precisely, thought – even as we like
to imagine it 'unthinkable' – and legally constituted through the stripping of rights of

those who were formerly within the protection of the law. Once the decision was implemented to shift the responsibility for the extermination of Jews and Roma from units of the *Einsatzgruppen* operating just behind the Eastern front to specially constructed death camps well within occupied territory, the Nazi genocide, notwithstanding technical problems and the individual sadism of its agents, was in its imagination by the state a machine governed by a principle of sovereignty and an amorally *dispassionate* destruction. Thus, the Nazis' imagination was, as Lacoue-Labarthe puts it, that 'Jews were treated in the same way as industrial waste or the proliferation of "parasites" is treated', in a 'purely hygienic or sanitary operation.'[20]

A work such as *One Thousand Years* is, then, striking in its attention to the imagination of power as a streamlined managerial enterprise, in which the subjects of power, once their use value is exhausted, or their alienation from the values of the state established, are disposed of as quickly and efficiently as possible. (One of the almost inevitable failings of Hirst's 'machines' is that the instrumental value of the bare life on which they depend is no more than a contribution to death as spectacle; there is *only* alienation.) Having earlier accused *One Thousand Years* of sterility in its refusal – as spectacle – to acknowledge the mundane abjection of dying and death (whether that is the singular domestic responsibility of cleaning the faeces from the bed and body of someone who can no longer control his/her bowels or the public, communal, collection and interment of bodies after a catastrophe), there is, nonetheless, a certain register within the work at which that sterility is perfectly pitched. This is not the register of the epitaph, nor even of the threnody: it is never a kind of mourning. Rather, it is a making manifest of the imagination of power over life and death in the corporate state. Hirst's technology of representation as *technology*, as much as in its content, renders visible the ideology of the modern state.

By contrast, we might consider a work such as Jake and Dinos Chapman's *Hell* (1998), whose subject is more overtly concerned with the Holocaust, a failure because of its portrayal of the slaughter as a psychosexually motivated chaos – no more than a massacre of the innocents or a pogrom conducted on the grand scale. *Hell* has the dubious virtue - through its market-sating sensationalism and mockery of the 'impossibility' of the representation it actually effects - of addressing the culture industry's neutering of history through reification in precisely the terms of that neutering. The event nevertheless demands that we make art that accounts for it, that represents it ideologically, even if it cannot render it as history. This is what the Chapmans are seemingly incapable of doing: instead they return us to individual agency and individual torturers and victims – small figures within the crowd, perhaps, but like Anthony Gormley's overtly humanistic figures within his *Field* works they are small figures that are both the same and different, that have a unique subjectivity. That is, in seeking to depict the incapacity of representation, when confronted by the Holocaust as historical event, by reducing that event to the mimetic scale of the toy soldier, the Chapmans come remarkably close to the humanist sentimentality that they would shun. We cannot make art that

'represents' death on an industrial scale, cannot depict the Nazi genocides in an art that merely attempts to represent an experience beyond experience, after which certain modes of representation are redundant. To do so is simply to make 'art' in the terms challenged by Celan.[21] It is to make representational forms, *as iterations rather than the intensification of presentation*, that are not merely inadequate but in some senses complicit with the atrocity that they depict. If 'art' gives us on one hand the redemptive fantasy of *Schindler's List* about a moment in which there was neither redemption nor hope, on the other the philosophically informed art of late capitalism gives us a meditation on the inadequacy of signs as signs that ends up doing much the same thing. At the edge of *Hell*, if you look long enough, you can almost make out on the edge of the woods, sneaking into the trees, that character of survival, 'the little fellow' who, just in time, will always find a way out, identified by Žižek in his study of the cinematic genre of Holocaust comedy and its disavowal of the reality of death.[22] As we shall see, this escape into 'art' may be a strategy that is also adopted in the face of the terror of subjective abstraction by Agamben.

Hirst's embodiment of ideology as technology, rather than representing history as subject through technology, may circumvent this 'escape', may acknowledge that the rules of relation have so changed that, in modernity, the horror is no longer so much that even the dead are not safe, as Benjamin fears, but that the dead, having been accounted for, no longer matter. The dead are, indeed, rendered invisible, intangible: they are no longer the corpses of Jews and partisans in the mass graves of the *Einsatzgruppen*; they are volatilised as smoke and ash. As Celan puts it, in his epitaph to the Jews who died in the camps, in *Todesfuge*: '[A]s smoke you will rise into air/then you will have a grave in the clouds...'[23] The problem with Hirst's work here – in the death machines – is that he turns the very condition of terror as ideology, the state of exception, into spectacle. That is, he fulfils to its limit Badiou's thesis that 'sure of its ability to control the entire domain of the visible and the audible...Empire [Badiou draws on the term proposed by Michael Hardt and Antonio Negri for the domain of globalised neoliberal economic and political power] no longer censures anything'.[24] Hirst's work may, then, be one of true horror in that he is able to present as spectacle to an audience stripped of the last vestiges of subjectivity, and - through the market – as object of consumption for the administrators and negotiators of this ideology, the governing principle of power as dispassionately managed death.

What if, however, Hirst was unable to do more than this? Unable to do so because the condition of subjectivity in the modern state as the sublimation of the particular into the abstract was also the condition of technologies of representation that emerged in, and to an extent defined, modernity? That is, what if modernity's forms of expression and representation cut off the very possibility of self-expression, the truth of self in self-identity, discovered through art, that Hegel posits as a way out of the relation of the individual to absolute power? In their proliferation, repetition and abstraction, I suggest, this is what the representational technologies of modernity do – first printmaking, then more emphatically the photograph and

film. The abstraction of subjective experience in modernity, so that what you feel about the world is no longer of significance to the world, is akin to the abstraction of the subject from time and space that accompanies photographic representation. It is this abstraction from the 'sensuous particular' – as Strauss terms it – that founds the critical reading of photography as a death-bearing apparatus for Barthes, Metz, Pierre MacOrlan and others. It is this alienation between the 'sensuous' subject and its abstraction that Barthes recognises when he writes of the first viewers of photographs as seeing before them a new kind of man, a genetic variation. Indeed, that genetic transformation is man in modernity.

In their reactions to this instrumentalism there is a curious parallel between Agamben and Foucault, on the one hand, and Heidegger, on the other: each invests heavily in a romantic notion of pre-modern subjectivity free from the determinations of the bureaucratic state (or, for Agamben, perhaps, the satraps of global corporations). There is an essence of being 'before the modern' (Foucault's historical avatars of disobedience), of being 'before the subject' itself (Heidegger's idea of *Dasein*) and, through being *within* its very interstices, 'before power' (Agamben's models of radical passivity). Indeed, as I have suggested, Heidegger's *Dasein* might be understood as a conceptual figure produced by the pressures of modernity, by a phobic reaction to its technologies of mass reproduction and mass disposal akin to that of Rilke, and, indeed, of Hegel. Of the artists I have dwelt on in this study, both Bacon and Emin seem to have, at the heart of their œuvres, a desire to pull the subject back from the depersonalising effects of modernity, the anonymity of modern death – whether that death is real or merely representational – and restore to it a particular dignity *as subject* that is wholly illusory in the historical contexts in which their work is made.

Regardless of the problematic relation of the subject and the law on which Agamben's theory rests – since it implies a disarticulation between subject and power that would free us from any responsibility for the determination of the law even as it makes us subject to the law – I want to take from it the notion of the overlooked as a strategy for countering the usurpation of the law by the state to facilitate its management of its subjects and disposal of their bodies. Adam Thurschwell suggests that 'Agamben's political philosophy retains the Heideggerian understanding of ethics as *ethos*, "dwelling" (albeit transposed ingeniously into the sphere of pure language...in place of Being)'.[25] I take that sense of the marginal and overlooked not as the unacknowledged 'place of survival' (which is how Agamben sites his linguistic resistance or testimony), but as a site from which ethics might be mobilised rather than located and determined in stasis. That overlooked space is the graveyard (as both a geographic coordinate and a more diffuse, even representational, concept of 'where we *keep* the dead' rather than 'where the dead dwell', since the dead do not 'live', do not 'dwell', anywhere) and death (as a conceptual parameter). Perhaps Agamben is right in his understanding of modern politics as a submission of the body to the state – in the figure of *Homo sacer* – that in its passivity and marginality paradoxically finds redemption and reveals the true structures of power. 'In the state of exception become the rule, the life of *Homo sacer*,

which was the correlate of sovereign power, turns into an existence over which power no longer seems to have any sovereign hold.'[26] I would suggest, however, that there is a romantic investment in the *Muselmann* as witness here that has something in common with Foucault's serial investments in outsider figures, such as the insane or the criminal, as 'failed subjects' who resist power. Power's hold over the *Muselmänner* was such that they were relegated to the margins of atrocity. Their submission to power's effects meant that they did not even have to be submitted, any longer, to the state's machinery of regulated slaughter.

If Agamben's use of the 'living dead' as figures of *passive* resistance is perhaps naïvely romantic, what of the dead themselves? Or, rather, what of the dead in, and as, their not-selves? They are at once the correlate of power, accounted for by it, whether or not their deaths are marked in space by memorial, and freed from it because they are, largely, of no further use. The spatial marginalisation of the dead has a useful effect *for modernity as power*: it destroys intimacy with tradition, shears the subject off from its own, local, history. This separation allows the isolated subject to receive, as substitute for history, firstly ideology as spectacle (within modernity) and subsequently (within postmodernity), the commodity. When the absent dead *are* mourned, as with the dead of World War 1, and perhaps more problematically with the dead of the Holocaust, they can be mourned within dominant ideologies. That is, they are recollected by institutions within the very structures of thought that caused their deaths, and only at moments when that spectacle of recollection can endorse the further extension or repetition of those ideologies.[27] Foucault's comments on death and modernity may be useful to us here – and whilst Agamben cites them he seems, nonetheless, to opt for a figure of difference as witness beyond power (the *Muselmann*) rather than death itself as something that power cannot grasp.[28] Foucault notes what Ariès and others have already observed: the 'gradual disqualification of death.'[29] Foucault makes it clear, however, that, for him, in connection with this removal of death from the public sphere – its 'privatisation' - once it no longer symbolises the transition of power from state sovereign to spiritual sovereign, 'death becomes...the limit or the end of power...'.[30] 'Death is outside the power relationship. Death is beyond the reach of power, and power has a grip on it only in general, overall, or statistical terms. Power has no control over death, but it can control mortality. [...] Power no longer recognizes death. Power literally ignores death.'[31]

This distance from and neglect of the dead may offer an advantage in the *remembrance* of history – rather than the opportunely sanctioned *mourning* occasioned by the state. Abandoned to the margins, death continues in the subject's forgetfulness of its former relation to others. Blanchot cautions us that '[W]e should not, by means of artifice, pretend to carry on a dialogue'; we can only remember, knowing that 'one does not remember.'[32] As a rediscovered sign of absence, however, the cemetery, the monument, memory, is also a sign of obsolescence, the exhaustion of instrumental usefulness.

Absence, then, might be precisely that space within language, *or a language in itself*, that Agamben seeks as a site of 'witness to the impossibility of bearing witness.'[33] Death in

modernity is the impossible, the unthought, even in the minds of those who are compelled to think it. The impossible representation of death may then, as Erik Vogt observes of dead languages, be such 'that it no longer marks out the space for a subject-position but a space that can, however, be reappropriated and recuperated by an author'.[34]

The graveyard may be precisely this place: impossible to comprehend because it is not governed by those structures that regulate and initiate subjectivity in the age of corporate instrumentalism. To think it in terms of site sustains the problem that Agamben encounters, however; it leads to a form of 'ethics as *ethos*', a home from which to imagine the other, from which to offer hospitality as qualified exchange.[35] Thought thus, the graveyard remains only that exotic, romantic place painted by Jacob van Ruisdael or evoked in poetry by Thomas Gray; it is a site of identification *and* desire for and with the other, a space for *identifiction* and the guarantee of a fantasy of the stable, imperishable self outside the work, outside life. Rather, let us say that the graveyard is a place where we, as subjects, are disturbed. Death, far from fixing us, puts us into play, both in death, as the mobile subjects of memory and the language of others, and before it, in our address to those who are already dead.

The graveyard, then, is a place of 'impossible' communication; there is no dialogue with the dead, so we have to learn another use for language. As Michael Naas remarks of Blanchot's writing, 'The friend "is" someone who cannot be spoken *of* but only *to* – and spoken to *as* the very apostrophe or turning of an invocation.'[36] That apostrophe is important, for it is spacing not only in the sense of an interruption in speech but in the terms of history. It is that *epoch* which grants history to us, not in its 'resumption' – not, as Nancy observes, in the sense that '[r]esumed history is presented history; the presence of subjectivity to itself'[37] – but in a suspension of relation that makes it clear that 'friendship [*with all that 'friendship' and mutuality imply in the conventional terms of politics*] actually involves a kind of noninteraction [sic] and interruption of communication'.[38] The graveyard is, then, a *condition* of friendship, not simply because it is where our friends are buried (and here we have to think the graveyard as other than space; think it in the context where the memorial may be no more than ashes scattered in the sea, no more than a sapling in a city park, no more than our own memory) but because it is where we are close to them, and yet distanced. They are there, and yet never there: the language of the graveyard, the address to the dead, is a discourse of indeterminacy, one that remains open when we expect death to provide some kind of convenient closure, whether to personal relation or to history. Turfed over, tombstone erected, the grave is never sealed. (Gravediggers knew this, as the 'clowns' with spades in *Hamlet* make obvious to their more sensitive prince.) The graveyard, then, may be the place where friendship begins. As Naas observes:

> It is separation and not union that the friend brings us, distance and not proximity, a worklessness [*sic*] rather than an activity, a listening rather than a speech, a speaking *to* rather than a speaking *of*, a reserve rather than an openness, death rather than life.

It might thus seem that the death of the friend, not their possible but their actual death, would be, contrary to all common sense, the accomplishment and fulfillment of friendship.[39]

Saying 'farewell' to the dead is to give ourselves the chance to greet, to welcome them – something that Derrida makes explicit in his valedictory texts on Levinas.[40] In these, as Jane Gallop suggests, there is made clear 'a relation between hospitality and death', 'a way of saying adieu that is also a welcome'.[41] Derrida stresses elsewhere that the *farewell*, 'adieu', amongst its meanings 'can just as well signify "hello", "I can see you", "I see that you are there", I speak to you before telling you anything else...'.[42]

An unsettling proximity to the 'other' – that basis of Levinasian ethics – depends not on presence, then, but on presence articulated *through* absence, and a corresponding absence that is emphasised especially in modern technologies of presence such as photography and film. The basis of this haunting is, therefore, not presence per se but a proximate relation. And proximity is, as Naas shows, in its foundational etymology a synonym of friendship: friendship is not a description of possession (the *having* in common that would define a political community, whether in the terms of Schmidt or Žižek) but an enactment of relation 'that is in the process of being either interrupted or recuperated, destroyed or reaffirmed'.[43] We find this relation, this 'impossible' friendship, in the company of 'ghosts'. The alien is no longer with us, but always, as Naas puts it, 'just a turn away': this is the governing condition of our relation towards the other.

Without wishing, for a moment, to claim it as a redemptive technology even as it signifies – as technology – modernity's annihilation of subjectivity, I want to suggest that the photograph, itself theorised as the fixing and abstraction of the subjective moment, enacts this fluid relation. Far from being, then, only a deathly representation from which the subject must be redeemed – as Bacon seems to think – the photograph already offers us a continual prolepsis of the subject returned to history. Everything in its frame is, in a sense, condemned to death, yet the photograph does more than demonstrate that we are haunted: in its materiality it may be how we are haunted, our way of entering the space of the dead, and they of entering ours. I am not thinking here of the image as evocative device but, rather, of a logical property in the photograph of 'one being in the other' through which the mirror of modernity aligns the relation of living to dead as an ethical possibility and a possibility of ethics. As Derrida notes of Barthes's theorisation of photographic affect, any aspect of communication by one element of the image may be contained in any other element: 'Ghosts: the concept of the other in the same, the *punctum* in the *studium*, the completely other, dead, living in me. This concept of the photograph *photographs* every conceptual opposition; it captures a relationship of haunting that is perhaps constitutive of every "logic".'[44] The medium that guarantees presence and truth as transcendent properties, above the subject, sustains indeterminacy where there should be only closure.

Yet if death is 'impossible' – because I cannot speak of my own death – we know that others die. The cemetery, both site and concept, is a useful corrective to figures posed against the statutory constitution and disposal of the subject in the state of emergency become the norm.[45] For Agamben, in his invocation of witness and his turning to Franz Kafka, to Giovanni Pascoli and to Paul Celan, redemption remains possible. Indeed, for Agamben, as for Benjamin, the catastrophe of history sows the seeds of its own salvation. This reappropriation of history by the subject is achieved through the rupturing of aesthetics by art. As Vogt observes, 'Art remains the locus for Agamben's thinking [of] historicity because it somehow continues to operate historically, despite its removal to the periphery called aesthetics'.[46] This is, I would suggest, precisely that redemption from the trauma of modernity that Bacon seeks for his subjects in an allegorical image of the past. If Bacon would loosen subject from predicate as an act of 'liberation', he nowhere attempts that disturbance of situation in the relation of 'I' and other that we might understand as a principle of Levinasian thought.[47] Tracey Emin seeks a similar repatriation for both her subjects (uncle Colin *and* Tracey Emin) in allegories of historical transcendence; it is the same historical catastrophe that Hirst would seek to efface through irony and spectacle. In each case it seems as if history is reclaimed from the past, its consequences evaded by a just-about-in-the-nick-of-time, transcendent, historically active subjectivity that survives at the limit of others' experience.

As Vogt asks, however 'Why is it that art should continue to have the power to provoke a thinking that transcends aesthetics and recalls a past (future) mode of historical existence?' For Agamben, it is because art sits 'at the limit of the aesthetic itinerary' and this limit itself marks a privileged 'turning point'[48] – it is that flash of illumination at the moment of danger of which Benjamin writes.[49] That 'turning point' is an articulation of redemption. The *Muselmann* and *Homo sacer* become extreme cases of survival by which change may be affected through a retrospective witnessing to history, through the arrival of their testimony *as an event after the event*, an interruption of history that reclaims it even as it brings its close. In his witnessing to catastrophe, Agamben is oddly eschatological in his thinking (as, of course, was Benjamin).

The cemetery – by contrast – tells us that no one comes out alive, that 'this enemy has never ceased to be victorious'.[50] Not only can *you* not die in someone else's place, *they* cannot die in yours; *not yet*. The cemetery removes us from sentiment and redemption. Yet it plunges us continually, as process and relation, back into history. Death is not a limit from which we rebound to violate the conventions of aesthetics or overcome historical vicissitudes. There is a culture of death, and yet, in its non-representability, there can be no culture of death, just as death itself is 'impossible'.[51] In the art of death we have already done with the business of art and the business of limits. Death is that limit which we always cross and yet which cannot be constituted as limit, since it has no other side. In the cemetery no one is saved, no one comes home.

How does this failure of salvation, this impossibility of repatriation, make history possible? Perhaps because 'history' is not a property located in some place called home to which we

return from trauma in a recuperating narrative. History is carried with us in relation, in encounter. The photograph, perhaps, is this 'portable history': it bears within it the logic of haunting, of 'one in the other', and it is where we keep the other closest to us. It is something that *seemingly* obeys the rules of identification and desire. As Lacan writes: 'What one cannot keep outside, one always keeps as an image within. Identification with the object of love is as bestially stupid as that'.[52] The transcendental category of representation, arresting meaning in its apodictic assertion of presence, is at the same time enfolded into something as unique and dynamic as the subject's imagination of itself, kept like a photograph, increasingly creased and abraded in a wallet. This is where history is sheltered, like a secret, not for reclamation or revelation, but for contemplation.

Eduardo Cadava has a sense of the photograph as this in Benjamin's thought, even as he imagines its flash as a kind of redemptive illumination. 'For Benjamin, history happens when something becomes present in passing away, when something lives in its death'.[53] This is the double action of photographic logic, and – taking note of Derrida's suggestion that such a movement may haunt every logic and using it to think of the death of the other - it answers two fundamental questions that Cadava raises: 'How can an event that appears only in its disappearance leave something behind that opens history? How can the photograph guard a trace of itself and inaugurate a history?'[54] The act of inauguration is possible because neither the photo, *as death*, nor death itself - given in the name - are straightforward identity cards, documents, visas. We cannot identify with the dead. Death removes all possibility of identification: to say 'We are all dead' is not to establish an *identifiction* with the other but to state the inevitable. Neither image nor condition represents a passport home; both are forms by which we carry the stranger within us – both the stranger to ourselves that we are, and the stranger that our friend or lover must necessarily be. (After all, what point would there be to a friendship with our mirror image, with 'people just like us', that narcissistic fantasy of nationalism?) History (and in its continuity, in the impossibility of our identification with it, it is clearly one lacking messiahs or the romance of revolution) is possible because the recognition of oneself, of what is one's own, is possible only through the encounter with the foreign as foreign.

In the forms of its representation, in the very impossibility of its representation or use, then, death puts us into an unsettling relation with the other. It calls into question the notion of an 'us' or an 'I', since the subject is continually confronted with the face of an other who will die, who, in some ways, embodies already the impossible, invisible death of the subject. It presents us with those with whom we have nothing in common save this need for recognition. Death gives us a law of hospitality – the right of the other to acknowledgement and aid. Belonging, recognising the other in a space, is not a matter of property. This is the source of a fundamental condition in the work of Nan Goldin, Ralph Eugene Meatyard, Derek Jarman and Shimon Attie. In each case, I suggest, even as it assumes a material, sometimes explicitly commercial status, their work represents a withdrawal from property or 'objecthood'. In

Aberfan a retreat from the mass media's turning of grief into a thing for consumption maintains the relationship to death as a continuing, necessarily incomplete, historical effect. What is kept unfinished – just as 'The Family Album of Lucybelle Crater' is sustained by Meatyard's death, just as Goldin's *Ballad of Sexual Dependency* never attains a definitive form – is the relation of the subject to the world. The boundaries necessarily remain diffuse and blurred. Only Meatyard emphasises this explicitly, but it is a condition of all these works that 'I' am no longer a property exclusive to myself, no longer exterior to history yet neither its passive victim. Rather, through the effect of the death of the other on me, through the effect of my death on others, I am obliged to be an agent – however constrained, however scared – within it.

Death, then, as it destroys the subject, would create both community and the history of that subject. Death is given to us *passively*, without calculation, by others: they cannot help dying as we cannot, one day, help dying. It is a perfect gift, one seemingly without reciprocity – what, after all can we do for the dead? As Mary Jacobus observes, 'The gift's agency comes from what it performs, rather than any ontological necessity.'[55] But what does this agency enact, where is its stage, and what is its potential effect?

I suggest that it may best be enacted in a culture of the neglected and the 'failed', an aesthetics where there is no reciprocity, only the gift, and where the boundary between donor and recipient is itself blurred. This is the value of Agamben's meditation on the *Muselmänner*, to understand that, if there is a spacing of language and history with the Holocaust, it is nonetheless one that produces a kind of witnessing within that space – in Nancy's terms, a 'finite history'. It is not one that renders ethics impotent, however, as Žižek would have it. Rather, it is a spacing that demands an ethical formulation to render history comprehensible, for only in that comprehension can we acknowledge the event and assume *political* responsibility for it as historical event, and as potential event. That the Nazi genocide *was* in some sense unspeakable and unimaginable does not mean that it did not happen, nor that it cannot be spoken of nor imagined, nor that it cannot be reiterated.[56]

Rather, the Holocaust is an event of history that must be continually accounted for, whose millions of deaths must be acknowledged, even if, in their wake, language seems powerless to describe what happened. The very difficulty of description is perhaps necessary; demands a silence that is not a void, demands otherwise the structurally shattered and shattering rhetorical forms of Celan. Here is the value of Lacoue-Labarthe's problematic meditation on Celan: allowing us to note that the poet's writing assumes those characteristics that Adorno sees as typical of the late work in order to speak in the void, however inadequate the expression remains. If there can be no lyric poetry after Auschwitz, no articulation of the free subject – as Adorno first claimed, and then, perhaps reluctantly, retracted - what would a lyric poetry look like that did not lay claim to such subjectivity, an art that reflected on its author's constraint and seemingly inevitable annihilation? All Celan's poetry is late work, because he writes as a witness to deaths in which he has already died, in which the possibility of his

being has been destroyed and yet must somehow be reclaimed.[57] In the relation of the singular to the multiple, in the work of art that emerges from the impossibility of representation, and in the inheritance from the dead, there is a paradigm for 'subjectivity' in the wake of all that renders subjectivity null and void – whether that is individual death, slaughter on the industrial scale or even the predations of the society of the secretariat that has emerged in its wake.

As Derrida makes clear in his commentary on Marin, it is death that gives representation its force, establishes it as an instrument of power. This is both the death that is to come and, therefore, the death that has already happened. Death, as the absence of others that will come or that has already come, is the opening out of culture into the world and the opening of power onto and into the world. We might say that history depends upon the horrible gift of death, given to us by others as they die; and Auschwitz is *given* to us, not a thing that we might want to accept, but nonetheless one that we must take and keep. If there is a relation between the mass deaths of Auschwitz and the singular death, it is not that if the singular may be represented, so also the multiple, but, rather, that the duty of care, the responsibility given to us, now – whether we want it or not – by all those who died in the Nazi genocide is a responsibility we need to bear, alongside it, for the solitary death. Perhaps this is borne in different ways; not in overt political structures of warning and prevention such as those which *might* constitute Europe as something other than a dominion of Empire, a frictionless surface for the transfer of goods and services, but in the daily work of memory and in knowing, keeping, *welcoming* the other. The alternative, perhaps, is Agamben's model of subjectivisation, one that looks increasingly like one of Hirst's 'death machines' on a universal scale, where we are impotent before the wanton gods of appropriated sovereignty, compensated by a sugar solution of junk food and the erotic lure of disposable, replaceable commodities.

Notes

Introduction.

1. Critchley, S. *Very Little...Almost Nothing: Death, Philosophy, Literature* (London: Routledge, 1997), p. 26.
2. The aesthetic history is, of course, well represented. For an overarching study of the tradition in Western culture, see Ariès, P. *Images of Man and Death* (Cambridge, MA: Harvard University Press, 1985).
3. Nancy, J.-L. 'Finite History' in Carroll, D. (ed.) *States of Theory* (New York: Columbia University Press, 1990), p. 161.
4. Critchley, S. 'Comedy and Finitude: Displacing the Tragic-heroic Paradigm in Philosophy and Psychoanalysis' in *Ethics-Politics-Subjectivity: Essays on Derrida, Levinas and Contemporary French Thought* (London: Verso, 1999) p. 222. Heidegger writes: 'Dying is something that every, *Dasein* itself must take upon itself at the time' (*Das Sterben muss jedes Dasein jeweilig selbst auf sich nehmen*). Heidegger, M. *Being and Time* (Oxford: Blackwell, 1978), p. 47.
5. Ibid.
6. Derrida, J. (Dutoit, T. trans.) *Aporias* (Stanford, CA: Stanford University Press, 1993), p. 22.
7. *Very Little...Almost Nothing*, p. 45.
8. See Nancy, J.-L. (Fort, J. trans.) 'Forbidden Representation' in *The Ground of the Image* (New York: Fordham University Press, 2005), p. 38.
9. 'Finite History', p. 161.
10. Strauss, J. 'The State of Death', *Diacritics,* vol. 30, no. 3 (2000), p. 9.
11. Blanchot, M. 'The Birth of Art' (Rottenberg, E. trans.) in *Friendship* (Stanford, CA: Stanford University Press, 1997), p. 11.
12. Alberti, L.B. *On Painting,* (London: Penguin Books, 1991).
13. Brault, P.-A. & Naas, M. 'To Reckon with the Dead: Jacques Derrida's Politics of Mourning' in Brault, P.-A. & Naas, M. (eds) *The Work of Mourning* (Chicago: University of Chicago Press, 2001), p. 1.
14. See Derrida, J. 'Mnemosyne' in *Memoires for Paul de Man* (New York: Columbia University Press, 1989), p. 19.
15. Marrati, P. *Genesis and Trace: Derrida Reading Heidegger and Husserl* (Stanford, CA: Stanford University Press, 2005), p. 166.
16. As Derrida remarks, '[F]riendship begins by surviving.' Derrida, J. (Collins, G. trans.) *Politics of Friendship* (London: Verso, 1997), p. 291.
17. Ibid. pp. 296–297.
18. Critchley, S. 'The Other's Decision in Me (What are the Politics of Friendship?)' in *Ethics-Politics-Subjectivity: Essays on Derrida, Levinas and Contemporary French Thought* (London: Verso, 1999), p. 257.
19. Ibid.
20. Freud, S. 'Mourning and Melancholia' in Dickson, A. (ed.) *Penguin Freud Library, Vol. 11, On Metapsychology: The Theory of Psychoanalysis* (London; Penguin Books, 1984).
21. Derrida, J. 'By Force of Mourning' in Brault, P.-A. & Naas, M. (eds) *The Work of Mourning* (Chicago: University of Chicago Press, 2001), p. 143.

22. See Pigler, A. 'Portraying the Dead', *Acta Historiae Artium Academiae Scientiarum Hungaraciae*, vol. 4, nos.1–2, (1956), pp. 1–74.

23. Blanchot, M. 'Two Versions of the Imaginary' (Davis, L. trans.) in Quasha, G. (ed.) *The Station Hill Blanchot Reader: Fiction and Literary Essays* (Barrytown, NY: Station Hill Press, 1999), p. 421.

24. Ibid. p. 420.

25. 'By Force of Mourning', pp. 151–152.

26. See my 'Lessons from What's Poor: *Monument* and the Discourse of Statues' in Townsend, C. (ed.) *The Art of Rachel Whiteread* (London: Thames & Hudson, 2004).

27. 'By Force of Mourning', p. 155.

28. Derrida, J. (Wills, D. trans.) *The Gift of Death* (Chicago: University of Chicago Press, 1995), pp. 5–6.

29. Scarry, E. *The Body in Pain: The Making and Unmaking of the World* (Oxford: Oxford University Press, 1985), p. 4.

30. Ibid, p. 31.

31. *Images of Man and Death*, p. 266. For the fuller historical survey, see Ariès, P. (Weaver, H. trans.) *The Hour of Our Death* (London: Allen Lane, 1981).

32. *The Body in Pain*, p. 31.

33. See, amongst many others, Llewellyn, N. *The Art of Death: Visual Culture in the English Death Ritual, c. 1500 – c. 1800* (London: Reaktion Books, 1991) and Aberth, J. *From the Brink of the Apocalypse: Confronting Famine, War, Plague and Death in the Later Middle Ages* (London: Routledge, 2001), especially pp. 181–257.

34. On Roman marriage and death practices, see Toynbee, J.M.C. *Death and Burial in the Roman World* (Baltimore: Johns Hopkins University Press, 1996), Carroll, M. *Spirits of the Dead: Roman Funerary Commemoration in Western Europe* (Oxford: Oxford University Press, 2006) and Koch, G. (ed.) *Roman Funerary Monuments, Vol. 1 (Occasional Papers on Antiquities no. 6)* (Los Angeles: Getty Trust Publications, 1990).

35. Dollimore, J. *Death, Desire and Loss in Western Culture* (London: Allen Lane, 1998).

36. On *Dead Christ* as affirming rather than challenging faith, see, Rowlands, J. *Holbein* (Boston: Godine, 1985), Gatrall, J. 'Representing the Divine in Holbein and Dostoevskii', *Comparative Literature* (Summer 2001), pp. 214–232 and Farronato, C. 'Holbein's "Dead Christ" and the Horror of the Broken Narrative', *Interdisciplinary Journal for Germanic Linguistics and Semiotic Analysis* vol. 3, no. 1 (1998), pp. 121–140.

37. See, *inter alia*, Adorno, T. (Gillespie, S.H. (trans.) 'Late Style in Beethoven' in Leppert, R. *Essays on Music: Theodor W. Adorno* (Berkeley: University of California Press, 2002), Said, E. *On Late Style* (London: Bloomsbury, 2006) and Painter, K. & Crow, T. (eds) *Late Thoughts: Reflections on Artists and Composers at Work* (Los Angeles: Getty Research Institute, 2006).

38. See my *Vile Bodies: Photography and the Crisis of Looking* (Munich: Prestel Verlag, 1998).

39. *The Hour of Our Death*, p. 29.

40. The self-portrait, in the work of Albrecht Dürer and Jan van Eyck, emerges at a time when the social status of the artist is transformed from marginalised artisan to that of creative 'prince', at the heart of Western intellectual and court life – as Dürer in his appropriation of the costumes of the fashionable aristocrat and the successful merchant (costumes that would have been denied to him, *as an artist*, by the sumptuary laws of his city) is only too happy to demonstrate in his self-portraits of 1493 and 1498. Again Dürer exemplifies this move with his self-portrait of 1500 – a picture that, as Joseph Leo Koerner observes, is so embedded in a tradition of religious portraiture that a contemporary would have seen it as a picture of Christ rather than of Dürer. But in representing himself as Christ, a move he makes several times, Dürer also brings us face to face with death. See Koerner, J.-L., *The Moment of Self-portraiture in German Renaissance Art* (Chicago: Chicago University Press, 1993), p. 72.

41. Kracauer, S. 'Photography' in Levin, T.Y. (trans.) *The Mass Ornament: Weimar Essays* (Cambridge, MA: Harvard University Press, 1995), p. 51.

42. 'For me *Da-sein* does not so much signify here I am, so much as, if I may express myself in what is perhaps impossible French, *être-le-là*. And *le-là* is precisely *Aletheia*: unveiling disclosure.' Letter to Jean Beaufret, 23

November 1945, cited in Agamben, G. (Pinkus, K.E. & Hardt, M. trans.) *Language and Death: The Place of Negativity* (Minneapolis: University of Minnesota Press, 1991), p. 4.

43. De Man, P. 'Sign and Symbol in Hegel's Aesthetics', *Critical Inquiry* (Summer 1982), p. 775.

44. Van Alphen, E. *Francis Bacon and the Loss of Self* (London: Reaktion Books, 1992), p. 190.

45. De Man, P. 'The Rhetoric of Temporality' in *Blindness and Insight: Essays in the Rhetoric of Contemporary Criticism* (London: Routledge, 1989) p. 222.

46. See Betterton, R. 'Why is My Art Not as Good as Me? Femininity, Feminism and "Life-drawing" in Tracey Emin's Art' in Merck, M. & Townsend, C. (eds) *The Art of Tracey Emin* (London: Thames & Hudson, 2002).

47. Rose, G. 'O! Untimely Death./Death!' in *Mourning Becomes the Law: Philosophy and Representation* (Cambridge: Cambridge University Press, 1996), p. 132.

48. *Memoires for Paul de Man*, p. 22.

49. Lingis, A. *The Community of Those Who Have Nothing in Common* (Bloomington, Indiana University Press, 1944), p. 12.

50. 'The Other's Decision in Me', pp. 257-258. In his Latin citation Critchley is alluding to Cicero in *De Amicitia*, vii, 23: 'What is still more difficult to assert, the dead live; so great is the respect, the recollection, the regret on the part of their friends that attends them.'

51. Bronfen, E. *Over Her Dead Body: Death, Femininity and the Aesthetic* (Manchester: Manchester University Press, 1992).

52. Reinhard, K. 'Toward a Political Theology of the Neighbor', and Žižek , S. 'Neighbors and Other Monsters: A Plea for Ethical Violence' in Žižek, S., Santer, E.L. and Reinhard, K. *The Neighbor: Three Inquiries in Political Theology* (Chicago: University of Chicago Press, 2005).

53. See Lacoue-Labarthe, P. (Tarnowski, A. trans.) *Poetry as Experience* (Stanford, CA: Stanford University Press, 1999) pp. 41–69.

54. *Images of Man and Death*, pp. 267–268.

55. Badiou, A. 'Fifteen Theses on Contemporary Art', *Lacanian Ink*, no. 23 (Spring 2004).

56. Crowley, M. 'The Human Without', *Oxford Literary Review*, vol. 27 (2005) p. 70.

57. Ibid.

58. *Politics of Friendship*, p. 302.

59. 'The Other's Decision in Me', p. 264; *Politics of Friendship*, p. 69.

Chapter 1. Francis Bacon

1. Gide, A. *Journal, 1889-1939* (Paris: Librairie Gallimard, 1951), p. 41.

2. Bacon remarks in an interview with David Sylvester that he does, in fact, use the mirror as well as photographs in making his self-portraits, and that 'sometimes one needs to see the person, also, while one's painting'. See Sylvester, D. *Interviews with Francis Bacon* (London: Thames & Hudson, 1980), pp. 142 and 144.

3. Leiris, M. *Francis Bacon: Full Face and in Profile* (London: Phaidon, 1983), p. 28.

4. Ades, D. 'Web of Images' in Ades, D. et al. *Francis Bacon* (London: Tate Gallery: 1985), p. 22.

5. Deleuze, G. (Smith, D.W. trans.) *Francis Bacon: The Logic of Sensation* (London: Continuum, 2004), p. 62.

6. *Very Little...Almost Nothing*, p. 179.

7. Barthes, R. *La chambre clair: Note sur la photographie; Ouvres complètes, vol. 3, 1974-1980* (Paris: Éditions du Seuil, 1995), pp. 1112–1113.

8. Levinas, E. (Lingis, A. trans.) *Totality and Infinity* (Pittsburgh: Duquesne University Press, 1969), p. 50.

9. Robbins, J. '*Visage, Figure*: Reading Levinas's *Totality and Infinity*', *Yale French Studies* no. 79 (1991), p. 137.

10. *Aporias*, p. 6.

11. Ibid., p. 7

12. 'Neighbours and Other Monsters', pp. 142-151 passim.

13. Nancy, J.-L. (Fort, J. trans.) 'Nous Autres' in *The Ground of the Image* (New York: Fordham University Press, 2005), p. 105.

14. *Genesis and Trace*, p. 142.

15. 'Nous Autres', p. 105.

16. Ibid., p. 104.

17. *Genesis and Trace*, p. 119.

18. *Being and Time*, p. 74.

19. *Being and Time*, p. 47.

20. *Genesis and Trace*, p. 144.

21. Critchley, S. 'Post-deconstructive Subjectivity' in *Ethics-Politics-Subjectivity: Essays on Derrida, Levinas and Contemporary French Thought* (London: Verso, 1999), p. 56.

22. Derrida, J. (Chakravorty Spivak, G. trans.) *Of Grammatology* (Baltimore: Johns Hopkins University Press, 1976), pp. 141-164.

23. *Francis Bacon and the Loss of Self*, p.162.

24. *Interviews with Francis Bacon* p. 40.

25. Ibid., pp. 40-41.

26. Ibid., p. 43.

27. 'Post-deconstructive Subjectivity', p. 57.

28. *La chambre clair*, p. 1169: 'La Photographie ne dit pas (forcément) *ce qui n'est plus*, mais seulement et à coup sûr, *ce qui a été*. Cette subtilité est décisive...l'essence de la Photographie est de ratifier ce qu'elle représenté' (my translation); and pp. 1169-1170: 'Toute photographie est un certificat de présence. Ce certificat est le gène nouveau que son invention a introduit dans la famille des images. Les premières photos qu'un homme a contemplées (Niepce devant *la Table mise*, par exemple) on dû lui paraître ressembler comme deux gouttes d'eau à des peintures (toujours la *camera obscura*); il *savait* cependant qu'il se trouvait nez à nez avec un mutant (un Martien peut ressembler à un homme); sa conscience posait l'objet rencontré hors de toute analogie, comme l'ectoplasme de "ce qui avait été": ni image, ni réel, un être nouveau, vraiment: un réel qu'on ne peut plus toucher' (my translation).

In the frequently cited English edition of Barthes's book *Camera Lucida* (London: Jonathan Cape, 1982), Richard Sheridan translates *gène* as 'embarrassment' (in other words, as if Barthes had written *gêne*). Such a translation does make a certain sense, if we understand the reference to a 'certificate of presence' as drawing us towards the identity card or passport photo, an image that is likely to cause embarrassment when it is shown to one's family or friends. When we get further into the paragraph, however, with Barthes's references to mutants and new beings, the idea of the photograph as characterising a genetic shift, a change in the nature of man that accompanies modernity (even as it initially obeys the representational codes of media that precede it), becomes clear. At this point the idea of the image as 'embarrassment' is no longer helpful, and indeed serves to obscure meaning in the passage.

29. *Interviews with Francis Bacon*, p. 30.

30. Benjamin, W. 'A Small History of Photography' in *One Way Street* (London: Verso, 1997), p. 251.

31. Heidegger, M. (Mitchell, A. & Raffoul, F. trans.) 'Seminar in Zähringen, 1973' in *Martin Heidegger: Four Seminars* (Bloomington: Indiana University Press, 2003), pp. 70-71.

32. Ibid, p. 71.

33. *Interviews with Francis Bacon*, p. 146.

34. Cadava, E. *Words of Light: Theses on the Photography of History* (Princeton, NJ: Princeton University Press, 1997), p. 8.

35. Metz, C. 'Photography and Fetish', *October* no. 34 (Autumn 1985), p. 84. Metz is citing, albeit in a modified form, Dubois, P. *L'Acte photographique* (Brussels: Éditions Nathan université/Labor, 1983).

36. 'Two Versions of the Imaginary', p. 419.

37. See Kuryluk, E. *Veronica and Her Veil: History, Symbolism and Structure of a 'True' Image* (Oxford: Blackwell: 1991).

38. See *The Moment of Self-portraiture*, pp. 63-64; also 'Portraying the Dead'.

39. *La chambre clair*, p. 1169. 'La Photographie ne dit pas (forcément) *ce qui n'est plus*, mais seulement et à coup sûr, *ce qui a été*. Cette subtilité est décisive...l'essence de la Photographie est de ratifier ce qu'elle représentê.' (my translation).

40. *Words of Light*, p. 8.

41. 'Mnemosyne', p. 28.

42. *La chambre clair*, p. 1174.

43. Ibid.

44. Ibid., p. 1163: [L]e Référent de la Photographie n'est pas le même que celui des autres systèmes de représentation. J'appelle 'référent photographique', non pas la chose *facultativement* réelle à quoi renvoie une image ou un signe, mas la chose *nécessairement* réelle qui a été placée devant l'objectif, faute de quoi il n'y aurait pas de photographie. La peinture, elle, peut feindre la réalité sans l'avoir vue. Le discours combine des signes qui ont certes des référents, mais ces référents peuvent être et sont le plus souvent des "chimères". Au contraire de ces imitations, dans la Photographie, je ne puis jamais nier que *la chose a été là*. Il y a double position conjointe: de réalité et de passé. Et puisque cette contrainte n'existe que pour elle, on doit la tenir, par réduction, pour l'essence même, le noème de la Photographie. Ce que j'intentionnalise dans une photo...ce n'est ni l'Art, ni la Communication, c'est la Référence, qui est l'ordre fondateur de la Photographie, (my translation).

45. Derrida, J. 'The Deaths of Roland Barthes' in Brault, P.-A. & Naas, M. (eds) *The Work of Mourning* (Chicago: University of Chicago Press, 2001), p. 53.

46. Ibid.

47. *La chambre clair*, p. 1175.

48. 'The Deaths of Roland Barthes', p. 34.

49. '*Visage, figure*', p. 137.

50. Barthes, R. (Howard, R. trans.) *Roland Barthes by Roland Barthes* (Berkeley: University of California Press, 1994), pp. 68-69. Derrida in 'The Deaths of Roland Barthes', p. 40, identifies this strategy as a 'virtue of suppleness'. See my discussion of this in the following chapter.

51. '*Visage, Figure*', p. 136; Robbins is citing Levinas's *Essays on Judaism*.

52. *Aporias,* pp. 22-24.

Chapter 2. Damien Hirst – Francis Bacon

1. Allthorpe-Guyton, M. 'Cry Wolf', *Artscribe*, no. 90 (February/March 1992), p. 62.

2. Krauss, R. 'Notes on the Index: Part 1' in *The Originality of the Avant-Garde and Other Modernist Myths* (Cambridge, MA: MIT Press, 1986).

3. Shone, R. 'Damien Hirst' in *Damien Hirst* (London: British Council, Visual Arts Dept, 1992) (publication for 3rd International Istanbul Biennial, 1992), n.p.

4. Burn, G. 'Is Mr Death In?', *Independent*, 17 February 1996.

5. Hilton, T. 'Genius Formed in the Blackness of the Blitz', *Guardian* Wednesday, 29 April 1992, p. 38.

6. 'Is Mr Death In?'.

7. *Interviews with Francis Bacon,* p. 22.

8. One might add here that, even in some of the 'Pope' paintings (for example, *Pope I* (1951)), Bacon distorts the construction of the box that holds his subject, the better to contrast it with the perfect Albertian perspective that is sketched into the architecture behind it.

9. *Aporias,* p. 23.

10. 'The Deaths of Roland Barthes', pp. 40-41.

11. Hollier, D. (Wing, B. trans.) *Against Architecture: The Writings of Georges Bataille* (Cambridge, MA: MIT Press, 1992), p. 119; see Bataille, G. (Michelson, A. trans.) 'Human Face', *October*, no. 36 (Spring 1986), pp. 17–21.

12. Johnson, B. translator's note in Derrida, J. (Johnson, B. trans) 'Fors: The Anglish Words of Nicolas Abraham and Maria Torok' in Abraham, N. & Torok, M. *The Wolf Man's Magic Word: A Cryptonymy* (Minneapolis: University of Minnesota Press, 1986), p. xii.

13. Derrida, J. (Bass, A. trans.) 'Signature Event Context' in *Margins of Philosophy* (Chicago: University of Chicago Press, 1982), pp. 314-321.

14. *Francis Bacon and the Loss of Self*, p. 147.

15. 'Fors', p. xiv.

16. Bacon does exactly this with the left and right panels of *Three Portraits: Posthumous Portrait of George Dyer, Self Portrait, Portrait of Lucien Freud* (1973), inserting a largely undistorted *en face* painting of a photograph of himself on the wall behind Dyer.

17. 'Web of Images', p. 21.

18. Ibid.

19. In a memoir of the artist, Jeffrey Bernard remarked that Bacon had 'a healthy contempt for money. "Bits of paper" he called it after a good night at the roulette table.' Bernard, J. 'Memories of Francis Bacon', *Independent on Sunday* (Arts Section), 3 May 1992, p. 14.

20. Blanchot, M. (Rottenberg, E. trans.) 'Friendship' in *Friendship* (Stanford, CA: Stanford University Press, 1997), p. 292.

21. *Politics of Friendship*, p. 295.

22. 'The Other's Decision in Me', pp. 258–59.

23. *Interviews with Francis Bacon*, p. 133.

24. Browne, T. '*Hydriotaphia*' in Patrides, C.A. (ed.) *Sir Thomas Browne: The Major Works* (London: Penguin Books, 1977), p. 289.

25. 'Is Mr Death In?'.

26. 'Web of Images', pp. 19-20.

27. Russell, J. *Francis Bacon* (London: Thames & Hudson, 1979), p.19.

28. Gowrie, G. *Francis Bacon: Loan Exhibition in Celebration of his 80th Birthday* (London: Marlborough Fine Art, 1989), n.p.

29. 'Is Mr Death In?', p. 12.

30. Buchloh, B. 'From Yves Klein's *Le vide* to Arman's *Le plein*' in *Neo-Avantgarde and Culture Industry: Essays on European and American Art from 1955 to 1975* (Cambridge, MA: MIT Press, 2000), p. 274.

Chapter 3. Tracey Emin

1. Townsend, C. 'Heart of Glass: Reflection, Reprise and Riposte in Self-representation' in Merck, M. & Townsend, C. (eds) *The Art of Tracey Emin* (London: Thames & Hudson, 2002), p. 92.

2. Vara, R. 'Another Dimension: Tracey Emin's Interest in Mysticism' in *The Art of Tracey Emin* (London: Thames & Hudson, 2002), pp. 172–194.

3. De Man, P. 'Autobiography as De-Facement' in *The Rhetoric of Romanticism* (New York: Columbia University Press, 1984), p. 76.

4. Nancy, J.-L. (Fort, J. trans.) 'Forbidden Representation' in *The Ground of the Image* (New York: Fordham University Press, 2005), pp. 35-36 points out that 'the initially iterative value of the prefix *re-* in Latinate languages is often transformed into an intensive or, as one says, "frequentative" value'.

5. Trade plates issued in Britain to garages and motor dealers allow the use of cars on the road prior to registration by their first owner without vehicle specific insurance. They are specific to a company or trader rather than to private individuals. A plate of this kind ('Limited Trade') in the early 1960s would allow a driver employed by a company to drive any car for a short period of time. (Other types of plate available at this time would allow private

motor traders to drive an unregistered car legally for as much as a month.) The presence of such plates (in this case indicating they belong to a north-west London garage) on a left-hand drive (therefore export) model of a British car would suggest that the driver was taking the car abroad for a customer, or at least driving it to the docks or an airport for shipping. (The USA was the primary export market for these expensive cars, 75% of the total production of XKE Jaguars being sold there.) Emin's reference in her letter to the vehicle as its driver's 'first car' is unlikely on a number of counts, therefore, representing a fragment of childhood memory based upon the photograph rather than the facts of the situation. Firstly, the plate suggests that it is a car awaiting delivery from a garage, rather than a private trader, and that it is not UK-owned or -registered; secondly, that it is a left-hand drive model suggests that the car is for export; thirdly, an XKE-type Jaguar in the early 1960s was a highly prestigious and expensive car, which does not really accord with the surroundings of the photograph. Given that the car is a Mk.1 XKE, which was replaced by the Mk.2 in 1965 (only shortly after Emin's birth) and therefore dating the image between mid-1961 and mid-1965, it is the image, and subsequent familial recollections of its moment, that constitutes her inherited memory of her uncle at this point, rather than any memory of the actual encounter.

6. 'Mnemosyne', pp. 21-22.

7. 'Another Dimension', p. 175. Vara here is citing Emin's remarks in two separate interviews: firstly, one she had with the artist in New York, 22 October 2001; and, secondly, one with Stuart Morgan, published as 'The Story of I', *Frieze*, no. 34 (May 1997), pp. 56-61.

8. 'Late Style in Beethoven', p. 566.

9. 'Mnemosyne', p. 11.

10. Loraux, N. (Sheridan, A. trans.) *The Invention of Athens: The Funeral Oration in the Classical City* (New York: Zone Books, 2006), p. 81.

11. Thucydides, *History of the Peloponnesian War* 2.34,1-8, cited in *The Invention of Athens*, p. 46.

12. *The Invention of Athens*, p. 79.

13. Ibid. p. 45.

14. Ibid. p. 26; Loraux is citing Plato's *Menexenus*, 235d, 3-7.

15. 'Autobiography as De-Facement', p. 74.

16. Bach, R. *Jonathan Livingston Seagull: A Story* (London: Macmillan, 1973).

17. Emin at the unveiling of *Roman Standard* (2005) cited at http://news.bbc.co.uk/2/hi/uk_news/england/merseyside/4267757.stm.

18. 'Autobiography as De-Facement', p. 72.

19. *Aporias*, pp. 32-33.

20. Agamben, G. (Heller-Roazen, D. trans) *Remnants of Auschwitz: The Witness and the Archive* (New York: Zone Books, 2002), p. 72.

21. Ibid.

Chapter 4. Nan Goldin

1. In the case of post-mortem portraiture, Jay Ruby notes that with the invention of photography many American journeymen painters who specialised in the genre switched to daguerreotypes. See Ruby, J. *Secure the Shadow: Death and Photography in America* (Cambridge, MA: MIT Press, 1995). For an example of the post-mortem portrait of the historical figure we need look no further than Nadar's study of Victor Hugo on his deathbed – an image that fifty years beforehand would have been rendered as a painting, if it was to be rendered at all.

2. See Duby, J. & Braunstein, P. (Goldhammer, A. trans.) 'Toward Intimacy: The Fourteenth and Fifteenth Centuries' in Duby, G. (ed.) *A History of Private Life, Vol. 2, Revelations of the Medieval World* (Cambridge, MA: Belknap Press of Harvard University Press, 1988), pp. 535-632.

3. See *Secure the Shadow* and *Vile Bodies*.

4. Silver, K. *Esprit de Corps: The Art of the Parisian Avant-Garde and the First World War, 1914-1925* (Princeton, NJ: Princeton University Press, 1992).
5. Richardson, J. *A Life of Picasso, Vol.2, 1907-1917: The Painter of Modern Life* (London: Jonathan Cape, 1996) p. 375.
6. Ibid. p. 387. As Richardson observes, it is even unclear if the source of the female figure in the dancing couple that serves as the central structure for the painting is indeed Eva or Gaby Depeyre.
7. *Images of Man and Death*, p. 266.
8. *Secure the Shadow*, p. 135.
9. See my 'Bohemian Ballads' in Hughes, A. & Noble, A. (eds) *Phototextualities: Intersections of Photography and Narrative* (Albuquerque: University of New Mexico Press, 2003), pp. 103-118.
10. Goldin, N. *The Ballad of Sexual Dependency* (London: Secker & Warburg, 1985), p. 6.
11. Holborn, M. 'Nan Goldin, *Ballad of Sexual Dependency*: An Interview', *Aperture*, no. 103 (1986), p. 45.
12. Sante, L. 'All Yesterday's Parties' in Goldin, N., Holzwarth, H.W. & Armstrong, D. *I'll Be Your Mirror* (Zurich: Scalo, 1996), p. 97.
13. Richardson, J. *A Life of Picasso, Vol. 1, 1881-1906* (London: Jonathan Cape, 1991), pp. 312–325.
14. 'Bohemian Ballads', p. 106.
15. In a taped interview with me in New York, 17 July 1996, Goldin commented on the importance of Warhol to her work, and identified him as an important influence in her desire to become an artist.
16. In the interview Goldin remarked that, by the early 1980s, she was sometimes shooting as many as thirty rolls of film a week.
17. Transcript to the BBC film *I'll Be Your Mirror* (Coulthard, E. & Goldin, N, dirs.) (London: Blast! Films, 1995), n.p.
18. See, in particular, Stewart, S. 'Scandals of the Ballad' in *Crimes of Writing: Problems in the Containment of Representation* (Durham, NC: Duke University Press, 1994).
19. Ibid., p. 125.
20. Ibid., p. 123.
21. Interview with Goldin, 17 July 1996.
22. Ibid.
23. Hoberman, J. 'My Number One Medium All My Life' in Goldin, N., Holzwarth, H.W. & Armstrong, D. *I'll Be Your Mirror* (Zurich: Scalo, 1996), p. 143.
24. Goldin, N. & Coulthard, E. 'I'll Be Your Mirror'. Programme entry for 26 *Internationales Forum des jungen films*, Berlin, 1996 (Berlin: 26 Internationale Filmfestspiele Berlin, 1996), n.p.
25. I am, necessarily, skating over the question of identification here and assuming rather than arguing the difference between temporal regimes in the presentation of the image in film, in slide show and in print, which would take the better part of a book.
26. *I'll Be Your Mirror*, transcript, n.p.
27. 'My Number One Medium All My Life', p. 280.
28. 'Nan Goldin, *Ballad of Sexual Dependency*: An Interview', p. 38.
29. *Politics of Friendship*, p. 294.
30. *The Hour of Our Death*, p. 559.
31. Levinas, E. (Bergo, B. trans.) *God, Death, and Time* (Stanford, CA: Stanford University Press, 2000), p. 93.
32. Ibid., p. 99.
33. Ibid., p. 94.
34. Ibid., p. 95.
35. Owens, C. 'The Trouble With Puerilism' in Bryson, S. (eds) Kruger, B., Tillman, L. & Weinstock, J.,*Beyond Recognition: Representation, Power and Culture* (Berkeley: University of California Press, 1993), p. 264.
36. Press release for exhibition 'Nan Goldin: "I'll Be Your Mirror"', 3 October 1996-5 January 1997 (New York: Whitney Museum of American Art, 1996) p. 3.

37. Liebmann, L. *Artforum*, vol. 35, no. 7 (March 1997), p. 85.

38. Deitcher, D. 'Death and the Marketplace' *Frieze*, no. 29 (July-August 1996), p. 45.

39. *Over Her Dead Body*, p. 46.

40. *God, Death, and Time*, p. 105.

41. Rose, G. *Love's Work* (London: Chatto & Windus, 1995), pp. 110-111.

42. For the *ars moriendi*, see *From the Brink of the Apocalypse*, pp. 215-221.

Chapter 5. Ralph Eugene Meatyard

1. *La Chambre clair*, (my translation; Sheridan uses the ambiguous 'stake' for *enjeu*) p.1175.

2. Barthes, R. 'Textual Analysis of a Tale by Edgar Poe' in (Howard, R. trans.) *The Semiotic Challenge* (Berkeley: University of California Press, 1994).

3. I'm thinking here of Meatyard's work, so often located in terms of the poetic, in contrast to the minimal inventory made by Charles Olson (1910-1970) in the last of his Maximus poems before he died from cancer: 'My wife my car my color and myself'. Olson, C. (Butterick, G. ed.) *The Maximus Poems* (Berkeley: University of California Press, 1983), p. 635.

4. Meatyard made three late self-portraits using a motor drive at slow speed: he is sitting alone on a hillside, facing the camera but looking down; he stands up, turns; and in the last shot he is walking out of the field of vision towards the brow of the hill.

5. *The Community of Those Who Have Nothing in Common*, p. 39.

6. Rhem, J. *Ralph Eugene Meatyard: The Family Album of Lucybelle Crater and Other Figurative Photographs* (New York: Distributed Art Publishers, 2002), plate 1.

7. Or indeed regardless of species... James Rhem points out (ibid., p. 123) that in one of the images excluded from the series Meatyard tried fitting the old man's mask on a horse. Rather than just being horseplay, this might have been an attempt to extend the local reference of the series to encompass Lexington's fame as the home of American horseracing.

8. Ibid., plate 51.

9. Meatyard used masks in a number of his works throughout the 1960s, and the hag's mask appears as early as 1963.

10. Merton died in an accident in his room in Thailand (electrocuted by a faulty light fitting) when he had finally been granted the right to go on a lecture tour overseas.

11. Rhem, J. 'The Structure and Poetics of Lucybelle', in *Ralph Eugene Meatyard: The Family Album of Lucybelle Crater and Other Figurative Photographs* (New York: Distributed Art Publishers, 2002), p. 48.

12. Ibid.

13. Merton, T. 'A Member of the Human Race' from *Conjectures of a Guilty Bystander* in McDonnell, T.P. (ed.) *A Thomas Merton Reader* (New York: Image Books, 1989), p. 345.

14. I'm thinking here particularly of the Roman ash casket of Lucius Abuccius Pothus from the middle of the first century AD in the Pergamon museum in Berlin, SMB Antikensammlung; Sk 1124.

15. Schleif, C. 'The Proper Attitude toward Death: Windowpanes Designed for the House of Canon Sixtus Tucher', *The Art Bulletin*, vol. 69, no. 4 (December 1987), p. 599.

16. On photography and captioning, see Price, M. *The Photograph: A Strange, Confined Space* (Stanford, CA: Stanford University Press, 1997); on the shift of meaning here, one might do well to reconsider Barthes's essay 'The Photographic Message' in (Howard, R. trans.) *The Responsibility of Forms* (Berkeley: University of California Press, 1985), pp. 3-20 in this light.

17. See my *Remains in Light: Materiality, Identity and Photography in Self-portraiture* (D. Phil. thesis, University of Sussex, 2001). The neologism 'identifiction' slides together and deliberately elides the difference between 'identification' and 'fiction' to emphasise the construction of the self through a performance of otherness

predicated upon the recuperation of an already established subjective position that remains outside the usually marginalised and sometimes abject identity that is assumed.

18. 'The Structure and Poetics of Lucybelle', pp. 40-43, and O'Connor, F. 'The Life You Save May Be Your Own' in Asals, F. (ed.) *A Good Man is Hard to Find: Women Writers Text and Contexts* (Newark, NJ: Rutgers University Press, 1993), pp. 31-54.

19. 'The Structure and Poetics of Lucybelle', pp. 42-43.

20. Ibid., pp. 40-41.

21. Ibid., p. 41.

22. 'Nous Autres', p. 102.

23. Althusser, L. 'Ideology and Ideological State Apparatuses' in *Essays on Ideology* (London: Verso, 1984).

24. 'The Deaths of Roland Barthes', p. 34.

25. Eliot, T.S. *Little Gidding* (London: Faber & Faber, 1942), II. 229–233.

26: Schmidt, C. (Schwab, G. trans.) *The Concept of the Political* (Chicago: Chicago University Press, 1996), pp. 26–27.

27. Merton, T. 'The Good Samaritan' in McDonnell, T.P. (ed.) *A Thomas Merton Reader* (New York: Image Books, 1989), p. 349.

28. Ibid., p. 348.

29. Ibid., p. 355.

30. Derrida, J. *Of Hospitality: Anne Dufourmantelle Invites Jacques Derrida to Respond* (Bowlby, R. trans.) (Stanford, CA: Stanford University Press, 2000), p. 45.

31. Ibid., pp. 15-29.

32. Ibid., p. 83.

33. Ibid., p. 47.

34. Ibid., p. 107.

35. 'Neighbors and Other Monsters', p. 148.

36. *Of Hospitality*, p. 62.

37. 'Neighbors and Other Monsters', p. 146.

38. Ibid., p. 162.

39. Ibid., p. 161.

40. *Remnants of Auschwitz*, p. 63.

41. 'Neighbors and Other Monsters', p. 161.

42. Ibid.

43. *Totality and Infinity*, p. 33.

Chapter 6. Derek Jarman

1. Watson, G. 'An Archaeology of Soul' in Wollen, R. (ed.) *Derek Jarman: A Portrait* (London: Thames & Hudson, 1996), p. 34.

2. Jarman's own preference was for the term; 'queer'; rather than 'gay', as a deliberately provocative assertion of marginalised identity. Jarman probably survived longer than everyone, including him, expected. He notes in *At Your Own Risk* that after his diagnosis he expected to live for only two or three years. By the early 1990s treatments for AIDS had, however, progressed to an extent that retarded the full effects of its illnesses; his survival for seven years was not untypical for a Western sufferer from AIDS at that time.

3. Jarman, D. (Collins, K. ed.) *Smiling in Slow Motion* (London: Vintage Books, 2001), p. 33.

4. 'An Archaeology of Soul', p. 34.

5. Morgan, S. 'Borrowed Time' in Wollen, R. (ed.) *Derek Jarman: A Portrait* (London: Thames & Hudson, 1996), p. 113.

6. Ibid., p. 116.

7. Ibid., p. 114.

8. *Smiling in Slow Motion*, p. 88.

9. Ibid., p. 112.

10. Jarman, D. *Chroma: A Book of Colour – June '93* (London: Vintage Books, 1995), p. 55.

11. *Smiling in Slow Motion*, p. 248.

12. Jarman, D. *Dancing Ledge* (2nd edn) (London: Quartet Books, 1991).

13. Local Government Act, 1988 (c. 9), Section 28, 2A – (1) (b) (London: Stationery Office, 1988).

14. *Chroma*, pp. 89-90. The term 'yellow press' dates back to the circulation war between the *New York Journal* and the *New York World* in the mid-1890s, when both papers sensationalised their news coverage.

15. Ibid., p. 90.

16. *Smiling in Slow Motion*, p. 88.

17. Ibid. Including the line 'I saw this', Jarman cites Francisco Goya's series *The Disasters of War*, his engravings of atrocities from the Peninsular War, where the artist gives his signature as authenticating witness to that which otherwise would be unbelievable.

18. Ibid., p. 249.

19. Script for *The Last of England*, cited in 'An Archaeology of Soul', p. 44.

20. Jarman, D. (Allen, S. ed.) *Dancing Ledge* (1st edn) (London: Quartet Books, 1984), p. 170.

21. *Smiling in Slow Motion*, p. 161

22. *Dancing Ledge* (1st edn), p. 244.

23. *Smiling in Slow Motion*, p. 132.

24. *Afterimage*, no. 12, p. 49, cited in 'An Archaeology of Soul', p. 44.

25. *Dancing Ledge* (1st edn), p. 122.

26. For scholarly studies of Dee – as opposed to occult fantasy – see Yates, F.A. 'John Dee: Christian Cabalist' and 'Spencer's Neoplatonism and the Occult Philosophy: John Dee and *The Fairie Queene*' in *The Occult Philosophy in the Elizabethan Age* (London: Routledge, 1979), pp. 79-93 and 95-108; Yates, F.A. *Theatre of the World* (London: Routledge & Kegan Paul, 1964); French, P. *John Dee: The World of an Elizabethan Magus* (London: Routledge & Kegan Paul, 1972) and Sherman, W.H. *John Dee: The Politics of Reading and Writing in the English Renaissance* (Amherst: University of Massachusetts Press, 1997). One might add that Jarman's understanding of Dee as a scholarly outsider conveniently elides the degree of influence at court ascribed to him by Frances Yates and the 'imperial' ambitions that he seemed to harbour for the nation under Elizabeth I.

27. The marginality of the Dungeness garden as metaphor for Jarman and the queer community is emphasised by Daniel O'Quinn; see 'Gardening, History, and the Escape from Time: Derek Jarman's *Modern Nature*', *October*, no. 89 (Summer 1999), p. 116.

28. *Dancing Ledge* (1st edn), 'Epilogue', n.p.

29. *Smiling in Slow Motion*, p. 140. 'Crambe' is either sea kale (*Crambe maritime*), the dominant plant of the Dungeness beach, or the variant *Crambe cordifolia*, which Jarman cultivated against the landward side of Prospect Cottage. See Lloyd, C. 'The Jarman Garden Experience' in Wollen, R. (ed.) *Derek Jarman: A Portrait* (London: Thames & Hudson, 1996), pp. 147-152.

30. Jarman had worked on various ideas for a 'John Dee' film from 1974, of which both *Jubilee* and *The Tempest* might be seen as partial realisations, along with *In the Shadow of the Sun*.

31. *Smiling in Slow Motion*, p. 153.

32. Ibid., p. 189.

33. Ibid., p. 154.

34. Garfield, S. 'Derek Jarman: Into the Blue', *Independent*, 14 August 1993, p. 25.

35. *Chroma*, p. 112.

36. 'Late Style in Beethoven', p. 564.

37. *Dancing Ledge*, p. 194.

38. *Smiling in Slow Motion*, p. 198.

39. Jarman's remarks at the 1993 Edinburgh Film Festival are reported in Pendreigh, B. 'Blue Movie that No One Wants to Watch', *Scotsman*, 25 August 1993, cited in Lawrence, T. 'AIDS, the Problem of Representation, and Plurality in Derek Jarman's Blue', *Social Text*, no. 52/53 (Autumn 1997), p. 249.

40. For Klein and Rosicrucianism, see, *inter alia*, Bois, Y.-A. 'Klein's Relevance for Today, *October*, no. 119 (Winter 2007), and *Painting as Model* (Cambridge, MA: MIT Press, 1990); Buchloh, B. 'Klein and Poses', *Artforum*, vol. 33, no. 10 (Summer 1995); McEvilley, T. 'Yves Klein and Rosicrucianism' in *Yves Klein: 1928-1962, A Retrospective* (Houston: Houston Institute for the Arts, 1982); and Stitch, S, *Yves Klein* (London: Hayward Gallery, 1994).

41. See Yates, F.A. *The Rosicrucian Enlightenment* (London: Routledge, 1972) and *Shakespeare's Last Plays: A New Approach* (London: Routledge, 1975).

42. Yates, F.A. 'Christian Cabala and Rosicrucianism' in *The Occult Philosophy in the Elizabethan Age*, (London: Routledge, 1979) p. 171.

43. Ibid.

44. 'AIDS, the Problem of Representation, and Plurality in Derek Jarman's *Blue*', p. 249.

45. Ibid,. p. 250.

46. *Smiling in Slow Motion*, p. 290.

47. 'Two Versions of the Imaginary', p. 254.

48. 'Late Style in Beethoven', p. 566.

49. *Poetry as Experience*, p. 44. The reference to Derrida is to his essay *'Pas (préambule)', Gramma*, no. 3/4 (1976). *Pas* in French means both 'step' and 'not', allowing Derrida to couple movement and negation as a figure of *différance*.

50. 'AIDS, the Problem of Representation, and Plurality in Derek Jarman's *Blue*', p. 252.

51. Ruttmann cited in Kurtz, R. *Expressionismus und Film* (Berlin: 1926).

52. If there is a film similar to *Blue* in the history of filmmaking it is, rather than other 'monochromic' films such as Nam June Paik's *Zen for Film*, perhaps Chantal Akerman's *News From Home* (1976), in which Akerman reads her mother's letters to her in New York whilst showing footage of downtown Manhattan in which the filmmaker never appears.

53. Plato (Lee, H.D.P. trans.) *The Republic* (London: Penguin Books, 2003), §372a.

54. *Smiling in Slow Motion*, p. 206.

55. *Dancing Ledge* (1st edn), p. 54.

56. *Smiling in Slow Motion*, p. 206.

57. 'Signature Event Context', pp. 315-316.

Chapter 7. Shimon Attie – Aberfan

1. McLean, I & Johnes, M. 'Corporatism and Regulatory Failure: Government Response to the Aberfan Disaster', on www.nuffield.ox.ac.uk/politics/aberfan/esrc.html.

2. Ibid.

3. Visiting Aberfan in the summer of 2006, I was told that in the previous six months some seventeen TV crews from different countries had come to make documentaries or film interviews and news items that might frame archival footage from 1966.

4. Kleebatt, N. 'Persistence of Memory', *Art in America* (June 2000), p. 98.

5. Young, J. 'Sites Unseen: Shimon Attie's Acts of Remembrance, 1991-1996' in *Sites Unseen: Shimon Attie, European Projects, Installations and Photographs* (Burlington, VT: Verve Editions, 1998), pp. 10-11.

6. 'Toward a Political Theology of the Neighbor', p. 49.

7. *Politics of Friendship*, p. 271.

8. Perhaps the most systematic of such projects within modernism would be that of the German photographer August Sander, whose 'Men of the Twentieth Century' attempted to document the representative figures of ordinary life in Germany in the 1920s and 1930s.

9. Marin, L. (Houle, M.M. trans) *Portrait of the King* (Minneapolis: University of Minnesota Press, 1988), pp. 206-214.

10. Derrida, J. 'Louis Marin' in Brault, P.-A. & Naas, M. (eds) *The Work of Mourning* (Chicago: University of Chicago Press, 2001), p. 151.

11. Ibid., p. 155. Derrida here is using an argument similar to that proposed by Ernst Kantorowicz in *The King's Two Bodies: A Study in Mediaeval Political Theology* (Princeton, NJ: Princeton University Press, 1997), which suggests that the emergence of autocratic monarchy depended on a concept of doubling between the king's physical body (which died) and an emancipated corpus of dignity, which never died. This doubling paralleled Christ's two bodies: one human, crucified, and the other divinely transcendent. Both Derrida and Agamben, in *Remnants of Auschwitz*, are concerned with how dignity may be conferred upon the neighbour stripped of it by the mechanisms of the administered society in general, in Derrida's work, and in Agamben's of the Nazis' extermination camps as the unacknowledged *nomos* of modernity, in the possibility of witnessing, somehow, to that which is beyond language and the restoration of dignity. In terms of contemporary politics, Agamben's discussion of the legal status of Jews in Nazi Germany as *entwürdigen* ('deprived of dignity') has important resonances in the Empire's illegal classification of its prisoners in Guantanamo Bay and in franchised centres for torture throughout the world.

12. Ibid.

13. *Remnants of Auschwitz*, p. 67.

14. Ibid., p. 68.

15. Certainly, in their treatment by the British establishment after the disaster we might understand that the citizens of Aberfan were imagined to be those in society without power and therefore without dignity even before the event.

16. 'Finite History', p. 149.

17. Ibid., p. 156.

18. Ibid., pp. 157-158.

19. 'Toward a Political Theology of the Neighbor', p. 16.

20. Agamben's point in *Remnants of Auschwitz* is that the camps become a limit case because they mark 'the ruin of every ethics of dignity'. Clearly, what happened in Aberfan is something different; the good that is carried into subsequent history by the survivors of Auschwitz is not dignity but, rather, the knowledge that 'it is possible to lose dignity and decency beyond imagination, that there is still life in the most extreme degradation.' (p. 69). This is the *Muselmann*, 'an ethics of a form of life that begins where dignity ends'. My concern with Aberfan is the way in which a community assumed never to have had any political dignity to begin with assumes that dignity for itself through the trauma of its children's deaths – that which has no dignity. As Agamben shows, there is a witnessing beyond dignity and beyond the conventional boundaries of ethics in the figure of the *Muselmann*, but he does not then resituate that witnessing within the structures of politics and the law.

21. Levinas, E. 'Dying for...' in Smith, M.B. & Harshav, B. (trans.), *Entre Nous: On Thinking of the Other* (New York: Columbia University Press, 1998), p. 216.

22. 'Toward a Political Theology of the Neighbor', p. 48.

23. Ibid., p. 64.

24. *Remnants of Auschwitz*, pp. 137-171.

25. Levinas, E. 'Dialogue on Thinking-of-the-Other' in Smith, M.B. & Harshav, B. (trans.), *Entre Nous: On Thinking of the Other* (New York: Columbia University Press, 1998), p. 202.

26. Ibid., p. 203.

27. Harvey, D. *Spaces of Global Capitalism: Towards a Theory of Uneven Development* (London: Verso, 2006), p. 27.

28. Caygill, H. *Levinas and the Political* (London: Routledge, 2002), pp. 151-158 and p. 174.

29. See Davis, M. *Planet of Slums* (London: Verso, 2006). For a fine overview of the debate around urban 'revolution', see Cunningham, D. 'Slumming It: Mike Davis's Grand Narrative of Urban Revolution', *Radical Philosophy*, no. 142 (March–April 2007), pp. 8–18.

30. 'Neighbors and Other Monsters', p. 182.

31. *Of Hospitality*, p. 70.

Conclusion

1. Strauss, J. *Subjects of Terror: Nerval, Hegel and the Modern Self* (Stanford, CA: Stanford University Press, 1998), p. 11.

2. Ibid., p. 28.

3. Ibid., p. 31.

4. Ibid., p. 19.

5. See McManners, J. *Death and the Enlightenment: Changing Attitudes to Death among Christians and Unbelievers in Eighteenth-century France* (Oxford: Oxford University Press, 1981), pp. 392–401.

6. Hegel, G.W.F. *Phenomenology of Spirit* (Oxford: Oxford University Press, 1977), pp. 359–360.

7. Foucault, M. *Society Must Be Defended: Lectures at the Collège de France, 1975-1976* (New York: Picador, 2003), pp. 240–241.

8. Foucault, M. *Security, Territory, Population: Lectures at the Collège de France, 1977-1978* (Basingstoke: Palgrave Macmillan, 2007), p. 352; see also pp. 42–49 and 55–86.

9. 'Society Must Be Defended' pp. 243-244.

10. Agamben, G. *Homo Sacer: Sovereign Power and Bare Life* (Stanford, CA: Stanford University Press, 1998), p. 3.

11. See for examples: Norris, A. 'Giorgio Agamben and the Politics of the Living Dead', *Diacritics*, vol. 30, no. 4 (Winter 2000), p. 38, citing 'the case of John Moore, an Alaskan businessman, who found his own body parts had been patented, without his knowledge, by the University of California at Los Angeles and licensed to the Sandoz Pharmaceutical Corporation'. (Norris's source is Rifkin, J. *The Biotech Century: Harnessing the Gene and Remaking the World* (New York: Putnam, 1998.) See also *Homo Sacer*, pp. 126-143 and 160-165.

12. *Homo Sacer*, p. 144.

13. Ibid., p. 145, citing Verschuer, O.F. von (ed.) *État et santé: Cahiers de l'Institut allemand* (Paris: Sorlot, 1942), p. 31.

14. Ibid., citing *État et santé*, p. 48.

15. Vogt, E. 'S/Citing the Camp' in Norris, A. (ed.) *Politics, Metaphysics and Death: Essays on Giorgio Agamben's 'Homo Sacer'* (Durham, NC: Duke University Press, 2005), p. 77.

16. Ibid., p. 79.

17. *Remnants of Auschwitz*, p. 49.

18. *Society Must Be Defended*, p. 260.

19. 'Giorgio Agamben and the Politics of the Living Dead', p. 52.

20. Lacoue-Labarthe, P. (Turner, C. trans.) *Heidegger, Art and Politics: The Fiction of the Political* (Oxford: Blackwell, 1990), p. 37.

21. *Poetry as Experience*, p. 67.

22. Žižek, S. 'Did Somebody Say Totalitarianism?' (London: Verso, 2001), p. 85. See also 'S/Citing the Camp', p. 95.

23. Celan, P. *Todesfuge: '[S]teigt ihr als Rauch in die Luft/dann habt ihr ein Grab in Wolken...'*.

24. 'Fifteen Theses on Contemporary Art'.

25. Thurschwell, A. 'Cutting the Branches for Akiba: Agamben's Critique of Derrida' in Norris, A. (ed.) *Politics, Metaphysics and Death: Essays on Giorgia Agamben's 'Homo Sacer'* (Durham, NC: Duke University Press, 2005), p. 191, n. 8.

26. *Homo Sacer*, p. 153.

27. Thus recollecting the sacrifice of the war dead of the past can endorse contemporary imperialist enterprises in the name of freedom – regardless of such a transformation in the meaning or values associated to the word that the

only degree of common cause might be in the intangibility of the concept of free disposal of the self, including self-sacrifice, to those who are sacrificed in its name - and the state-sponsored mourning of Jewish victims of the Nazis by nations that, firstly, did nothing to check the rise of Fascism and, secondly, did little to accommodate refugees from it can disguise their continued, often racist-inspired, refusal of hospitality to the alien 'other'.

28. *Remnants of Auschwitz*, pp. 82–83. One should observe a perhaps strategic misreading of Foucault by Agamben here. Where Foucault writes that the power to make live and let die penetrates and permeates the old right, but does not erase it, Agamben writes that this older right 'gives way' to the 'new, inverse model which defines modern biopolitics'. This allows for a reading of modernity (and indeed the Holocaust) as historical rupture, whereas Foucault's presentation of historical transformation would suggest that the new sovereign power functions within and extends the inherited regime of earlier structures of power – which is certainly the case for both Nazi Germany and the contemporary neoliberal state.

29. *Society Must Be Defended*, p. 247.

30. Ibid., p. 248.

31. Ibid.

32. 'Friendship', p. 292.

33. 'S/Citing the Camp', p. 94.

34. Ibid.

35. 'Cutting the Branches for Akiba', p. 191. See also Derrida, J. 'A Word of Welcome' in *Adieu to Emmanuel Levinas* (Stanford, CA: Stanford University Press, 1999), pp. 17–18.

36. Naas, M. *Jacques Derrida and the Legacies of Deconstruction* (Stanford, CA: Stanford University Press, 2003), p. 141.

37. 'Finite History', p. 155. Nancy is discussing Derrida in *Writing and Difference*.

38. *Jaques Derrida and the Legacies of Deconstruction*, p. 137.

39. Ibid., p. 143.

40. See Derrida, J. *Adieu to Emmanuel Levinas* (Stanford, CA: Stanford University Press, 1999).

41. Gallop, J. 'Reading Derrida's *Adieu*', *Differences*, vol. 16, no. 3 (Fall 2005), p. 18.

42. *The Gift of Death*, p. 47.

43. *Jacques Derrida and the Legacies of Deconstruction*, pp. 145–146.

44. 'Deaths of Roland Barthes', pp. 41–42.

45. 'On the Concept of History', p. 392.

46. 'S/Citing the Camp', p. 98.

47. 'A Word of Welcome', p. 22.

48. 'S/Citing the Camp', p. 98.

49. 'On the Concept of History', p. 391.

50. Ibid.

51. *Aporias*, pp. 21–33.

52. '*Ce qu'on ne peut pas garder au-dehors, on a toujours l'image au-dedans. C'est aussi bête que ça, l'identification à l'objet d'amour.*' Lacan, J. (1973) *Le Séminaire de Jacques Lacan: Livre XI, Les quatre concepts fondamentaux de la psychanalyse* (Paris: Éditions du Seuil: 1973), p. 219. My translation.

53. *Words of Light*, p. 128.

54. Ibid.

55. Jacobus, M. '"Distressful Gift": Talking to the Dead', *South Atlantic Quarterly*, vol. 106, no. 2 (Spring 2007), p. 402.

56. For a critique of the 'impossibility' of the Holocaust in French thought, see Anderson, M. 'The "Impossibility of Poetry": Celan and Heidegger in France', *New German Critique*, vol. 53 (Spring-Summer 1991). Gillian Rose in 'Architecture after Auschwitz', *Assemblage*, no. 21 (1993), accuses Philippe Lacoue-Labarthe of figuring the Nazi genocide as a caesura in representation that makes the event 'unassimilable [*sic*] to finitude, history or meaning'. See Lacoue-Labarthe, P. (Turner, C. trans) *Heidegger, Art, Politics: The Fiction of the Political* (Oxford: Blackwell,

1990), pp. 41-52. As my chapter makes clear, I would see Lacoue-Labarthe's position, at least in his writing on Celan, as demanding a corresponding rupture in representational forms to reintroduce the event to history. The importance of the Holocaust as historical event is that it remains an apostrophe unassimilable to 'history' even as it is historically located and produced.

57. *Poetry as Experience*, p. 56.

Bibliography

Aberth, J. *From the Brink of the Apocalypse: Confronting Famine, War, Plague and Death in the Later Middle Ages* (London: Routledge, 2001)

Ades, D. 'Web of Images' in Ades, D. et al. *Francis Bacon* (London: Tate Gallery, 1985)

Adorno, T. (Gillespie, S.H. trans.) 'Late Style in Beethoven' in Leppert, R. (ed.) *Essays on Music: Theodor W. Adorno* (Berkeley: University of California Press, 2002)

Agamben, G. (Pinkus, K.E. & Hardt, M. trans.) *Language and Death: The Place of Negativity* (Minneapolis: University of Minnesota Press, 1991)

Agamben, G. *Homo Sacer: Sovereign Power and Bare Life* (Stanford, CA Stanford University Press, 1998)

Agamben, G. (Heller-Roazen, D. trans) *Remnants of Auschwitz: The Witness and the Archive* (New York: Zone Books, 2002)

Alberti, L.B. *On Painting* (London: Penguin Books, 1991)

Althusser, L. 'Ideology and Ideological State Apparatuses' in *Essays on Ideology* (London: Verso, 1984)

Anderson, M. 'The "Impossibility of Poetry": Celan and Heidegger in France', *New German Critique*, vol. 53 (Spring–Summer 1991)

Ariès, P. (Weaver, H. trans) *The Hour of Our Death* (London: Allen Lane, Penguin Books, 1981)

Ariès, P. *Images of Man and Death* (Cambridge, MA.: Harvard University Press, 1985)

Badiou, A. 'Fifteen Theses on Contemporary Art', *Lacanian Ink*, no. 23 (Spring 2004)

Barthes, R. (Howard, R. trans.) *Roland Barthes by Roland Barthes* (Berkeley: University of California Press, 1994)

Barthes, R. 'Textual Analysis of a Tale by Edgar Poe' in Howard. R (trans.) *The Semiotic Challenge* (Berkeley: University of California Press, 1994)

Barthes, R. *La chambre claire, Note sur la photographie* in *Oeuvres complètes*, vol. 3, (Paris: Éditions du Seuil, 1995)

Bataille, G. (Michelson, A. trans.) 'Human Face', *October*, no. 36 (Spring 1986)

Benjamin, W. 'A Small History of Photography' in *One Way Street* (London: Verso, 1997)

Blanchot, M. 'The Birth of Art' (Rottenberg, E. trans.) in *Friendship* (Stanford, CA: Stanford University Press, 1997)

Blanchot, M. (Rottenberg, E. trans.) 'Friendship' in *Friendship* (Stanford, CA: Stanford University Press, 1997)

Blanchot, M. 'Two Versions of the Imaginary' (Davis, L. trans.) in Quasha, G. (ed.) *The Station Hill Blanchot Reader: Fiction and Literary Essays* (Barrytown, NY: Station Hill Press, 1999)

Brault, P.-A. & Naas, M. 'To Reckon with the Dead: Jacques Derrida's Politics of Mourning' in Brault, P.-A. & Naas, M. (eds) *The Work of Mourning* (Chicago: University of Chicago Press, 2001)

Bronfen, E. *Over Her Dead Body: Death, Femininity and the Aesthetic* (Manchester: Manchester University Press, 1992)

Browne, T. 'Hydriotaphia' in Patrides, C.A. (ed.) *Sir Thomas Browne: The Major Works* (London: Penguin Books, 1977)

Cadava, E. *Words of Light: Theses on the Photography of History* (Princeton, NJ: Princeton University Press, 1997)

Carroll, M. *Spirits of the Dead: Roman Funerary Commemoration in Western Europe* (Oxford: Oxford University Press, 2006)

Caygill, H. *Levinas and the Political* (London: Routledge, 2002)

Critchley, S. *Very Little...Almost Nothing: Death, Philosophy, Literature* (London: Routledge, 1997)

Critchley, S. 'Comedy and Finitude: Displacing the Tragic-heroic Paradigm in Philosophy and Psychoanalysis' in *Ethics-Politics-Subjectivity: Essays on Derrida, Levinas and Contemporary French Thought* (London: Verso, 1999)

Critchley, S. 'Post-deconstructive Subjectivity' in *Ethics-Politics-Subjectivity: Essays on Derrida, Levinas and Contemporary French Thought* (London: Verso, 1999)

Crowley, M. 'The Human Without', *Oxford Literary Review*, vol. 27 (2005)

De Man, P. 'Sign and Symbol in Hegel's Aesthetics', *Critical Inquiry* (Summer 1982)

De Man, P. 'Autobiography as De-facement' in *The Rhetoric of Romanticism* (New York: Columbia University Press, 1984)

De Man, P. 'The Rhetoric of Temporality' in *Blindness and Insight: Essays in the Rhetoric of Contemporary Criticism* (London: Routledge, 1989)

Deleuze, G. (Smith, D.W. trans.) *Francis Bacon: The Logic of Sensation* (London: Continuum, 2004)

Derrida, J. (Chakravorty Spivak, G. trans.) *Of Grammatology* (Baltimore: Johns Hopkins University Press, 1976)

Derrida, J. (Bass, A. trans.) 'Signature Event Context' in *Margins of Philosophy* (Chicago: University of Chicago Press, 1982)

Derrida, J. (Johnson, B. trans) 'Fors: The Anglish Words of Nicolas Abraham and Maria Torok' in Abraham, N. & Torok, M. *The Wolf Man's Magic Word: A Cryptonymy* (Minneapolis: University of Minnesota Press, 1986)

Derrida, J. 'Mnemosyne' in *Memoires: For Paul de Man* (New York: Columbia University Press, 1989)

Derrida, J. (Dutoit, T. trans.) *Aporias* (Stanford, CA: Stanford University Press, 1993)

Derrida, J. (Wills, D. trans.) *The Gift of Death* (Chicago: University of Chicago Press, 1995)

Derrida, J. (Collins, G. trans.) *Politics of Friendship* (London: Verso, 1997)

Derrida, J. 'A Word of Welcome' in *Adieu to Emmanuel Levinas* (Stanford, CA: Stanford University Press, 1999)

Derrida, J. (Bowlby, R. trans.) *Of Hospitality: Anne Dufourmantelle Invites Jacques Derrida to Respond* (Stanford: Stanford University Press, 2000)

Derrida, J. 'The Deaths of Roland Barthes' in Brault, P.-A. & Naas, M. (eds) *The Work of Mourning* (Chicago: University of Chicago Press, 2001)

Derrida, J. 'Louis Marin' in Brault, P.-A. & Naas, M. (eds) *The Work of Mourning* (Chicago: University of Chicago Press, 2001)

Dollimore, J. *Death, Desire and Loss in Western Culture* (London: Allen Lane, 1998)

Dubois, P. *L'acte photographique* (Brussels: Éditions Nathan Université/Labor, 1983)

Duby, J. & Braunstein, P. (Goldhammer, A. trans.) 'Toward Intimacy: The Fourteenth and Fifteenth Centuries' in Duby, G. (ed.) *A History of Private Life*, vol. II, *Revelations of the Medieval World* (Cambridge, MA: The Belknap Press of Harvard University Press, 1988)

Eliot, T.S. *Little Gidding* (London: Faber & Faber, 1942)

Farronato, C. 'Holbein's "Dead Christ" and the Horror of the Broken Narrative', *Interdisciplinary Journal for Germanic Linguistics and Semiotic Analysis*, vol. 3, no. 1(1998)

Foucault, M. '*Society Must Be Defended*': *Lectures at the Collège de France, 1975–1976* (New York: Picador, 2003)

Foucault, M. *Security, Territory, Population: Lectures at the Collège de France, 1977–1978* (Basingstoke: Palgrave Macmillan, 2007)

Gallop, J. 'Reading Derrida's *Adieu*', *Differences*, vol. 16, no. 3 (Fall 2005)

Gatrall, J. 'Representing the Divine in Holbein and Dostoevskii', *Comparative Literature* (Summer 2001)

Goldin, N. *The Ballad of Sexual Dependency* (London: Secker & Warburg, 1985)

Gowrie, G. *Francis Bacon: Loan Exhibition in Celebration of his 80th Birthday* (London: Marlborough Fine Art, 1989)

Hegel, G.W.F. *Phenomenology of Spirit* (Oxford: Oxford University Press, 1977)

Heidegger, M. *Being and Time* (Oxford: Blackwell, 1978)

Heidegger, M. (Mitchell, A. & Raffoul, F. trans.) 'Seminar in Zähringen, 1973' in *Martin Heidegger: Four Seminars* (Bloomington: Indiana University Press, 2003)

Hoberman, J. 'My Number One Medium All My Life' in Goldin, N, Holzwarth, H.W. & Armstrong, D. *I'll Be Your Mirror* (Zurich: Scalo, 1996)

Holborn, M. 'Nan Goldin, *Ballad of Sexual Dependency*: An Interview', *Aperture* no. 103 (1986)

Hollier, D. (Wing, B. trans.) *Against Architecture: The Writings of Georges Bataille* (Cambridge, MA: MIT Press, 1992)

Jacobus, M. '"Distressful Gift": Talking to the Dead', *South Atlantic Quarterly*, vol. 106, no. 2 (Spring 2007)

Jarman, D. (Allen, S. ed.) *Dancing Ledge* (London: Quartet Books, 1984)

Jarman, D. *Chroma: A Book of Colour – June '93* (London: Vintage, 1995)

Jarman, D. (Collins, K. ed.) *Smiling in Slow Motion* (London: Vintage, 2001)

Koch, G. (ed.) *Roman Funerary Monuments*, vol. I (Occasional Papers on Antiquities no. 6) (Los Angeles: Getty Trust Publications, 1990)

Koerner. J.-L, *The Moment of Self-portraiture in German Renaissance Art* (Chicago: University of Chicago Press, 1993)

Kracauer, S. 'Photography' in Levin, T.Y. (trans.) *The Mass Ornament: Weimar Essays* (Cambridge, MA: Harvard University Press, 1995)

Krauss, R. (1976) 'Notes on the Index: Part 1' in *The Originality of the Avant-garde and Other Modernist Myths* (Cambridge, MA: MIT. Press, 1986)

Kuryluk, E. *Veronica and Her Veil: History, Symbolism and Structure of a 'True' Image* (Oxford: Blackwell, 1991)

Lacoue-Labarthe, P. (Turner, C. trans.) *Heidegger, Art and Politics: The Fiction of the Political* (Oxford: Blackwell, 1990)

Lacoue-Labarthe, P. (Tarnowski, A. trans.) *Poetry as Experience* (Stanford, CA: Stanford University Press, 1999)

Lawrence, T. 'AIDS, the Problem of Representation, and Plurality in Derek Jarman's Blue', *Social Text*, nos 52/53 (Autumn 1997)

Leiris, M. *Francis Bacon: Full Face and in Profile* (London: Phaidon, 1983)

Levinas, E. (Lingis, A. trans.) *Totality and Infinity* (Pittsburgh: Duquesne University Press, 1969)

Levinas, E. 'Dying for...' in Smith, M.B. & Harshav, B. (trans.) *Entre Nous: On Thinking of the Other* (New York: Columbia University Press, 1998)

Levinas, E. 'Dialogue on Thinking-of-the-Other' in Smith, M.B. & Harshav, B. (trans.) *Entre Nous: On Thinking of the Other* (New York: Columbia University Press, 1998)

Levinas, E. (Bergo, B. trans.) *God, Death, and Time* (Stanford, CA: Stanford University Press, 2000)

Lingis, A. *The Community of Those Who Have Nothing in Common* (Bloomington: Indiana University Press, 1994)

Llewellyn, N. *The Art of Death: Visual Culture in the English Death Ritual, c. 1500 – c. 1800* (London: Reaktion Books, 1991)

Lloyd, C. 'The Jarman Garden Experience' in Wollen, R. (ed.) *Derek Jarman: A Portrait* (London: Thames & Hudson, 1996)

Loraux, N. (Sheridan, A. trans.) *The Invention of Athens: The Funeral Oration in the Classical City* (New York: Zone Books, 2006)

Marin, L. (Houle, M.M. trans) *Portrait of the King* (Minneapolis: University of Minnesota Press, 1988)

Marrati, P. *Genesis and Trace: Derrida Reading Heidegger and Husserl* (Stanford, CA: Stanford University Press, 2005)

McManners, J. *Death and the Enlightenment: Changing Attitudes to Death among Christians and Unbelievers in Eighteenth-century France* (Oxford: Oxford University Press, 1981)

Merton, T. 'A Member of the Human Race' (from *Conjectures of a Guilty Bystander*) in McDonnell, T.P. (ed.) *A Thomas Merton Reader* (New York: Image Books, 1989)

Merton, T. 'The Good Samaritan' in McDonnell, T.P. (ed.) *A Thomas Merton Reader* (New York: Image Books, 1989)

Metz, C. 'Photography and Fetish', *October*, no. 34 (Autumn 1985)

Morgan, S. 'Borrowed Time' in Wollen, R. (ed.) *Derek Jarman: A Portrait* (London: Thames & Hudson, 1996)

Naas, M. *Jacques Derrida and the Legacies of Deconstruction* (Stanford, CA: Stanford University Press, 2003)

Nancy, J.-L. 'Finite History' in Carroll, D. (ed.) *States of Theory* (New York: Columbia University Press, 1990)

Nancy, J.-L, (Fort, J. trans.) 'Forbidden Representation' in *The Ground of the Image* (New York: Fordham University Press, 2005)

Nancy, J.-L. (Fort, J. trans.) 'Nous Autres' in *The Ground of the Image* (New York: Fordham University Press, 2005)

Norris, A. 'Giorgio Agamben and the Politics of the Living Dead', *Diacritics*, vol. 30, no. 4 (Winter 2000)

O'Connor, F. 'The Life You Save May Be Your Own' in Asals, F. (ed.) *A Good Man Is Hard to Find: Women Writers Text and Contexts* (Newark, NJ: Rutgers University Press, 1993)

O'Quinn, D. 'Gardening, History, and the Escape from Time: Derek Jarman's Modern Nature', *October*, no. 89 (Summer 1999)

Painter, K. & Crow, T. (eds) *Late Thoughts: Reflections on Artists and Composers at Work* (Los Angeles: Getty Research Institute, 2006)

Pigler, A. 'Portraying the Dead', *Acta Historiae Artium Academiae Scientiarum Hungaraciae*, vol. 4, nos. 1/2, (1956)

Plato (Lee, H.D.P. trans.) *The Republic* (London: Penguin Books, 2003)

Price, M. *The Photograph: A Strange, Confined Space* (Stanford, CA: Stanford University Press, 1997)

Rhem, J. *Ralph Eugene Meatyard: The Family Album of Lucybelle Crater and Other Figurative Photographs* (New York: Distributed Art Publishers, 2002)

Richardson, J. *A Life of Picasso, vol. I: 1881–1906* (London: Jonathan Cape, 1991)

Richardson, J. *A Life of Picasso, vol. II: 1907–1917: The Painter of Modern Life* (London: Jonathan Cape, 1996)

Robbins, J. '*Visage, Figure*: Reading Levinas's Totality and Infinity', *Yale French Studies*, no. 79 (1991)

Rose, G. 'Architecture after Auschwitz', *Assemblage*, no. 21 (1993)

Rose, G. *Love's Work* (London: Chatto & Windus, 1995)

Rose, G. 'O! untimely death. / Death!' in *Mourning Becomes the Law: Philosophy and Representation* (Cambridge: Cambridge University Press, 1996)

Ruby, J. *Secure the Shadow: Death and Photography in America* (Cambridge, MA: MIT Press, 1995)

Russell, J. *Francis Bacon* (London: Thames & Hudson, 1979)

Sante, L. 'All Yesterday's Parties' in Goldin, N, Holzwarth, H.W. & Armstrong, D. *I'll Be Your Mirror* (Zurich: Scalo, 1996)

Said, E. *On Late Style* (London: Bloomsbury, 2006)

Scarry, E. *The Body in Pain: The Making and Unmaking of the World* (Oxford: Oxford University Press, 1985)

Schleif, C. 'The Proper Attitude Toward Death: Windowpanes Designed for the House of Canon Sixtus Tucher', *The Art Bulletin*, vol. 69, no. 4 (December 1987)

Schmitt, C. (Schwab, G. trans.) *The Concept of the Political* (Chicago: University of Chicago Press, 1996)

Shone, R. 'Damien Hirst' in *Damien Hirst* (London: British Council, Visual Arts Department, 1992)

Silver, K. *Esprit de Corps: The Art of the Parisian Avant-garde and the First World War, 1914–1925* (Princeton, NJ: Princeton University Press, 1992)

Strauss, J. *Subjects of Terror: Nerval, Hegel and the Modern Self* (Stanford, CA: Stanford University Press, 1998)

Strauss, J. 'The State of Death', *Diacritics*, vol. 30, no. 3 (Autumn 2000)

Sylvester, D. *Interviews with Francis Bacon* (London: Thames & Hudson, 1980)

Thurschwell, A. 'Cutting the Branches for Akiba: Agamben's Critique of Derrida' in Norris, A. (ed.) *Politics, Metaphysics and Death: Essays on Giorgio Agamben's 'Homo Sacer'* (Durham, NC: Duke University Press, 2005)

Townsend, C. *Remains in Light: Materiality, Identity and Photography in Self-portraiture* (DPhil thesis, University of Sussex, Brighton, 2001)

Townsend, C. 'Heart of Glass: Reflection, Reprise and Riposte in Self-representation' in Merck, M. & Townsend, C. (eds) *The Art of Tracey Emin* (London: Thames & Hudson, 2002)

Townsend, C. 'Bohemian Ballads' in Hughes, A. & Noble, A. (eds) *Phototextualities: Intersections of Photography and Narrative* (Albuquerque: University of New Mexico Press, 2003)

Toynbee, J.M.C. *Death and Burial in the Roman World* (Baltimore: Johns Hopkins University Press, 1996)

Van Alphen, E. *Francis Bacon and the Loss of Self* (London: Reaktion Books, 1992)

Vara, R. 'Another Dimension: Tracey Emin's Interest in Mysticism' in Merck, M. & Townsend, C. (eds) *The Art of Tracey Emin* (London: Thames & Hudson, 2002)

Vogt, E. 'S/Citing the Camp' in Norris, A. (ed.) *Politics, Metaphysics and Death: Essays on Giorgio Agamben's 'Homo Sacer'* (Durham, NC: Duke University Press, 2005)

Watson, G. 'An Archaeology of Soul' in Wollen, R. (ed.) *Derek Jarman: A Portrait* (London: Thames & Hudson, 1996)

Yates, F.A. 'John Dee: Christian Cabalist' and 'Spencer's Neoplatonism and the Occult Philosophy: John Dee and The Fairie Queene' in *The Occult Philosophy in the Elizabethan Age* (London: Routledge, 1979)

Žižek, S. *Did Somebody Say Totalitarianism?* (London: Verso, 2001)

Žižek, S., Santer, E.L. and Reinhard, K. *The Neighbor: Three Inquiries in Political Theology* (Chicago: University of Chicago Press, 2005)

Index